City of Bristol College
ASHLEY DOWN STUDY CENTRE
Ashley Down Road
Bristol BS7 9BU
TEL: (0117) 3125098

Return on or before the date stamped below.

Studi

Publi

Gene

Cultu
natio

amor

Inter
Perfo
the 1
'Cult
'Perf(

Titles

Patri(
VIOL
Local

Elain
STAG

Elain
ROY/

Chris
PACI
Thea

Susar
WOF

Karei
PERF
Ident

Helei
PERF
Cros:

Milij,
PERF
Trau1

Helei
PERF

Susar
CON

Aesthetics and Politics

Judith Hamera
DANCING COMMUNITIES
Performance, Difference and Connection in the Global City

Ketu Katrak
CONTEMPORARY INDIAN DANCE
New Creative Choreography in India and the Diaspora

Sonja Arsham Kuftinec
THEATRE, FACILITATION, AND NATION FORMATION IN THE BALKANS
AND MIDDLE EAST

00186841

CITY OF BRISTOL COLLEGE

Daphne P. Lei
ALTERNATIVE CHINESE OPERA IN THE AGE OF GLOBALIZATION
Performing Zero

Peter Lichtenfels and John Rouse *(editors)*
PERFORMANCE, POLITICS AND ACTIVISM

Carol Martin *(editor)*
THE DRAMATURGY OF THE REAL ON THE WORLD STAGE

Carol Martin
THEATRE OF THE REAL

Christina S. McMahon
RECASTING TRANSNATIONALISM THROUGH PERFORMANCE
Theatre Festivals in Cape Verde, Mozambique and Brazil

Yana Meerzon
PERFORMING EXILE, PERFORMING SELF
Drama, Theatre, Film

Lara D. Nielson and Patricia Ybarra *(editors)*
NEOLIBERALISM AND GLOBAL THEATRES
Performance Permutations

Alan Read
THEATRE, INTIMACY AND ENGAGEMENT
The Last Human Venue

Ashis Sengupta *(editor)*
MAPPING SOUTH ASIA THROUGH CONTEMPORARY THEATRE
Essays on the Theatres of India, Pakistan, Bangladesh, Nepal and Sri Lanka

Marcus Tan
ACOUSTIC INTERCULTURALISM
Listening to Performance

Joanne Tompkins
UNSETTLING SPACE
Contestations in Contemporary Australian Theatre

Denise Varney, Peter Eckersall, Chris Hudson and Barbara Hatley
THEATRE AND PERFORMANCE IN THE ASIA-PACIFIC
Regional Modernities in the Global Era

Maurya Wickstrom
PERFORMANCE IN THE BLOCKADES OF NEOLIBERALISM
Thinking the Political Anew

Studies in International Performance
Series Standing Order ISBN 978–1–403–94456–6 (hardback)
978–1–403–94457–3 (paperback)
(outside North America only)

You can receive future titles in this series as they are published by placing a standing order. Please contact your bookseller or, in case of difficulty, write to us at the address below with your name and address, the title of the series and the ISBN quoted above.

Customer Services Department, Macmillan Distribution Ltd, Houndmills, Basingstoke, Hampshire RG21 6XS, England

Theatre of the Real

Carol Martin

palgrave
macmillan

First published 2013
First published in paperback 2015 by
PALGRAVE MACMILLAN

Palgrave Macmillan in the UK is an imprint of Macmillan Publishers Limited, registered in England, company number 785998, of Houndmills, Basingstoke, Hampshire RG21 6XS.

Palgrave Macmillan in the US is a division of St Martin's Press LLC, 175 Fifth Avenue, New York, NY 10010.

Palgrave Macmillan is the global academic imprint of the above companies and has companies and representatives throughout the world.

Palgrave® and Macmillan® are registered trademarks in the United States, the United Kingdom, Europe and other countries.

ISBN 978–1–137–29572–9 hardback
ISBN 978–1–137–52282–5 paperback

This book is printed on paper suitable for recycling and made from fully managed and sustained forest sources. Logging, pulping and manufacturing processes are expected to conform to the environmental regulations of the country of origin.

A catalogue record for this book is available from the British Library.

A catalog record for this book is available from the Library of Congress.

Typeset by MPS Limited, Chennai, India.

In memory of my teacher, Brooks McNamara

Contents

List of Illustrations

Preface to the Paperback Edition

While doing research for my first book, *Dance Marathons: Performing American Culture of the 1920s and 1930s*, I became aware of a blurring of the borders between representation, simulation, and real life. From their start as hourly dance contests in the 1920s through their development as infamous 1930s Depression-era entertainments, dance marathons troubled the border between the real and the theatrical well before documentaries and 'reality shows' joined the now pervasive culture of film, video, and digital media. Dance marathons were real contests of physical and mental endurance with rigged outcomes. During the competitions, dancers fell in love and out of love, ate their meals, shaved, did their hair, read letters from families and friends, and generally took care of all but their most private basic needs in public.Dance marathons were real and not real, theatrical but not theatre.

After the 1994 publication of *Dance Marathons*, I wrote the essay 'High Critics/Low Arts' about dance critic Arlene Croce's refusal in 1995 to review *Still/Here* by the choreographer Bill T. Jones. Croce refused to review *Still/Here* on the grounds that by including the words and images of ill and dying people, Jones made his work—'literally undiscussable' and thereby beyond the reach of criticism. Croce's assumptions were many: theater artists have a choice about who they will present onstage, while those who are sick have no choice; using actual illness in art is tantamount to displaying victimhood and martyrdom, both of which make critical evaluation impossible. In 'High Critics/Low Arts', I disagreed with Croce and her assumptions. My essay challenged the dichotomies Croce used to support her position: art vs life, objective vs subjective, and formalist vs utilitarian (see Martin 1996). My refutation of Croce's notion of art as separate from life, supported by my analysis of dance marathons as staging both the real and the simulated, prepared me for my research on the theater of the real. The intimate relationship that live performance has with the real, the ideological investment of critical evaluation, and the value of both archival and empirical research methodologies in relation to live performance continue in the present work.

Since *Theatre of the Real* went to press in 2013, a great number of international works that proceed from real events have been performed. A number of these works address the interface between performance

and the archive both in terms of interrogating the archive and adapting the portrayal of memory to a theatrical space. *O Jardim* (2011) by Companhia Hiato of Brazil tells the stories of three generations of the same family. Although the overarching narrative of the work is fictional, its infrastructure is real: it uses the performers' family photographs and portions of their life stories to build the narrative. *Brickman Brando Bubble Boom* (2012) by Agrupación Señor Serrano of Spain tells the story of John Brickman who invented the mortgage system in Victorian England and fought for the right of everyone to have a home. Brickman's story is intercut with footage of Marlon Brando in *The Godfather* at the same time as a narrator describes Brando playing the role of Brickman in a film. Soon enough we learn that the very plausible story of Brickman is fictional while the fantastic story of Brando's succession of homes culminating in the purchase of an island is true. Live-feed projection shows the performers manipulating tiny human figures and Monopoly houses to illustrate Brickman's housing projects and map the locations of Brando's many homes.

Both performance theorists and artists are turning their attention to how documents, whether real or fictional, material or digital are framed; to the status of these documents as artifacts; and to their implications for dramaturgy, scenography, and mise-en-scène. Analyzing the way documents are used in live performance provides insight into not only how documents work as stage objects, but also how audiences perceive meaning in relation to the presentation of documentation (see Martin 2015).

One of the most important artworks produced as this book first went to press is Rabih Mroué and Linah Sineh's *33 Rounds Per Minute and Then Some* (2012). This performance installation shows the final days of Beirut resident Diyaa Yamout and a portion of his home: his workspace with a table and two chairs, an open computer with a screen showing his Facebook page, a television, a cell phone, and an answering machine. Yamout is absent yet omnipresent as he inhabits his technological afterlife. There is never a reason given for Yamout's disappearance. Rather there is a lot of speculation about what happened to him, especially in the context of his artistic life, his religion, his personal relationships, and the Arab Spring. In the media-driven world brought into Yamout's room through the electronic devices shown, all the information is potentially significant and relevant while none of it seems to definitively reveal anything about Yamout beyond the thoughts of those posting on his Facebook page, leaving messages on his answering machine, and, eventually, announcing his death on television. The entire work amounts to the staging of a simulated biography.

33 Rounds Per Minute and Then Some engages the problem of technology functioning as a sign of the real. It borrows the 'authenticity' of the media to effectively critique the media. In theater of the real, the use of media is not secondary—not merely a recording of live events—but primary; today media is a key arbiter of truth even as its representation of 'truth' is much challenged. Media is still 'evidence' that what is purported to have happened actually did happen. It functions as a record of events, as a form of testimony, and as source information open to extensive manipulation.

The technological afterlife that is 'Yamout' is staged for a real audience in real time. The invented responses of his Facebook 'friends' are in concert with the real as we know it through our digital devices and serve to reveal how we invent what we think we know. What live audiences see in this actorless installation is, finally, just the flickering texts, images, and sounds of technology; texts, images, and sounds that are, nevertheless, overburdened with meaning (see Martin 2014). The archive that informs *33 Rounds Per Minute and Then Some* is the daily performance of self on digital media. It is an imagined and invented experiential archive that is not literally verbatim. This archive presents a past that never happened. The digital version of Yamout's life is fictional even as it is figuratively happening in all our lives all the time. Mroué and Saneh show the technical means of archiving as part of the archive; reality is eating its own tail. An image speaks a thousand words but not all of them are true.

33 Rounds Per Minute and Then Some stages today's technology as a social practice that portends the real even as it pretends its own actuality. It is a postmodern version of Henrik Ibsen's dramaturgy where the fiction onstage represents the reality offstage in provocatively new ways. Twenty-first-century dramaturgy employs the technical means at hand—the Internet, computers, live streaming, smartphones—just as the nineteenth-century activist playwright used what was new to his age, highly realistic stage sets dressed with meticulous visual detail animated by actors who appeared not to be acting.

Theater about real events has generated new methodologies and styles for staging stories, and new uses for the ubiquitous technologies of our daily lives to (re)mediate these stories. Theater creators' methods are just as much a part of the subject of their artworks as the stories they tell. This turn toward complex, multivalent, and contradictory ways of seeing informs the way we experience reality generating a radical uncertainty about both actual events and their simulation. The proliferation of forms of remediation such as sampling, remix, collage, and mashup

is perhaps because one form alone cannot account for the complexity of contemporary experience. The historical contexts of uncertainty along with the dramaturgy of remediation both need greater critical attention. By interweaving fiction and nonfiction and simulating documentary style to upend assumptions about how we understand the world, artists of the real challenge us to make sense of how the metaphoric lifts from its physical presence onstage to a realm of ideas both on and offstage.

Carol Martin

References

Martin, Carol. *Dance Marathons: Performing American Culture of the 1920s and 1930s*, University Press of Mississippi, Jackson, Mississippi, 1994.

Martin, Carol. 'High Critics, Low Arts', *Moving Words: Re-Writing Dance* edited by Gay Morris, Routledge, London, England,1996.

Martin, Carol. 'Reality Dance: American Dance Marathons' in *Ballroom, Boogie, Shimmy Sham, Shake: A Social and Popular Dance Reader* edited by Julie Malnig, University of Illinois Press, Champaign, Illinois, 2009.

Martin, Carol. 'Tables on Stage: The Rise of the Messenger' in *Performance Studies in Motion: International Perspectives and Practices in the Twenty-First Century* edited by Sharon Aaronson-Lehavi, Atay Citron and David Zerbib, Methuen, London, England, 2014.

Martin, Carol. 'The Theatrical Life of Documents' in *Dokument in den Künsten* edited by Daniela Hahn, Wilhelm Fink publishers, Berlin, 2015.

Series Editors' Preface

The 'Studies in International Performance' series was initiated in 2004 on behalf of the International Federation for Theatre Research, by Janelle Reinelt and Brian Singleton, successive Presidents of the Federation. Their aim was, and still is, to call on performance scholars to expand their disciplinary horizons to include the comparative study of performances across national, cultural, social, and political borders. This is necessary not only in order to avoid the homogenizing tendency of national paradigms in performance scholarship, but also in order to engage in creating new performance scholarship that takes account of and embraces the complexities of transnational cultural production, the new media, and the economic and social consequences of increasingly international forms of artistic expression. Comparative studies (especially when conceived across more than two terms) can value both the specifically local and the broadly conceived global forms of performance practices, histories, and social formations. Comparative aesthetics can challenge the limitations of national orthodoxies of art criticism and current artistic knowledges. In formalizing the work of the Federation's members through rigorous and innovative scholarship this series aims to make a significant contribution to an ever-changing project of knowledge creation.

Janelle Reinelt and Brian Singleton

International Federation for Theatre Research
Fédération Internationale pour la Recherche Théâtrale

Acknowledgements

The many generous artists with whom I have been in conversation in relation to this book include: Rabih Mroué, Linah Saneh, Marianne Weems, Adelheid Roosen, Jonathan Ned Katz, Leeny Sack, Herman Helle, Pauline Kalke, Victoria Hanna, Joan MacIntosh, JoAnne Akalaitis, Doug Wright, Jefferson Mays, Marc Wolf, and Emily Mann. Extra special thanks to Jane Arnfield, Jefferson Mays, and Marc Wolf for performing and talking about their work in my classes at NYU and to Doug Wright for speaking about his work with my documentary theatre students.

Special thanks are due to many people who provided me with the opportunity to present my work and receive important feedback. Derek Paget and Mary Luckhurst invited me to give keynote lectures at the 'Acting With Facts' conference at the University of Reading and the 'Unspeakable' conference at the University of York, respectively. Paul Allain invited me to be a respondent to Jane Arnfield's *The Tin Ring* and to teach a class on *My Name Is Rachel Corrie* at the University of Kent. Jane Arnfield invited me to present my work to faculty and students at Newcastle University. Siri Foberg invited me to give a keynote at the 'Monsters of Reality' conference and festival at Dramatikkens Hus in Oslo. Jules Odendahl-James, Claire Conceison, and Sarah Beckwith facilitated a three-day residency to present my work and be a respondent to a production of *The Laramie Project* at Duke University. A lecture at Tel Aviv University that eventually became a chapter in this book was arranged by Freddie Rokem. Frank Hentschker and the late Dan Gerould invited me to curate a series of evenings devoted to documentary at CUNY's Martin E. Segal Theatre. Lifelong friends and colleagues William Sun and Faye Fei enabled me to speak about my work at the Shanghai Theatre Academy, China. Tadashi Uchino arranged for me to speak on documentary theatre at Tokyo University during my semester-long residency at that University. Joanna Klass at the Adam Mickiewicz Institute in Warsaw and Agata Grenda, formerly of the Polish Cultural Council in New York, brought me to Poland on three different occasions to see the extraordinary new Polish theatre and meet the Polish playwrights who are redefining Polish theatre and culture. All of these events continue to inform my thinking about contemporary theatre. Several times I have been a guest of Double Edge Theatre in Ashfield, Massachusetts where I worked on portions of this book. I am indebted to Stacy Klein

and Carlos Uriona and the members of Double Edge for their warm hospitality and generous conversations.

Many thanks to scholars, colleagues, and friends Sharon Aaronson-Lehavi, Atay Citron, Kimberly Jannarone, Sarit Cofman, Aniko Szucs, Klaus Tindemanns, Jim Ball, Henry Bial, Cindy Rosenthal, James Harding, and Elinor Fuchs. Tracy Davis read an early draft of a chapter and made observations that proved insightful for the whole project. Several librarians and archivists were instrumental: Marvin Taylor and the staff at New York University's Downtown archive in the Fales Library; Pamela Bloom, the performing arts librarian at New York University's Bobst Library; Clay Hapaz, the archivist for The Wooster Group; and Erica Laird, the Managing Director of The Builders Association.

Many friends and colleagues have been enormously helpful on my research trips. Josh Abrams and Jennifer Parker-Starbuck have been gracious hosts. Shmulik and Tamar Havilio, Sarit Cofman-Simhon and Avi Simhon generously welcomed me into their homes in Jerusalem. Varda Fish and Atay Citron hosted me in Tel Aviv. Jane Arnfield invited me to stay with her and her family in York when we did not yet even know one another. New York University Abu Dhabi provided generous support for this project.

Mariellen Sandford and Nikki Cesare have been wonderful readers. Janelle Reinelt and Brian Singleton deserve special recognition as this is the second book I have in their award-winning series devoted to international theatre. Paula Kennedy, Benjamin Doyle, and Penny Simmons at Palgrave Macmillan have been professional, helpful, and gracious.

An earlier version of Chapter 4 first appeared in *Jews, Theatre, Performance in an Intercultural Context* edited by Edna Nashon.

I also lovingly appreciate Sophia Martin Schechner, who sometimes consented to listening to a few pages at a time; J. S. Rothbard, who wants to read this book; and Richard Schechner, who remains ever himself, generous beyond most, wise and...

1
Theatre of the Real: An Overview

*Then he undertook an existentially complicated task: he
tried to pinpoint, very precisely, on the actual highway, the
spot where the fictional Aomame would have climbed down
into a new world. 'She was going from Yoga to Shibuya,' he
said, looking out the car window. 'So it was probably right
here.' Then he turned to me and added, as if to remind us
both: 'But it's not real.' Still, he looked back through the
window and continued as if he were describing something
that had actually happened. 'Yes,' he said, pointing. 'This
is where she went down.' We were passing a building called
the Carrot Tower, not far from a skyscraper that looked as if
it had giant screws sticking into it. Then Marakami turned
back to me and added, as if the thought had just occurred
to him again: 'But it's not real.'*

Sam Ander writing about Haruki Murakami

At the beginning of a performance of *Is.Man* by the Dutch writer and
director Adelheid Roosen, presented at St Ann's Warehouse in Dumbo
on Sunday, 7 October 2007, Youssef Sjoerd Idilbi, the lead actor, had a
problem with his microphone. Idilbi shook his head and broke text for
a moment but then uttered 'Ah, there' as the sound system resumed
working normally. After a moment, the problem returned; then disap-
peared again. Things went well until the middle of the performance.
Then, just as the dramatic arc was building toward the brutal murder
of a woman and her child – the central performative moment in the
production about Kurdish honor killing in Holland – the sound system
again broke down. Idilbi (Illustration 1.1), who carried most of the
dramatic weight of the performance, playing a son searching to find

1

2

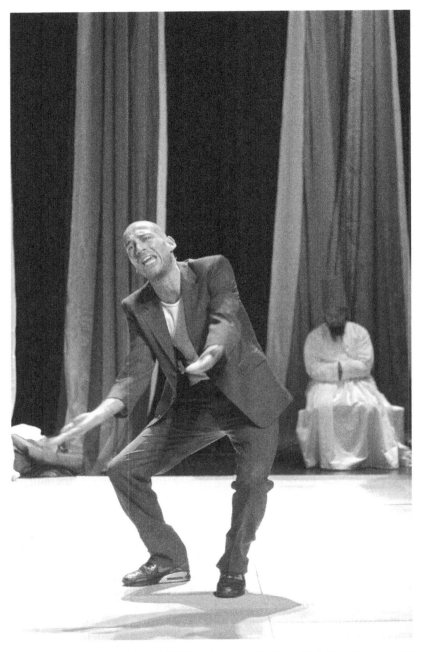

Illustration 1.1 Youssef Sjoerd Idilbi as the son with Oruç Sürücü as the dancer in
Is.Man, written and directed by Adelheid Roosen. Photograph by Ben van Duin

out what happened to his mother and sister, took his headset off and continued without amplification. Idilbi's voice was now much softer, so to hear him, the audience leaned in toward the stage at the end of the deep space of the warehouse theatre.

After less than a minute of speaking without amplification, Idilbi threw up his hands, walked upstage, tossed aside a piece of drapery that was part of the set, picked up a plastic water bottle, and left the stage. The audience heard the door to the theatre slam shut behind him. Had Idilbi walked out of the theatre in the middle of his performance? For several moments the audience sat in undecided quiet, not knowing whether the events that had just taken place were part of the performance or a rude eruption of real life into a play about a real event. Following a hushed commotion in the tech booth, someone rushed through the audience to a silent amplifier in the wings. Then another person ran across the stage. Was this a staging of a murder interrupted by the failure of technical devices in order to make a point about theatre's intervention in the outside world? Or was this an unsanctioned outbreak of the real exploding the realm of theatre? For my part, as a member of the audience, I was in a state of performance theory ecstasy – a state interrupted when one of the freshman honor students who had accompanied me to the theatre turned to me and asked, 'Is this for real?' After a pause, and at great risk of losing face for the rest of the semester, I whispered definitively, 'I don't know.'

After some moments passed, Brader Musiki, performing the roles of musician and grandfather, started singing. Oruç Sürücü, the dancer in the production, calmly walked downstage and began a whirling dervish dance. The performance seemed to be continuing, but was this the performance that was meant to continue? We heard shouting coming from the lobby. A woman a few rows in front of my students and me stood up and yelled, 'The playwright will not permit the actor to return to the stage.' How would she know? She must be a plant, I thought. It seemed anything might happen from here on. I was quietly hoping for a theatre riot of riled-up spectators whose real anger could only be quelled by the definitive resumption of the theatrical.

As the house lights went up, it seemed certain that the real had raised its unruly head in the midst of the theatre. The stage manager stopped the dervish from twirling and announced: 'Ladies and gentlemen, we will need a few moments to make some adjustments. The playwright is preparing to take the stage. You are welcome to move around, but please stay for the rest of the show. We want to tell you this story.' At that point I thought that the playwright wanted to be a performer and

had devised this whole crazy thing in order to get on the stage. When the stage manager announced that the play would now continue, to my thrill and horror an audience member stood up and yelled, 'We want to know what happened!' The stage manager replied, 'The performer kept saying his stomach hurt, that's all I know.' So it was real, I thought. But then director/playwright Roosen appeared in the wings and walked downstage with a script in her hands. 'We must tell the truth here. The same thing happened last night with the sound system. And it was opening night. Today the performance was being filmed. The performer just got fed up.' So it's staged, I thought. But neither I, nor anyone else in the audience, knew for sure.

This overlap and interplay between 'theatre' and 'reality,' the blurred boundary between the stage and the 'real' world, is the subject of this book. I discuss a variety of international performances that, although by different means and to different ends, claim specific relationships with events in the real world. My aim is to portray a shift in the pattern of understanding the representation of the real as necessarily involving verbatim and documentary sources to one that includes a variety of forms and methods and acknowledges a paradigm, a perspective, a subject, and the development of different methodologies. This will hopefully become clear as I examine the problems and possibilities of the ways theatre of the real seeks to 'get real,' to access 'the real thing,' to represent reality, and to be part of the circulation of ideas about our personal, social, and political lives. My methodology is to discuss and analyze specific performances of international authors, directors, performers, and theatre companies in a variety of contexts rather than the body of work of a few specific artists or companies. The focus of my analysis is more on performance, the meanings produced by the live works on stage, rather than the abundant and important dramatic literature composed of letters, diaries, court records, depositions, interviews, and histories. To consider the ways in which theatre of the real enacts social and personal actualities by recycling reality for the stage, I sometimes theorize audience reception – occasionally including my own, because I have seen most of the performances I discuss. Performances with Jewish subject matter recur throughout the book because the fateful experiences of Jews in the twentieth and twenty-first centuries have been at the center of discussions of one of the most important subjects of theatre of the real – social justice.

In *Get Real*, Alison Forsyth and Chris Megson discuss the nomenclatures used to describe theatre that cites reality by putting aside the question of definition in favor of specific critical approaches that 'probe

the utility and viability of these terms' (2009:2). While there may be no universal agreement on individual terms, there is an emerging consensus that theatre of the real includes documentary theatre, verbatim theatre, reality-based theatre, theatre-of-fact, theatre of witness, tribunal theatre, nonfiction theatre, restored village performances, war and battle reenactments, and autobiographical theatre. All of these types of theatre claim a relationship to reality, a relationship that has generated both textual and performance innovations. The array of terms indicates a range of methods of theatrical creation that are not always discrete, but may overlap and cross-fertilize. These methods include, but are not limited to: theatre created from the verbatim use of transcripts, facts, trials, autobiography, and interviews; theatre created from reenacting the experiences of witnesses, portraying historic events, and reconstructing real places; theatre created from the Internet including YouTube and Facebook; and any combination of these. In this kind of theatre, there is an obsession with forming and reframing what has really happened. There is the desire to produce what Roland Barthes dubbed the 'reality effect,' the result of a form of citation that confers the status of legitimacy upon the artwork with the concomitant sense that what is represented is real or has a relationship with what is real (Van Alphen 1997:21).

The phrase 'theatre of the real' identifies a wide range of theatre practices and styles that recycle reality, whether that reality is personal, social, political, or historical. In using the phrase, I aim to note theatre's participation in today's addiction to and questioning of the real as it is presented across media and genres.[1] With the unprecedented growth of virtual entertainment and personal communication technology, our ubiquitous cultural experience of the real results from both live and virtual performances of the self and others in a variety of media. Facebook, YouTube, and reality TV serve as personal performance vehicles. Theatre of the real is born from a sea change in archiving brought on by digitization and the Internet. The proliferation of websites ranging from group and individual homepages to Facebook and YouTube have democratized the exchange of images, both still and moving, as literally millions of people gained heretofore specialized skills in making and processing audiovisual information.

Of necessity, throughout this book I engage history and historiography, because theatre of the real participates in how we come to know and understand what has happened. Arguably, some theatre of the real can even be understood as intervening in history – as changing, or trying to change, history itself. In his essay about the changing critical

response to *The Investigation* by Peter Weiss, Robert Cohen reminds us that 'history has no language and that the language of history is the language of men and women who relate it – an institutionalized discourse with all that that implies' (Cohen 1998:49).

History, too, is an act of the imagination. Both the historian and creators of theatre of the real 'select events from an uninterrupted stream and invent meanings that create patterns within that stream' (Van Alphen 1997:31). The process involves not only imagination but also traces of evidence that both provide an account and have to be accounted for.[2] 'Historians, that is to say, proceed inferentially,' writes Paul Connerton in *How Societies Remember*:

> They investigate evidence much as lawyers cross-question witnesses in a court of law, extracting from that evidence information which it does not explicitly contain or even which was contrary to the overt assertions contained in it. Those parts of the evidence which are made up of previous statements are in no sense privileged; a previous statement claiming to be true has for the historian the same status as any other type of evidence. Historians are able to reject something explicitly told them in their evidence and to substitute their own interpretation of events in its place.
>
> (1999:13)

In 'Portrait of An Enigma,' the brief essay that accompanies his play *I Am My Own Wife*, Doug Wright states that one of his breakthrough moments in trying to figure out the structure of his play came when he decided that he would chart his changing relationship with his real-life subject as part of the play (2004:xv). Wright assuaged his fear of charges of narcissism by making clear the parallel between the subject of his play, the transvestite Charlotte von Mahlsdorf who publicly donned a dress in the face of both Nazism and Communism, and himself: von Mahlsdorf as a curator of nineteenth-century antiques and Wright in his self-designated role as curator of von Mahlsdorf's life (xv). The result was a 35-character play, with all the roles performed by one actor. Wright's idea was that 'the whole piece could be a rumination on the preservation of history: Who records it and why? What drives its documentation? Is what we come to know as history objective truth, or the personal motive of the historian? When past events are ambiguous, should the historian strive to posit definitive answers or leave uncertainty intact?'(xv). Including himself as a character in the play enabled Wright to implicitly pose these questions. The play is about, among

other things, Wright's own process of infatuation, love, disillusion, and then acceptance of Charlotte von Mahlsdorf as a flawed transvestite heroine, first praised for preserving a Weimar cabaret in her basement and then reviled for being a liar and an informer for the Stasi (East German secret police). As performer Jefferson Mays, author Wright, and director Moisés Kaufman worked together on the script, they frequently reminded one another that they were not making a play in the conventional sense and thus were not obliged to observe the rules of classic, Aristotelian dramatic structure. The operative idea was more a mosaic.[3] Wright states that the first meeting of Charlotte and Alfred in *I Am My Own Wife* was based entirely on conjecture, that he felt no need to be bound by fact. The play's main character, created from interviews that Wright conducted with von Mahlsdorf as well as Wright's inclusion of himself in the play, is both fiction and nonfiction. When spectators left the theatre they saw a photograph of von Mahlsdorf as a boy, sitting with two lion cubs on his lap – the very image mentioned in the final moments of the play as the photo that von Mahlsdorf sent Wright shortly before s/he died.

Mays's skill as an actor was also a key factor in determining the dramaturgical structure and histrionic interpretation of *I Am My Own Wife*. When working on developing the production at Sundance Theatre Lab in Utah, Mays created a scene with dollhouse-size furniture, making Wright realize that there were 'countless new ways of dramatizing my existing text' (2004:xx). Mays played 34 of the 35 characters wearing a simple black dress with pearls (Illustration 1.2), and thereby making all the characters, save one, appear cross-dressed. In this transgendered pageant, Mays played everyone as if they all lived in one person and by performative extension the audience was asked to consider an analogous kind of incorporation. Wright created the eleventh-hour number in *I am My Own Wife* as an act of homage to Mays, giving him a chance to show off his virtuosity. In rapid succession, Mays played Charlotte, Wright, a German News Anchor, Markus Kaufmann, Ulrike Liptsch, and Ziggy Fluss as a whirl of commentary on von Mahlsdorf being found out as an informer. In writing this section of the play, Wright provided Mays with something like the solo 'pure dance' variation performed by the prima ballerina in a narrative ballet. To further the sense of the spectators' relationship with antiquity, history, and period, the off-Broadway premiere that I saw in 2003 at Playwright's Horizons had a magnificent upstage wall of all kinds of antique clocks.

Mays never met Charlotte von Mahlsdorf. But after her death in 2002, he performed *I Am My Own Wife* at her Gründerzeit Museum.

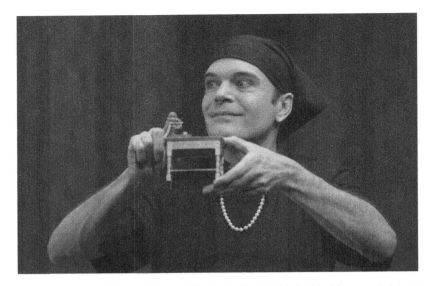

Illustration 1.2 Jefferson Mays as Charlotte Van Mahlsdorf holding a miniature replica of Van Mahlsdorf's antique phonograph in *I Am My Own Wife* by Doug Wright, directed by Moisés Kaufman. Photograph by Joan Marcus

There is a moment in the play where Charlotte recalls seeing through the window of her aunt's home her violent father walking in the snow. During Mays's January 2006 performance at the Gründerzeit Museum, he realized that the couch he describes in the play was the same couch actually present in the room where he was performing. When Mays walked to the window of the museum and pulled the curtains aside, saying, 'and I looked through the window and it was snowing,' he was, in fact, looking through a real window at an actual snowstorm outside.[4] At this moment, von Mahlsdorf's memory, as played by Mays in the real Gründerzeit Museum, was duplicated and confirmed by the real couch and window mentioned in the play. Was Mays's performance history, fiction, nonfiction, or something else and not quite either? In a seeming trick of nature, the real snow seemed to take its cue from the play. The world of the play was actually happening in the real world. It was really snowing outside, and the snow could be seen through the window. But the snow is also called for by the drama. So the snow was both 'real' and 'theatrical.' At that moment, the real inhabited the theatrical, providing spectators with an uncanny spectacle of double vision, an inherent pleasure of the theatrical.

Intrusions of the real into the theatrical, whether unplanned – as with Idilbi leaving the stage or with the serendipitous duplication of real snow outside a real window in Mays's performance at the Gründerzeit Museum – or effected by deliberate artistic intervention displays the closeness and the distance of the real and the theatrical. Attilio Favorini reminds us that Herodotus, who referred to himself as speaking – what we would surely refer to as performing today – rather than as writing history, reported that the playwright Phrynichus was fined a thousand drachmas for writing about the Persian War too soon after its occurrence, thus traumatizing the spectators anew (1995:xii).

Before people grew apprehensive about the proximity of the theatrical to the real, there was first a tension between imitation and authenticity. In *The Real Thing* (1989) Miles Orvell argues that the high value Americans put on authenticity in the late nineteenth and early twentieth centuries, for example, marked a shift in the arts from imitation and illusion to showing and doing 'the real thing' (xv). As credible machine-made replicas of all kinds of goods became readily available, a culture of authenticity arose in 'an effort to get beyond mere imitation, beyond the manufacturing of illusions, to the creation of more 'authentic' works that were themselves real things' (xv). The culture of authenticity that was integral to modernism was formed alongside the mainstream culture of aesthetic imitation (xv).

According to Forsyth and Megson, 'much documentary theatre has complicated notions of authenticity with a more nuanced and challenging evocation of the 'real' (2009:2). In addition to a growing number of reflexive performance techniques, which focus the spectator's attention on how the performance is made and therefore acknowledge the complexity of the performance's reality, is the shift away from single-perspective notions of truth toward ambiguity and multiple viewpoints. 'The one trenchant requirement that the documentary form should necessarily be equivalent to an unimpeachable and objective witness to public events has been challenged in order to situate historical truth as an embattled site of contestation' (6).

Complicating and questioning truth claims in order to interrogate the real is indicative of the ways in which what is deemed real can be understood and determined in diverse ways in different historical circumstances. Walter Benjamin wrote that human perception changes with humanity's modes of existence and this existence is largely a function not of nature but of historical circumstances ([1936] 1968:222). Theatre of the real is in a shadowy conversation with what Benjamin wrote about in the 1930s in 'The Work of Art in the Age of Mechanical Reproduction'

([1936] 1968:217–51). Mechanical reproduction destroyed what was then the accepted notion of authenticity based on the existence of an original (219–20). Theatre of the real also claims authenticity based on an original source that is then copied and simulated and never 'for the first time.' As the result of recycling testimony, documents, film, and video and practices that both exploits and disrupts notions of authenticity, theatre of the real often calls the original into question, even as it employs what Benjamin called the 'aura' of the original (221).

The stickler in all this is the actor. The actor is both valorized as the vehicle of imitation and castigated as the teller of lies. An actor's performance can exist on a continuum from imitation to allusion to invention to parody. Acting occurs when a person stands in for someone else. In theatre of the real this other person is not a fictional character, but a person who actually existed or still exists. The proof of this existence, whether present or past, is verified by documents, audiotape, film, videotape, and general public knowledge. Evidence of the person having really existed and events having really happened are offered to audiences as proof of the legitimacy of the representation of the subject matter. Documents are presumed to be authentic (not forged, distorted, or invented) and are assumed to preexist the theatrical performance based on those documents. Paradoxically, the ability to perform authentic documents has become dependent on reproduction. Scholars have pointed out the difficulties and complexities of the processes of remembering, interviewing, editing, creating characters for the stage, writing effective dramatic narratives, using dramatic structures and literary forms, according to the shifting conventions of theatrical representation (Bar-Yosef 2007; Bottoms 2006; Ferguson 2011; Hesford 2006; Martin 2006b; Reinelt 2006).

Another paradox challenges most theatre of the real: the person speaking onstage is a 'real person,' an actor, playing another real person who is known in the real world but is not actually present onstage and yet who appears to be present with the willing suspension of disbelief of the spectators. Sometimes, as in Spalding Gray's *Rumstick Road* (1977), the actor playing the real person is the real person, yet he or she is appearing with other actors playing real persons whom they are not. It can, and does, get that mixed up and complicated. Performance of the real can collapse the boundaries between the real and the fictional in ways that create confusion and disruption or lead to splendid unplanned harmonies in the service of the creation of meaning.

Theatre of the real poses questions relevant to both theatre makers and historians. What does it mean to be an instrument of memory

and of history? In what ways is performance embodied kinesthetic historiography, and what end does this serve? What is the relationship between individual stories and the grand narrative of history? Is using the imagination an assault on historical accuracy? Documentary accounts of the Holocaust are often considered the most appropriate and effective (Van Alphen 1997:18). From this perspective, theatricalized autobiographical and biographical accounts such as *The Survivor and the Translator* by Leeny Sack (1980) and *The Tin Ring* by Jane Arnfield (2012) are inherently superior to fiction about the same subject matter. 'Documentary realism,' writes Van Alphen, 'has become the mode of representation that novelists and artists must adopt if they are to persuade their audience of their moral integrity – that is of their reliance on cognitive intentions and their rejection of aesthetic considerations' (1997:19). At the same time, Van Alphen acknowledges that realism and everything it hauls along with it is an 'old mode of representation with all its "guarantees" of objectivity and transparency' (24).

This is especially true when we consider that in the second decade of the twenty-first century, avant-garde techniques are more than a hundred years old and have achieved the status of a 'tradition' alongside realism. Within this register, objectivity and transparency can be accomplished by means of avant-garde methods as readily as with the conventions of realism. Both are acknowledged as artistic 'languages,' wholly constructed. In the West, realism is often attributed with the ability to provide accurate portrayals of the conflicts of average people, operating within a credible plot. This assumption was quickly undone by avant-garde movements that rejected linear narrative and a literal depiction of reality. Stream of consciousness, symbolism, surrealism, abstract expressionism, Brechtian epic theatre, theatre of the absurd, and postmodernism all intervened in the conventions of and assumptions about realism. These avant-gardes have been in existence almost as long as realism itself. Most were born of shifts in philosophical and scientific thinking. Concerning implications of pataphysics for art practice, for example, Kimberly Jannarone points out: 'One of the many paradoxes of pataphysics resides in this fusion of science and art, (presumed) objectivity and subjectivity. Even as the individual is galvanized to disregard existing theories of science, thought, and reality, he or she is encouraged to construct his or her own theories with rigorous logic, or at least with elegant idiosyncrasy' (2001:247).

Theatre of the real is not beholden to any particular style, whether realism or any other, though realism continues to be a strong presence. Theatre of the real can be mimetic and plot driven, or not. Mimesis is

only one possibility among many now that realism coexists alongside and in combination with many other approaches to representation. None is ontologically more real, more authentic or true, than any other. In theory, they are all 'unreal' as well as 'real.' All are constructions. The seeming contradiction of theatre of the real performed by actors is no longer a contradiction if the proximity of historical and imaginative approaches is acknowledged. Iterations of the real can occur in isolated moments without attempting to indicate a stream of continuous reality. The Builders Association's *House / Divided* (2011), for example, makes extensive use of multiple projection screens, live actors, real and fabricated artifacts, and general technological extravaganza in an episodic narrative structure about the housing foreclosures resulting from the most recent recession.

Regardless of style, theatre of the real does not necessarily document the real with complete historiographic accuracy. Creators of performance reinterpret history and represent it according to their fascination, proclivities, imagination, and individual convictions about whether or not a definitive truth can be known, all the while using the archive as source material. The result is not the truth, but a truth, that many times conflicts with other narratives. *My Name Is Rachel Corrie* (2005), for example, is a play about a young woman, Rachel Corrie, who writes about her experience in Gaza apart from the historical narratives that have created that particular place. The editors of her emails and journal entries, Alan Rickman and Katharine Viner, created a structure for the play by making omissions, additions, subtle changes of rhetoric, and juxtapositions. Finally, even Brecht's proposal for theatre being like an event on a street corner can eschew the social truth he claims is the goal of his theatre and produce instead the continuation of conflicting stories (see Brecht 1964:121). Presented with evidence, people can remain convinced of their own views without having to entertain, let alone understand or agree with, the views of anyone else. What ensues may be more a hot argument about convictions than insight. Tolerating differing narratives with equanimity is not the same as considering the merit of multiple views in order to arrive at truth about social reality. Reality may be multifaceted, but people may very well believe only in one version of events. When an author writes many views into his play or performance, he still controls the selection and portrayal of all the views represented but not their reception.

Popular entertainment in the United States of the 1930s, such as dance marathons and its progeny, the roller derby, contained heavy doses of the real. Promoters presented contestants as regular 'girls' and

'boys' who happened to be competing for cash prizes.[5] Dance marathons anticipated the blurring of representation, simulation, and real life with their interlaced performance of fiction and nonfiction (see Martin 2009b:93). Many times what was presented as real in a marathon was phony. Audiences were not naïve, many knew that marathons were fixed. Spectators were drawn to the mix of the risk of the physical effort of dancing for hours and days at a time *and* the performance of that risk. Contestants really danced, and some even died during the contests. At the same time, they performed and exaggerated their effort to create theatre for the show.

Circus sideshows – popular from the nineteenth through the mid-twentieth centuries – presented the real's cousins: everything faked, forged, and freakish; things that both were and were not what they claimed to be. Circus man P. T. Barnum exhibited the skeleton of a mermaid, shackles of the formerly enslaved, and 'Indian costumes.' Barnum exploited the public's fascination with the melange of the fabricated and the authentic occurring in the same space (see Nickell 2005). Sideshow aficionados also appreciated the flim-flam as flim-flam; and today's reality show viewers know what is going on.

The bona fide and the counterfeit, the authentic and the forged, the real and the fake continue to be close partners. Today's reality television shows employ a strategy much like dance marathons and sideshows. Producers claim that reality TV is 'unscripted' – but everyone knows the shows are rigged. Producers seek unstable and fragile people and guide them through highly charged and very personal narratives that demand confrontation among characters. On *Judge TV*, real litigants come before former actual judges and argue their small claims cases to the delight of millions in the daytime-television viewing world. The faking and mixing of the actual and the fictional enhances rather than detracts from the enormous popularity of reality TV and judge TV, which together account for more than a quarter of primetime broadcast programming and an even higher proportion of afternoon programming in the United States.

In August 2009, a page-one article in *The New York Times* noted that while reality TV is very profitable for networks and producers, the contestants are neither paid nor protected by union representation. Contestants have been locked in hotels, deprived of personal possessions such as cell phones and books, and been subjected to communication blackouts. They are not allowed to communicate with that other reality where they come from: no newspapers or radios are permitted; contestants are escorted in buses with blackened or curtained windows

to and from taping. Isolation, vulnerability, separation from normal daily waking life, 18-hour work days, and alcohol are the ingredients that lower the threshold of usual decorum and promote wild behavior. Nondisclosure agreements protecting the secrecy of what happens on the set are standard (see Wyatt 2009). Such agreements are demanded not only of participants in the shows but also of the office workers who may be busy in the background. These measures are taken so that reality TV can present actions and situations that are allegedly authentic by making sure no one leaks how things are staged for the cameras. The result is a conflation of the real and the represented, the actual and the fictional – with the representational swiftly becoming what millions of people accept, albeit with a grain of salt, as reality. Just as audiences for realistic theatre suspend their disbelief, so viewers of reality TV suspend theirs, more or less. Is the audience really fooled – anymore than Barnum's viewers were? 'There's a sucker born every minute,' Barnum famously pronounced.

Today's theatre of the real both acknowledges a positivist faith in empirical reality and underscores an epistemological crisis in knowing truth.[6] User-generated sites such as Facebook and YouTube feature images and videos posted by 'real people' who want to share their experiences, and sometimes even their most intimate selves, with so-called 'friends' as well as with the general public. Add to this the professional videos and images made by a host of agencies, organizations, institutions, and governments, and the result is an unregulated mix of homemade and professional performances with different ideological aims served up on the same platforms. The primary behaviors of everyday life – that is, life as lived 'live' – have become secondary as these behaviors are quickly mediatized. Theatre of the real uses media in many different ways: as a gauge of truth, as a demonstration of the ways in which people's lives are permeated by simulation, and as an arrow aimed at a history of ideas that includes the disinformation and misrepresentations of popular culture (including what we call 'the news').[7]

The ways in which social media controls information are analogous to the way theatre of the real manages information. Facebook Newsfeed, for example, shows only algorithm-selected information based on what is termed 'Edge,' which is the number of tags, comments, likes, dislikes, messages, and profile searches that occur between two people. Every posting has a ranking that creates a posting's 'EdgeRank.' The higher the rank, the greater the possibility that the post will appear in a user's Newsfeed.[8] Information is invisibly manipulated, added, or eliminated, according to formula and desired outcome. There is a correlation

between select methods of social media and theatre of the real. What is important to note here is that we have become habituated to the manipulation of information across media.

Sophisticated and affordable technology supports the tendency to blur the distinctions between what is 'really happening,' 'made for the camera (or other media),' 'simulated,' 'reenacted,' 'treated,' and 'made consciously as art.' What we understand as the 'really real' has its own continuum that includes the unmediated, the replicated, the staged, the reconstructed, and also, sometimes, the simulated. In selecting, editing, and staging the raw data of life to meet particular cultural, political, and theatrical needs, theatre of the real in all its forms participates in how we come to know, understand, and analyze things. The domains of actual daily life and the performance of daily life continue becoming increasingly blurred. Marvin Carlson writes about experiencing theatre as a repetition, citing Herbert Blau's identification of an uncanny sense of return – 'we are seeing what we saw before.' Citing Richard Schechner and Joseph Roach, Carlson points out that Blau's notion of repetition has been theorized by other thinkers in other ways (Carlson 2001:2). Theatre, Carlson writes, is a place haunted not only by ghosts of past performances and actors but also by a search for an 'original' (2). Schechner's concept of 'restored behavior,' in which every action is an iteration of an earlier behavior, and Roach's notion of 'surrogation,' in which culture reproduces itself through memory, performance, and substitution identify the ways memory is created and reinforced by performance. Carlson writes:

'Theatre, as a simulacrum of the cultural and historical process itself, seeking to depict the full range of human actions within their physical context, has always provided society with the most tangible records of its attempts to understand its own operations. It is the repository of cultural memory, but, like the memory of each individual, it is also subject to continual adjustment and modification as the memory is recalled in new circumstances and contexts' (Carlson 2001:2). Theatre and dreaming share experience, 'in imaginary configurations that, although different, are powerfully haunted by a sense of repetition and involve the whole range of human activity and its context' (3).

Beyond popular culture, contemporary theatre that stages events occuring in the real world has antecedents in the 1920s epic theatre of Erwin Piscator and the theoretical writings of Bertolt Brecht.[9] Piscator's production of *In Spite of Everything* (1925) was a portrayal of German history from the outbreak of World War I to the 1919 assassination of German communist leader Karl Liebknecht. Documentary film footage

of the war functioned as what Piscator named a 'chorus filmicus' in reporting offstage events; the chorus was coupled with sketches portraying individual incidents (Mason 1977:263). Piscator thought the production to be a historically truthful montage of actual speeches, articles, newspaper clippings, slogans, leaflets, photographs, and films of the war and revolution. For Piscator, this was the first time that representation confirmed his experience with 'absolute truth,' and he felt the performance was as dramatic, suspenseful, and moving as fictional theatre (in Mason 1977:263–4). Piscator made theatre about the masses, not the individual. He envisioned nonnaturalistic use of the physical properties of the stage, even as he wanted theatre to become a reality for its spectators so that it was, 'no longer stage against auditorium, but one big meeting hall, one big battlefield, one big demonstration' (264). Piscator's use of new technology to make a socially engaged theatre stands at the beginning of theatre of the real as we have come to understand it today. Learning from Piscator and then striking out on his own, Brecht reconsidered the connection between life (the real) and theatre (the professed fictional). Brecht thought theatre should present itself as theatre in the service of 'socially practical significance,' not the creation of pure emotion (Brecht 1964: 122).

The works I discuss in *Theatre of the Real* are in conversation with the idea that we perform ourselves on a spectrum that ranges from the daily performances of self to the most elaborate and codified performances on stages and in sacred and secular rituals. Several of the works included here are a ritual revocation of authority by means of new narratives and bodily displays and processes that are meant to lead to changes in ideology and action. Other works enact a conservative closure of thought by providing sweeping summaries that ease the dissonance of irresolvable difference to enable forgetting of uncomfortable narratives.

In Chapter 2, I examine one political, social, and national context for the way encounters between writers, directors, and actors have contributed to the invention of writing, performing, and directing theatre of the real. These encounters form and are formed by specific political, social, and aesthetic contexts. In US theatre, they are influenced by two major streams of practice. Together these streams of practice flow from rethinking everything that happens on stage, including acting, directing, playwrighting, and stage design and environments and contributions from playwrights who began to write their plays by integrating different forms of documentary evidence. These two streams were also

greatly influenced by ideas coming from Europe, especially the practice and theories of Bertolt Brecht and Jerzy Grotowski. Brecht's plays and his dramaturgical theories demonstrated one way to create entertaining contemporary political theatre with incisive analysis. Brecht's theories of acting insisted that performers self-consciously enact dramatic meaning so that spectators become critical observers of the action and active participants in the creation of meaning. Grotowski's physical practice-based theatre research which deeply reconfigured actor training and performing, showed how theatre could emerge from the psychophysical inventions of the actor arising from personal experience formed into rigorous and precise ritualized actions. Taken together, Brecht and Grotowski gave theatre practitioners new tools for communicating a broad range of contemporary experience and content. The theatre techniques I discuss in this chapter include the use of personal experience and memory, non-matrixed acting (performing without creating a character), the use of the set and the *mise-en-scène* as forms of character, and the incorporation of selected verbatim documents and interviews. Works discussed include *The Serpent* (1966) by Jean-Claude van Itallie and the Open Theatre, *Coming Out!: A Documentary Play About Gay Life and Liberation* (1975) by the historian Jonathan Ned Katz, Joanne Akalaitis's *Southern Exposure* (1979), and *Rumstick Road* (1977) by Spalding Gray.

In Chapter 3, I discuss how theatre of the real stages memory and history to create new aesthetic versions of human experience. This staging constructs and reconstructs personal and social memory from the raw data of experience and history with the use of specific theatrical methodologies. The resulting creation of meaning often exposes the fault line between documentary evidence as fact and social memory as invention. Framing is a way of negotiating the difference between individual knowledge based on memories that are always in the process of being formed and reformed, and historical knowledge that is always in the process of being revisited and revised. To illustrate how memory is transformed from individual memory to historical accounts I begin by relating my memory of the terrorist attack on the World Trade Towers as I saw it from the window and the terrace of my Greenwich Village apartment and on television. Following this personal memory, I analyze *History of the World – Part Eleven*, a live-animation simulation of the two planes crashing into the Towers on that day. This artwork was created by Herman Helle of Hotel Modern who saw the attack on the World Trade Towers only on television. The 'primary reality' of Helle's memory was formed from a single-focus, already edited version of that event.

This is different from the 'primary reality' of my viewing experience formed from the contradiction between my direct experience of the attack and the versions of the attack presented on television. Finally, I discuss *Kamp* (2006) also by Hotel Modern. *Kamp* depicts in miniature and in silence events what happened at Auschwitz-Birkenau. The representation of beatings, work routines, hangings, and other events were created more than 50 years after the end of World War II. *Kamp* is not based on personal lived experience or even on a shared experience of a contemporary event, but on research of the experience of those who lived through it and on the actual physical place of Auschwitz-Berkenau. In this, *Kamp* is different than the first two works I discuss. No one in Hotel Modern claims Jewish lineage or familial experience of the Holocaust. *Kamp* both distances itself from the Holocaust and brings it closer by combining miniaturization, live performance, and live film of the live performance – film made in the mode of a documentary of what happened at Auschwitz-Birkenau but performed with puppets. *Kamp* exemplifies the confounding of lived experience, constructed memories, and virtual reality that informs today's theatre of the real.

In Chapter 4, I examine a recurring representation of Jewish identity in five works spanning 33 years: Emily Mann's *Annulla (An Autobiography)* (1977); Leeny Sack's *The Survivor and The Translator: A Solo Theatre Work about Not Having Experienced the Holocaust, by a Daughter of Concentration Camp Survivors* (1980); Anna Deavere Smith's *Fires in the Mirror* (1993); David Hare's *Via Dolorosa* (1998); and Lawrence Wright's *The Human Scale* (2010). These works approach the idea of truth as factual, ethical, and in the grand-human-scheme-of-things sense. Because these works span a 33-year period, they are good examples of the same subject matter being presented with different styles of theatre with different aesthetic assumptions. What connects these works to each other is a shared subject matter: representations of 'being Jewish' as told in the Bible and experienced in the Holocaust. Each of these productions was created from interviews with Jewish subjects and performed by a solo performer. They premiered at venues ranging from the regional theatre and off-off-Broadway to off-Broadway and Broadway. Despite this, there is a troublesome stability of the approach to the subject matter of Jewish identity as if it can only be understood as a timeless and unchanging identity tragically marked by Holocaust. The chapter demonstrates one way in which representation in theatre of the real can traffic in stereotypes even, paradoxically, with good intentions. Narrative structures and historiographical intentions result from an iterative process that depends upon previous representations, whether imitated or rejected.

The subject of Chapter 5 is how theatre of the real can radically reduce complexity of understanding, inflame prejudices, and support one-sided perspectives. The controversy that generated the play and performance of *My Name Is Rachel Corrie* (2006), edited by Alan Rickman and Katharine Viner, is the subject of this chapter. In Chapter 6 I discuss three productions that confront political reality with different theatrical methods: audience participation, a simulated environment, and the creation of a fictional aesthetic manifesto of the Syrian revolution: *Surrender* (2008) by Josh Fox and Jason Christopher Hartley, a participatory production about the Iraq War; *House / Divided* (2011), a production by The Builders Association, directed by Marianne Weems, that uses artifacts from foreclosed homes, interviews with realtors in Columbus, Ohio, portions of *The Grapes of Wrath* and verbatim portions of Alan Greenspan's testimony to a Committee of Congress; and *The Pixelated Revolution*, an examination of the aesthetics of the YouTube uploads of Syrian protestors by Rabih Mroué (2011). The three working examples demonstrate the ways in which theatre of the real uses theatrical devices not solely meant to construct objective witnesses or stable notions of truth. Through the use of entertaining play frames created with audience participation, the inconclusive juxtaposition of contemporary and historical information, and the use of forensic analysis to create a fictional aesthetic manifesto, these works show how some contemporary theatre of the real engages in the disruption of aesthetic authenticity, documentary certainty, and unassailable truth.

In closing I would like to recount another personal experience in the theatre. At a dinner cabaret of student work created by my friend and colleague Atay Citron in Tel Aviv on 5 June 2005, I experienced another kind of performance of the real. Early in the evening Sancho (Yaron) Goshen performed a political commentary on contemporary Israel in the form of a lesson on how to eat falafel. At a table covered with a white tablecloth Goshen devoured a falafel to the accompaniment of sedate Middle Eastern music. The deep-fried, crisp ball of mashed chickpeas was shown to be a messy and grotesque cultural icon as Goshen ceremoniously overstuffed his mouth and smeared tahini sauce all over his face as he chewed without swallowing. The music changed to blaring klezmer music and Goshen spat out the chewed mash onto a silver platter. He then molded the regurgitated mash into a little mound, covered it with chocolate syrup, decorated it with birthday cake sprinkles, and topped it off by planting a tiny paper Israeli flag on the summit. Goshen then rang a little dinner bell, the cue for the kitchen staff to send out the first dish of the evening. What the waiters brought to

the tables looked exactly like what Goshen had chewed, spit out, and sculpted on his silver plate, including the little Israeli flag. Some members of the audience ate it.

Toward the end of the evening, after a series of other sketches, Goshen came back onstage dressed as a woman, announced that the evening's cabaret was not political enough, and proposed to show the audience what 'political art' really is. Wrapping each arm with a tourniquet – one made from a Palestinian flag, the other from an Israeli flag – Goshen then inserted a heparin lock, a needle with a catheter, in the veins of both arms and opened them. As the blood flowed down his arms, he simply said: 'Stop the blood' (Illustration 1.3). This powerful phrase echoes in Israeli collective consciousness as the words that Menachem Begin uttered at the signing of Israel's 1979 peace treaty with Egypt. Spectators were momentarily frozen in silent commemoration. A recording of Bach's *St John's Passion*, the composition that Israeli television played when Prime Minister Rabin was assassinated in November 1995, began playing at low volume as Goshen continued to bleed. Rabin had been considered by many Israelis the hope for peace between Israelis and Palestinians. After a few moments, the audience began to realize that

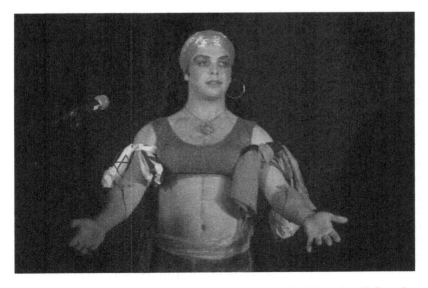

Illustration 1.3 Sancho Goshen with one arm wrapped with an Israeli flag, the other with a Palestinian flag, performing 'Stop the blood' in Tel Aviv. Photograph courtesy of Atay Citron

'stop the blood' was not only an allusion to a momentous moment in Israel's history but also a call for a specific action now. An intervention was being called for. As Goshen continued bleeding, the videographer fainted, creating a wakening stir that prompted a member of the audience to get up and remove a tourniquet and then take the heparin lock out of Goshen's arm. As he began doing this, another man fainted, and another spectator got up to stop the bleeding in Goshen's other arm. Still another person, this time a woman, fainted.

The audience had been catapulted from humor to horror, from parody to an evocation of the bloody tragedy that makes up part of Israeli history. They also faced the real blood rushing down Goshen's arm, a sign of the daily pain of both Palestinians and Israelis. Goshen's real bleeding was truly shocking, a gesture that deeply violated the convention that theatre not be for real. After audience members stopped Goshen's bleeding, another long moment of silence ensued. Shortly afterward, as the audience was breaking up and leaving, I received a phone call from my husband who was crying. My mother had died, he said. I retreated to some nether space of the theatre and then found someone to go get my friend Atay. The phone call ripped me out of the painful pleasure of Goshen's shattering of theatre and propelled me into the real pain of the real's interruption of theatre. The phone call paralleled Goshen's act. His bleeding brought spectators back to the reality outside the theatre; the phone call shocked me back to a reality that took me out of the theatre... but years later, back in. The spontaneous occurrence of ad-hoc real events in the theatre is markedly different from purposefully staging the real.

That evening was unlike the evening Idilbi left the stage at St Ann's Warehouse. Back and forth, back and forth went my judgment of that unusual event. This kind of 'ontological theatre doubt,' these strange new realities created from combining the real with the fictional are just as much a product of our times as the blood flowing down Goshen's arms.

2
The Theatricalization of Public and Private Life

Documentation (and the increasingly refined technology of documenting) is now the heart of a re-discovery of historical material by New Theater in this country.
James Leverett (1979)

In the latter half of the twentieth century, the importance of life outside the theatre became part of a realist epistemology that wed the politics of the day to the idea that theatre could and should stage 'the real' – with words, costumes, sets, props, or place. The appreciation of knowledge gleaned from real experience facilitated new approaches to all aspects of making theatre, but not with realism as a style.[1] Theatre of the real was influenced by two major streams of practice. One stream, with antecedents in popular culture, flowed from radical rethinking of all aspects of creating theatre: acting, directing, playwrighting, and sets/environments. The changes resulting from this reconsideration of how to make theatre were informed by the realist epistemology that emerged in the context of the theatricalization of public and private life. The other stream came from playwrights who began to build their work from interviews, depositions, tribunal records, and other documents. Verbatim and documentary playwriting has been amply written about (see, for example, the anthologies edited by Favorini 2009, Forsyth and Megson 2009, and Martin 2009a). Performing verbatim theatre has been the subject of international conferences, special issues of journals, and anthologies (see *Studies in Theatre and Performance* 31:2 devoted to 'Acting with Facts' edited by Derek Paget and *Playing for Real: Actors on Playing Real People* edited by Mary Luckhurst and Tom Cantrell). Less thoroughly examined are the ways in which revised approaches to acting, directing, stage design, and environments (from sets to site-specific

locations) have contributed to theatre of the real. 'The real,' in the discourse of the period, was equated with authenticity and truth, and also with personal liberation, autonomy, and collectivism.

From the 1960s forward, actors, directors, and playwrights experimented with theatre as an agent of social change. Much work focused on the convergence of self-expression with a call for collective social justice. In the United States, changes in approaches to actor training, playwriting, and set design proceeded alongside a renewed interest in theatre as a political forum, directly related to the period's abiding concerns, such as feminism, civil rights, and the antiwar movement. The result was that all aspects of making theatre, as well as productions and plays resulting from this process, were commonly understood as implicitly linked to political intentions.

Much socially active theatre was driven by utopian movements that called for 'changing the world' both inside and outside the theatre. Theatre artists wanted to unmask the hypocrisies of middle-class life and expose what were thought of as the lies of the US government, especially in relation to the Vietnam War. Social and political critiques were linked to personal experience. Group theatres, such as The Living Theatre, The Open Theatre, The Performance Group, Mabou Mines, and The Women's Experimental Theatre, used autobiography in their rehearsal process and in their performances. Playwrights and directors developed ways to transparently use primary source material, in the form of documents, interviews, and still and moving images, as enunciations of the real. Theatre artists incorporated personal narratives, audio recording, photography, film, and television into their works in order to represent what was deemed reality outside the theatre. The theatre techniques developed during this period are foundational to theatre of the real: acting as witnessing and testimony through the use of personal experience and memory, nonmatrixed acting (performing without creating a character), use of the set and the *mise-en-scène* as forms of character, and the incorporation of verbatim documents and interviews. Performances that came from this process were meant to openly disclose both personal and public truth in a manner that demanded a new social consciousness.

Today's questions about 'the 'real' were not the consuming questions of the 1960s and 1970s.[2] In those decades, the real was understood as something able to be known but that was hidden underneath a façade of lies proffered by the middle class with its social conventions, large corporations, and the government. The youth culture of the 1960s aimed to destroy the façade and expose the 'really real' and truth.

Many theatre practitioners of the period thought that access to a definitive truth was possible via the real, even as competing realities fueled many of the protests of this period. At its first convention in 1962, Students for a Democratic Society (SDS) issued the *Port Huron Statement* (named for the town in Michigan where the document was composed). The *Port Huron Statement* chronicled the discontent of a generation before proposing the antidote: participatory democracy. The *Statement* declared that the equality-for-all public stance of the US government was a hollow assertion in the face of ongoing racial discrimination in both the South and the North. The *Port Huron Statement* positioned the Cold War actions of the US government against its public assertions of 'peaceful co-existence.' The authors pointed out that industry, science, and technology were destroying old forms of social organization, while the new forms created by the leaders of the day did little to alleviate injustice or relieve the drudgery of meaningless work. Modern technology created great wealth for some in the developed world, while doing little to address the suffering of the impoverished both at home and in developing countries. The US government appeared to condone the raping of natural resources by uncontrolled corporate exploitation. The US military had already created a nuclear holocaust by killing over 200,000 people in Hiroshima and Nagasaki, and it continued to threaten millions more through the policy of MAD (Mutually Assured Destruction), as would happen in an atomic war between the United States and the Soviet Union. To the authors of the *Port Huron Statement*, the foundational ideals expressed in Abraham Lincoln's 'of, by, and for the people' had been rendered delusional by the war-mongering US government in thrall to the military-industrial complex (as warned by President Dwight D. Eisenhower).

At roughly the same time as the *Port Huron Statement*, Betty Friedan blew the lid off the supposed happiness of suburban housewives with *The Feminine Mystique* (1963). In her book, Friedan detailed the use of tranquilizers and the pervasive anomie experienced by American women resulting from, in her view, an idealized version of femininity that deprived women of individual development and opportunity by isolating them in a mythically idealized (via film, television, and advertising) suburbia. Women's unhappiness was the 'problem that had no name,' and its cause was thought to be forgoing career for marriage and motherhood. Part of the antidote to this problem is contained in the phrase coined by Carol Hanisch, 'the personal is political.' That personal discontent could be understood in terms of the political dysfunction of a society was a powerful new idea that became the rallying

cry of the surge of feminism that emerged in the 1960s (see Hanisch [1969] 1970). The women's movement, following as it did upon the civil rights movement, was soon joined by the gay rights movement. The 1969 Stonewall riots in New York City exposed not only police corruption and brutality but also rampant homophobia.[3] The emergence of 1960s feminism and gay rights activism corresponded to the continuing struggle of African Americans led by Martin Luther King Jr. King's 'I have a dream' speech of 1963 posited not only a better future but a painful past and present – the dream as yet unfulfilled. King and other leaders of the civil rights movement pointed out that the American dream was to be dreamt only by those who held the right race card.

The binding and gagging of Black Panther Bobby Seale during the Chicago Conspiracy Trial (September 1969 – February 1970) dramatically staged the contradictions of American justice. In her essay, 'Theater in the Courtroom: The Chicago Conspiracy Trial,' Pnina Lahav discusses how law and theatre interacted during the trial. Lahav characterizes the theatricality of the defendants as enacting subplots of politics, race, class, religion, gender, and hyphenated identities (2003:385). 'It [the trial] has sex. It contains grotesque scenes, amazing spectacles, poignant and intense dialogues' (385). Lahav's use of theatre terminology – scenes, spectacle, dialogue – is not simply metaphorical. The entire essay is focused on the ways in which law and theatre interacted during the trial. When the defendants, who were charged with violating the Anti-Riot Act, were first presented to the jury, Tom Hayden raised his fist in what was then a customary gesture of the counterculture. Abbie Hoffman blew a kiss in the mode of 'make love, not war.' Bobby Seale insisted that none of the defense lawyers in the courtroom could represent him, as he was a dispossessed black man. When the actual trial began, the defendants spread an American flag and a Vietcong flag on their table, only to have both taken away by a court marshal. Seale, the only black defendant, sat apart from the others, interrupting the prosecution with his own attempt to cross-examine the witnesses. An exasperated Judge Julius Hoffman warned Seale that if he continued to interrupt, he would be bound and gagged. After further angry exchanges, Seale was chained to his chair and his mouth was taped shut. He continued shouting through the gag and struggling with his chains, effectively performing the lack of rights of black men in America (387). It was a planned performance enabled by the threats of Judge Hoffman's court.

The defendants employed theatrical strategies that transformed the conventional institutional space of the courtroom into a theatre where those running the trial – the judge, the bailiffs, and the system itself – were put

on trial in the 'court of public opinion' by the defendants' use of performance to make social and political points, often by means of absurdity and contradiction. Confrontation, participation, and the destruction of long-accepted hierarchies suggested that stale and outmoded legalisms could be transformed into something living and entertaining by theatrical means. Belief and action were part and parcel not only of the trial of the Chicago Seven but also of the experimental theatre of the time. While gagged and tied to his chair, Seale's voice was stifled, but his gagged sounds, glares, and struggle against his bondage clearly communicated his enslavement. Seale effectively acted out what was, in fact, an expertly devised *mise-en-scène*.

On the streets, public performance – in the form of sit-ins, marches, strikes, rock festivals, and concerts – was the preferred form of theatricality. As important as the SDS' *Statement* was, the sit-ins staged by the Student Non-Violent Coordinating Committee (SNCC), the marches led by Martin Luther King Jr., and the many protests against the Vietnam War were much more effective in influencing both the supporters of the protests and the general public who watched much of the action on television. War lost its heroic-endeavor narrative with the nightly broadcasting of the Vietnam War, a conflict that was dubbed 'the living room war' because of its continuing appearance on the nightly news. For the first time, violence and suffering occurring afar could be dramatically seen in living color in one's living room almost at the same time that this violence was occurring. And, as the surest symbol of government intransigence, President Richard Nixon continued flashing his two-finger 'V for victory' sign in a gesture that mocked the peace sign that was emblematic of the antiwar movement. With his gesture, Nixon tried to appropriate the peace sign and enlist it as a signifier in support of the war. Nixon's ironic and stolen gesture became a sign of the government's duplicity.

Allan Kaprow, creator of 'Happenings,' was also a leading proponent of the performed real, as he staged a series of tasks he called 'lifelike art.' Some years later, in his essay 'The Real Experiment' (1983), Kaprow asserted that Western art has two histories with contrasting philosophies of reality: artlike art and lifelike art. Artlike art maintains a distinction between art and life. Lifelike art is connected to life, can take place anywhere and anytime, and can be created by anyone; it attempts to unify the body and mind, the individual and the group, and nature and civilization. Kaprow understood doing – taking any action – as a therapeutic integration with reality. Kaprow considered artlike art the hallmark of a mainstream, dualistic Western art tradition that strictly divides disciplines. In artlike art, works are shown in distinct venues, such as

museums, concert halls, and theatres, where artists display their work as part of ongoing professional dialogues with other artists and the public. In contrast, lifelike art, often humorous, holistic, and interdisciplinary, explores events that participate in life, are part of life, and are liberated from being ensconced in arts institutions and buildings. According to Kaprow, lifelike art is in dialogue with life itself and as such does well in real-life circumstances, such as streets, homes, stores, schools, businesses, or beaches. Lifelike art is not a 'thing' like a painting, a piece of composed music, a sculpture, or a play presented in special art settings. Lifelike art, as its name asserts, is inseparable from real life (Kaprow 1983:204).

Written from the vantage point of the tradition of plastic arts, Kaprow's manifesto encouraged artists – painters and sculptors especially – to conceive of themselves and their actions *as* artworks. Art as active process, as an ongoing flow of self in the process of doing, was the operative idea. Stepping through the picture frame into the gallery and then leaving the gallery for the outside world was the trajectory Kaprow proposed. Galleries, museums, and public spaces would soon be transformed by lifelike art acts. Kaprow and those influenced by him made performances not by acting, but by performing a series of tasks, nontransformational scores of movement, gesture, and voice.

Many productions began to play with the border between theatre and what was then understood as the real world. Jack Gelber's *The Connection* (first performed in 1959 by The Living Theatre), for example, confronted audiences with an environment and actions that blurred the boundary between theatre and ordinary life. In a nonnarrative style, *The Connection* portrayed a group of junkies waiting for their dealer, their 'connection,' to arrive with heroin, their 'shit.' The junkies wait, talk, play and listen to jazz... just go about their hapless lives of waiting. The plotless, improvisational acting, the jazz-inflected cadence of the dialogue, and the live jazz played onstage were groundbreaking. Shocking to theatre audiences was the use of street culture and street language. During the intermission the actors solicited money from the audience, ostensibly for drugs. More than a few spectators thought the actors really were junkies.[4] The language, setting, and performing were alarming because of their street-smart reality, a rough reality presented without any redeeming theatrical posing or politeness, without any fictional rescue. Nineteen fifty-nine was the same year that Irving Goffman published his seminal sociological study, *The Presentation of Self in Everyday Life,* in which he discussed social life as consisting of social actors who use theatre and performance techniques to create situational realities.

Theatre became a key place for people to create, speak about, and experience truth about self, race, war, government, politics, and corporatization. Theatre was also a place where new worlds were wrought – worlds not without their own problems and contradictions. Directors, playwrights, actors, and audiences of this period wanted both social and personal reality represented on the stage in ways not previously seen. The aesthetic translation of participatory democracy into theatrical process led to experiments in audience participation, acting of the self-as-self, collective directing, and group-devised performance texts. Rehearsals were no longer solely devoted to finding gestures and blocking to illustrate the words of a text. Instead, rehearsals were used to create images that exposed contemporary reality in new ways. Theatre both took from and gave to the political consciousness of the day, so often enacted in massive marches, sit-ins, draft-card burnings, and other performative forms of protest.

The staging of personal experience and identity that was intended to actively advance social justice was a new turn in the theatricalization of the real. Technology and art grew closer together in 'multimedia' performance, a form that sought to combine multiple forms of media with liveness. In the US, theatre of this period was deeply informed by the intersections of art and life, political activism, and the increasing availability of film and audio records of the real. Theatre was also decisively informed by the idea that actors could and should be present on stage as themselves alongside the characters they played. Group theatres endorsed participatory democracy within their collectives, with the conviction that in so doing they were promoting a form of social justice consistent with the notion of blurring art and life that was foundational to the period's political activism. In the spirit of participatory democracy, theatre practitioners wanted to be free from all forms of absentee authority, including playwrights not present at rehearsals, and texts that could not be changed. Rejection of the absentee playwright was perhaps the strongest manifestation of the desire of many actors and directors to assert the authority of their craft over the authority of the playwright and anyone else whom they deemed wanting to impose a fixed system from afar. At the same time, the authority of the director, as the one who singlehandedly determined everything that took place onstage, was often redistributed among the creative collective. Some playwrights, such as Megan Terry and Jean-Claude van Itallie, joined rehearsals and developed their work in tandem with actors and directors.

Collectively devised theatre provided new ways for performers to participate in the creation of productions. Directors managed the collective

vision of the group, but were also often contested by group members. Beyond the formidable problems encountered in formulating new ways of working, collectively devised theatre developed the text and the *mise-en-scène* from the experiences of group members. Daily experience, memory, autobiography, and biography were important resources sought and cultivated in rehearsals. From these starting points came the still popular solo performances written and performed by performers who created original roles in which their own life story (or fantasy) was conflated with more orthodox notions of theatrical character. Performers – no longer 'actors' – became much more than interpreters of characters and texts written by others. As performers and directors shifted the emphasis in making theatre away from dramatic texts (plays) and toward behavior (performances), they became acutely aware of their own contributions to the creation of theatrical representation.

Actor training based on exploring a performer's actual self cultivated the conviction that actors could and should display their own subjectivity in order to expose the social injustices happening to the characters they portrayed. The approach to acting that formed during this period asserted that the performer was present on stage *both* as himself *and* as a 'character.' Performers and directors varied the ratio of the equation as needed. Another approach was that the actor could alternately be herself, a performer, a character, or an abstract idea. Both approaches – the actor as a subjective self and the actor as a performer of successive identities and ideas – knit the personal with the political, each informing the other. Bertolt Brecht and Jerzy Grotowski's methods of training were explored as new tools for communicating a broad range of contemporary experience and content. Brecht was focused on the societal and political, while Grotowski was alert to the personal and to ritual. Taken together in the American context, Brecht and Grotowski were understood as providing new ideas about how theatre practitioners and spectators could have a range of personal, political, social, and archetypal relational experiences in the theatre. The observation was not intended as an argument for open-ended interpretation, but as a sign of the existential fluency of theatre and performance.

William Finley's opening lines in *Dionysus in 69* (1968) are one example of this fluency in depicting the dual presentation of actor and character.[5]

Good Evening, I see you found your seats. My name is William Finley, son of William Finley and Dorothy Wainwright. [...] I was born twenty-seven years ago and two months after my birth the

hospital in which I was born burned to the ground. I've come here tonight for three important reasons. The first and foremost is to announce my divinity. The second is to establish my rites and rituals. And the third is to be born, if you'll excuse me.

(The Performance Group 1968)[6]

Speeches like Finley's meant that spectators were not allowed to forget that they were witnessing a theatre event presented by a person acting in a performance that was understood as part of the spectrum of 'real life.'[7]

Grotowski and his leading actor of that epoch, Ryszard Cieslak, gave their first workshop in New York in November 1967, an event that had an enormous influence on the emerging experimental theatre. Grotowski's stated pursuit of truthful acting – in his lectures, workshops, and book *Towards a Poor Theatre* (1968) – coincided with the era's rejection of what were felt to be the lies and contradictions of orthodox theatre – which, in America, was connected to the US government's actions and assertions in relation to nuclear warfare, racial social injustice, homophobia, sexism both in and beyond the workplace, and the military-industrial complex. Grotowski's emphasis on truth, as expressed by and in the body of the actor, as both the source and the medium for performance, relied on techniques that emphasized bringing one's self, as opposed to only one's character, to the performance (see Saivetz 2003:77–8). Bringing one's self to performance was already an incubating idea when Grotowski arrived, and so the European master's techniques were easily digestible. Americans understood Grotowski's techniques as a means of discovery that could be used in the service of truth about history, society, government, the law, and the self as a social and political agent. Joan MacIntosh, a founding member of The Performance Group, writes: 'We wanted to create an alternative theatre, an alternative structure for society that stood outside and in opposition to what we perceived as the brutality of Capitalism.'[8]

Exposing hypocrisy, inequality, discrimination, and repression was the common denominator of works that sought to break aesthetic and political barriers. At its best, experimental theatre of the period was a courageous, head-on encounter with social and political realities in the context of aesthetic invention. Grotowski returned to New York in 1969 with *Akropolis*, his production about Auschwitz in which the performers played inmates in the death camp while building the crematorium that would turn them into ash. His return furthered developing ideas about the centrality of *mise-en-scène* in theatrical meaning and about

the ability of theatre to physicalize indictments. A reviewer for *Time Magazine* quoted Grotowski as saying, 'At a moment of psychic shock, a moment of terror, of mortal danger or tremendous joy, a man does not behave "naturally."' The reviewer concluded, 'By attacking the whole concept of natural behavior, Grotowski divorces himself from the cult of psychological realism, as exemplified in the Actors' Studio.'⁹

Several new works used innovative techniques for encountering reality onstage that changed the representational methods of theatre practice. A collectively devised work such as *The Serpent* (1966), by Jean-Claude van Itallie and The Open Theatre and directed by Joseph Chaikin and Roberta Sklar, reenacted the assassination of John F. Kennedy as captured in the famous Abraham Zapruder film and used interviews with the performers as a source for portions of the text. *Coming Out! A Documentary Play about Gay Life and Liberation in the U.S.A.* (1975) by the historian Jonathan Ned Katz documented the 1969 Stonewall riots and the history of discrimination against gays and lesbians. Joanne Akalaitis's *Southern Exposure* (1979) staged portions of the diaries of Sir Ernest Shackleton written during his 1914–17 Antarctic expedition. Performer-generated biographical and autobiographical works such as The Performance Group's *Rumstick Road* (1977), devised by Spalding Gray and directed by Elizabeth LeCompte, used animated *mise-en-scène* and interviews to stage the intersections of autobiography and history.

None of these productions was strictly documentary or verbatim. They are important because they show how theatre artists who were incorporating the real in their work brought about a sea change in the use of *mise-en-scène*, media, historical sources, autobiography and biography, interviews, documents, and agit-prop techniques. Although all the works are American, the techniques of these works have also been developed elsewhere, in different ways and in different social and political contexts. My intention is not to propose a lineage but to draw attention to the importance of new approaches to performing, designing, and directing that helped generate theatre of the real.

Acting as witnessing and testimony: *The Serpent*

In *The Presence of the Actor* Joseph Chaikin describes acting as witnessing and giving testimony, as 'a way of making testimony to what we have witnessed – a declaration of what we know and what we can imagine' ([1972] 1991:2). Chaikin, and the actors with whom he worked, explored directing, acting, and *mise-en-scène* that interrogated the idea of utopia, critiqued the institutionalization of life and death, and

questioned conventional social structures. *The Serpent* was a result of a process of witnessing, testimony, and critique. Partly based on the biblical Book of Genesis, *The Serpent* approached the text as a foundational story of mythic origin still informing contemporary life. The Garden of Eden and Cain's murder of Abel were aligned with the assassinations of President John F. Kennedy in 1963 and of his brother, Robert Kennedy, and Martin Luther King Jr. in 1968. *The Serpent* showed through image and simulation how Paradise was indeed lost, as murder was a recurring crime from nearly the beginning of time. Both the process of making *The Serpent* and the resulting production were meant to raise consciousness about self, family, and society in a way that conjoined the personal self with the world (see Martin 2006a:81–2).

Chaikin and Sklar placed the reenactments of the assassinations of the Kennedy brothers and King before the expulsion from the Garden of Eden.[10] The actual moment of the JFK assassination, as etched into the consciousness of the millions of Americans who saw the Zapruder film, was played and replayed in stop-action style, forward and backward, by members of The Open Theatre at Washington Square Church in a precise, 12-part sequence in which they reenacted the crowds in Dallas, the assassin, and the presidential party in Kennedy's car (van Itallie et al. 1969:85). Their filmic mimicry was a replication of the media's rebroadcasting of the assassination over and over during the days, weeks, and months following JFK's assassination, even as replaying the film revealed no new information about the assassination. The broadcast of the Zapruder film attempted to satisfy a deeply shocked and news-hungry nation by bonding Americans in a virtual ritual of mourning-in-the-moment in which everyone (with a television) could participate. The replaying of the film clip initially reinforced national mourning for a beloved and glamorous young president. It also drew viewers, increased the value of media time in advertising dollars, and exploited an event that commentators intoned as tragic.[11] In the context of *The Serpent*, the reenactment of the Kennedy assassination was a critical intervention in the idea that Americans are innocent in the face of history. Murder has always happened, this murder included, and it will continue to happen.

Beyond the reenactment and the replaying of these media images – two documentary reenactments (JFK and RFK), plus an artistic fictional compilation of images (King) – were the interviews van Itallie conducted with four actors in The Open Theatre. The interviews focused on the actors' experience of a division between interior and exterior reality. Fragments of the interviews made their way into *The Serpent* as

examples of the ways in which the demands of social life often mask other feelings.

> I went to a dinner.
> The guests were pleasant.
> We were poised,
> Smiling over our plates,
> Asking and answering the usual questions.
> I wanted to throw the food,
> Ax the table,
> Scratch the women's faces,
> And grab the men's balls.

> (van Itallie et al. 1969:87–8)

At the end of *The Serpent* the actors slowly walked forward holding photographs of their former selves, most of which looked like high-school yearbook photos of clean-cut American teenagers that contrasted with the 'counterculture' appearance of the actors at the time of making *The Serpent*. The action implied that through this production the actors came closer to their true selves. The assertion of the work as a whole was that the unrelenting violence that characterizes human social life, a violence that began in the biblical Book of Genesis, has remained with us. The photographs the actors held at the end of the performance implied that the journey the actors had taken to make *The Serpent* changed them just as, by extension, witnessing the performance and the events depicted might change the spectators. But even in the face of change, in the face of aging and dying, violence and murder continue unabated. Change of consciousness, *The Serpent* asserted, is still valuable even as it may not be possible. Like Eve, actors and audience alike are cast out of Eden after eating the apple, leaving them to contend with knowledge and the lost security of Eden. With a beautifully direct and simple *mise-en-scène*, The Open Theatre asserted that the secure ignorance of Eden's patriarch-controlled, constrained freedom had to give way to knowledge about the violence human beings create, tolerate, and perpetuate.

With the actors slowly walking forward carrying their photographs at the end of *The Serpent,* history was collectively and individually charted. Individual transformations in appearance documented a change away from conservative hairstyles and dress to the 1960s counterculture. Collectively the group had gone on a journey that produced new knowledge and new affiliations. Asserting this combination was part of the

point of *The Serpent*. In the ethos of the era, history and autobiography were welded together. The photographs signaled a mobility of consciousness that situated individuals within contemporary history as a public event and processes of theatre as the means to examine that history. The impulse from which the work sprang consisted of both subjective inquiry and documentary objectivity.

The personal is political: *Coming Out!*

Another work that confronted its audiences with violence and social injustice was *Coming Out! A Documentary Play about Gay Life and Liberation in America* (first performed in 1972 and published in 1975) by historian Jonathan Ned Katz. Framed by a defining moment in the history of the gay rights movement, the Stonewall riots that erupted in the late hours of 27 June and continued until 29 June 1969, *Coming Out!* was an agit-prop-style account of oppression against gays and lesbians.[12] In writing *Coming Out!* Katz drew on public documents, fiction and poetry, and autobiographical and historical accounts of gay and lesbian identity from writers such as Willa Cather, Alexander Berkman, Allen Ginsberg, Walt Whitman, and Gertrude Stein. Performances of *Coming Out!* were somewhere between political rally and theatre, the acting decidedly amateur, and the perspective definitively gay- and lesbian-centered.

The Stonewall riots were provoked by a police raid on the Stonewall Inn at 53 Christopher Street in New York City, a location in the heart of New York's downtown gay community. Police raids harassing gays and lesbians were common, but on this particular night gay and lesbian patrons spontaneously fought back with beer cans and almost anything else in reach. The police responded furiously by beating and then arresting dozens of people. What started that night continued for several days in the form of further violence and protests during which many people began to publicly identify themselves as gay and lesbian, marking a cultural shift in identity from the closet and into the street. Gays would no longer permit their identity to be shrouded in obscurity or deception. The events of June 1969 led directly to the formation of gays and lesbians as a political constituency with their own advocacy and lobbying groups. The demonstration against the injustice and absurdity of the raid on Stonewall eventually gave rise to the annual Gay Pride Parade in New York City, which still follows a route down Fifth Avenue, turning west to Christopher Street and ending at the Stonewall Inn. The Inn was named a national historic landmark in June 1999.

Coming Out! was produced by the Gay Activists Alliance and directed by David Roggensack. It opened on 16 June 1972 at the Firehouse

(99 Wooster Street, New York) and was also performed in September of the same year at the Washington Square Methodist Church (where Grotowski's works were first performed in the US three years earlier), and then again in June 1973 at The Nighthouse, in a tiny room on the ground floor at 249 West Eighteenth Street in the Manhattan neighborhood of Chelsea. Katz envisioned a play 'like Martin Duberman's documentary play *In White America* [first produced in 1963 at the Sheridan Square Playhouse in New York City], which I'd heard about but not seen, the piece I imagined would employ American historical and literary materials to evoke dramatically our changing situation, emotions, and consciousness' (Katz 1972). Katz was especially inspired by the way Duberman compiled a range of documents. Erwin Piscator had also used this technique of 'drama by documents as well as *of* documents,' remarking, 'Not by chance does the material become the hero in all my plays' (in Mason 1977:264). Writing in the *Village Voice*, Dick Brukenfeld identified *Coming Out!* as the first documentary play about gay life that treated the subject historically (see Brukenfeld [1972] 1975).

Coming Out! used a nascent version of the technique with which Moisés Kaufman would later become associated: citation as an integral part of the performance.[13] In *Coming Out!* the performers cited the sources of their speeches before they gave them. The production began with Speaker I stating, '*The Village Voice*, 1969' and then continued with a quote from the downtown newspaper: 'This weekend the sudden specter of "gay power" erected its brazen head in Greenwich Village and spat out a fairy tale the likes of which the area has never seen. The forces of faggotry spurred by a Friday night police raid on one of the city's largest, most popular gay bars, the Stonewall Inn, rallied in an unprecedented protest against the raid and continued to assert presence, possibility, and pride until the early hours of Monday morning' (Katz 1975:1). Accounts of the Stonewall riots opened the production, giving a tone of urgency to all that followed, which was seen in light of this new moment of gay and lesbian collectivism and group identity. The set consisted of different arrangements of black-painted wooden milk crates, found in the street or stolen from supermarkets, that allowed a flow and freedom of configuration for different scenes.[14] The performers combined citations from the historical record with stage business, such as cops running through the audience blowing police whistles, and with storytelling.

Much of the documentation in the play is about prejudice against, and the lack of social justice for, gays and lesbians. At one point in the performance, the 1966 *Time* Magazine article 'The Homosexual

in America' is alternately quoted and interpolated with kinder senti-
ment. 'Even in purely non-religious terms, homosexuality represents a
misuse of the sexual faculty. It is a pathetic little second-rate substitute
for reality, a pitiable flight from life. As such it deserves (*SWITCH TO
"SYMPATHY"*) fairness, compassion, understanding, and, when possi-
ble, treatment. (*BACK TO VENOM*) But it deserves no encouragement,
no glamorization, no rationalization, no fake status as minority martyr-
dom, no sophistry about simple differences in taste – and above all, no
pretense that it is anything but a pernicious sickness' (Katz, 1975:58).[15]

Most of the actors had little if any previous acting experience, result-
ing in great variations in style and delivery. The actors performed the
views of their own community if not their own experiences. Their per-
formance of themselves as gay persons, if not characters, was greeted
with both pleasure and with criticism. In his 14 September 1972 review
in *The Village Voice* entitled 'In Straight America,' critic Michael Feingold
noted that while the actors evidenced devotion and inspiration, their
delivery was sometimes lost due to lack of training.

> The cast, for some odd reason, is entirely amateur – odd because
> there are certainly enough gay professional actors in New York to
> staff a project of this sort. Nor am I convinced that only gay actors
> ought to be used, any more than I thought Joseph Papp needed to
> cast his abortive stage version of 'Winning Hearts and Minds' solely
> with Vietnam veterans. Authenticity onstage has to do with how well
> you project the words, actions and feelings, not with whether you
> really own them offstage. As it is, I lost some interesting passages in
> 'Coming Out!,' and don't feel the cast gets nearly as much out of the
> texts as a trained one might; their evident devotion, however, has
> inspired them all to a dignity that is the mark of the best amateur
> work, and is at times extremely moving.
>
> ([1972] 1975)

Feingold's *Village Voice* review did not discuss the layered realities of
Coming Out! His critical interest was in asserting that documentary
plays offer the opportunity to come into contact with the 'certification'
of facts. Facts in the theatre, Feingold wrote, are marked with impor-
tance unlike facts in a book, making the method of *Coming Out!*, and
by implication other documentary plays, as important as its subject
matter ([1972] 1975).[16] What Feingold ignored in his review was the
urgent realist epistemology, the legal subjugation of identity as person-
ally experienced by members of the cast, as the driving force of *Coming*

Out! In representing the lawfully enforced repression of identity, Katz and performers were making a claim for social justice, a justice they could map but not yet inhabit. In so doing, they created the phenomenological engagement that Reinelt identifies both as the experience of documentary theatre and as the means of constituting the reality the theatre represents (Reinelt 2009:7). Feingold glosses over the same realist epistemology when he states in passing that the play *Winning Hearts and Minds* (1972), adapted and directed by Paula Kay Pierce and presented by Joseph Papp, did not need to cast real Vietnam vets. *Winning Hearts and Minds* was adapted from poems by veterans of the Vietnam war and had a cast of nine, six of whom were, in fact, Vietnam vets, 'and three women.'[17]

Feingold's critical concern with the professional competence of the actors was not shared by everyone. Other critics argued that the amateur status of the actors, which proved that they were speaking about themselves, gave the work a powerful authenticity, as the actors identified themselves as a class of people. They were judged by the legitimacy of their factual claims *and* their affiliation with those claims. Lorraine Grassano wrote: 'The five men and women who act do not wear masks. It is their own thoughts, experiences, and inner conflicts that they relive while re-enacting the lives of the gay and anti-gay figures. In the last scene the historical date is 1972 and now; thus the stage is completely dissolved and the actors play no parts at all: they are themselves and they invite the audience to talk with them' ([1972] 1975). The actors were not quite acting and not quite witnessing; they were giving the testimony of others that pertained equally to themselves. The personal identity of the actors came to bear on the meaning of the performance just as much as the facts of the material. Katz, who attended every rehearsal, notes that the realist epistemology informing the production, in the form of the actors' relationship to what they were performing, was considered necessary. In other words, the real, in terms of the verifiability of the claims of text supported by the passion of the actors and their personal connection to the history they were telling, became for many the important experience of the production. Critical reaction attempted to sort out the difference between receiving the work as art and receiving the work as an important occasion for social justice.

In the first draft of the play, Katz used the pseudonym Jon Swift (a reference to Jonathan Swift, eighteenth-century author of a searing attack on the British ignoring the devastating famine decimating Ireland in his 1720 *A Modest Proposal*) out of anxiety about the subject matter of the play and his connection to it.[18] Even after Stonewall, anxiety and fear

were omnipresent. Very quickly it occurred to Katz that using a pseudo-nym for a play entitled *Coming Out!* was a blatant contradiction. Before the Stonewall riots, Katz had sought psychotherapy to address his homosexuality. After Stonewall, in 1971, a year before writing *Coming Out!* he started attending the weekly meetings of the Gay Activists Alliance at an Episcopal church at 28th Street and Ninth Avenue. There he began taking part in intense private discussion groups about gay life and rights as well as psychologically oriented consciousness-raising groups. As with other productions of this time period, Katz's writing was driven by his own autobiography, especially in relation to civil rights for gays and lesbians. This fact eventually enabled Katz and other participants in the production to use their real names. Still, some pro-fessional actors dropped out of rehearsals fearing that participation in a 'gay liberation play' would damage their careers (Katz [1972] 1975). Mostly amateurs remained.

In performance, *Coming Out!* was situated somewhere between a presentation of historical characters and the stories of those performing it. *Coming Out!* portrayed characters from history played by performers who really were seeking civil rights for their community. The perform-ers implicitly and explicitly presented themselves as gay or lesbian. There was a sovereign rite being performed by the actors in *Coming Out!*. With the performance of documents as documents, Katz and the actors were asserting the rights of equality promised by the US Constitution. *Coming Out!* added to what was becoming the dazzling circulation of the real and represented occurring in live performance as a medium of social change.

Mise-en-scène and nonmatrixed acting: *Southern Exposure*

Southern Exposure: A Theater Piece (1979), about Sir Ernest Shackleton's attempts between 1914 and 1917 to cross Antarctica by passing through the South Pole, was directed and constructed by 'Akalaitis,' a non-naturalistic environmental character, which, along with two performers, enacted and demonstrated the otherworldliness of the vast frozen ter-rain and its natives – the penguins as well as the explorers' attempts to traverse the Antarctic from sea to sea, a journey considered at the time as a last 'great, heroic human journey' (see Harris 1979).[19] Akalaitis assem-bled the text from Shackleton's account of his Antarctic expedition and from Robert Scott's *Voyage of Discovery*. The production as a whole docu-mented the valiant plans and experiences of the vulnerable explorers and the heroic leadership of Shackleton after their ship, the *Endurance*,

sank after getting trapped in and then crushed by pack ice. The loss of the ship sent Shackleton and his men on a seven-month march, hauling lifeboats and equipment to reach the open sea and then rowing for seven days to reach Elephant Island. Realizing there was no hope of rescue from that island, Shackleton, along with five others, decided to make an 800-mile journey to a whaling station on South Georgia to get help. After three attempts, Shackleton and the rescue team arrived at Elephant Island and saved all the men. Not one life was lost.

As the audience entered the theatre to see *Southern Exposure*, they were greeted with a Prologue. A Woman (Ellen McElduff) in period costume whispered an improvised lecture on the mating and breeding habits of penguins while aligning small stones on a downstage platform as if they were penguin nests.[20] Everything on the set was angled and covered in different shades of white sheets, fabric, and paper. One critic noted that the *mise-en-scène* was so integral to the performance that it functioned like a third character. 'We are in a stark, white on white room hung with parachute-silk draperies and dominated by a large bed. The protean piece of furniture becomes the ice-packed waters the intrepid explorers explored' (Stasio 1979:n.p.). A Woman and A Man, played by McElduff and David Warrilow, were captive in this frozen white domain as if they were living behind glass in a natural history museum diorama. Embedded in a whiteness carved by blue shadows in a way that seemed to create a lacuna of time and space and 'the endlessness of the icy expeditions,' in the journeying part of the piece the performers moved across the set in full Antarctic gear. The bed that served as the central set piece was covered with a white quilt made by Anne C. Morrell, and the headboard was veiled in white paper; the cyclorama that served as the upstage 'wall' was made of white parachute cloth. As the performers explained the expedition, they instructively used pen and paper to draw maps on the headboard and stitch the routes taken by the Shackleton expedition on the quilt (Illustration 2.1). This mode of explanation and discovery underscored the archival sources of *Southern Exposure* and gave a feeling of the presence of a past first-time discovery. By the end of the evening, spectators had experienced a reenactment of a journey through a bitter and unforgiving terrain, as well as self-conscious theatrical inventions that conveyed the monotony of the frozen and blinding whiteness many times in slow-motion sequences without dramatic tedium.

Akalaitis preferred to call *Southern Exposure* 'a piece' rather than a play because of the way she structured the approach to performing and to the narrative, which she presented as fragmentary and without closure. Neither McElduff nor Warrilow played characters as we know them in a

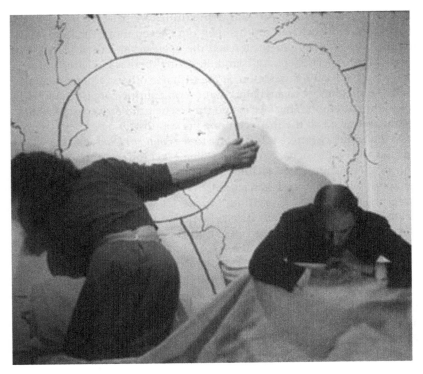

Illustration 2.1 Ellen McElduff and David Warrilow in *Southern Exposure*, devised and directed by JoAnne Akalaitis. Photograph courtesy of Richard Schechner

traditional theatre. In terms of performance Akalaitis stated her goal as: 'The objective was the presentation of stories, so there's no manipulation of the audience. What David's [Warrilow] doing as a performer is communicating, not interpreting' (Harris 1979). The text identifies their roles as types but does not contain anything that might be understood as character motivation or development. The Woman is schoolmarmish and pleasant, age 25 to 40, and The Man is serious and plain-speaking, age 30 to 50. Both were wearing clothing in the fashion of the 1910s (Akalaitis 1979). The narrative was illustrated *and* enacted as the two performers alternately lectured, performed, illustrated, and instructed spectators about the foreboding landscape that was for nineteenth-century explorers one of the last frontiers of exploration and conquest. Sometimes McElduff, for example, approached the narrative by portraying a physical idea about penguins with her own body, arching her

back and lifting her chin in imitation of penguin behavior. This was not so much acting, defined as characterization, as what Michael Kirby has call nonmatrixed acting, an approach to performing that relies on references applied to and by the performer. The intention was not to have McElduff simulate or become a penguin, but rather for her to create an allusion to and citation of penguins. Another reference applied to McElduff was the photos of penguin chicks projected on her skirt, making McElduff seem like a penguin mother without doing anything except being the screen for the projection.

At still other moments, McElduff was a nineteenth-century woman lecturing to the audience on what it must have been like to have been on an expedition to the South Pole. Then Warrilow entered, exuding seedy propriety in his high, starched collar. Most of the remainder of the piece was performed on a large, tilted bed covered with a snow-white blanket. Together in this section of the piece (there were no conventional scenes), McElduff and Warrilow evoked a Victorian couple, secure and warm in their bourgeois nest, communicating a final chapter in one of the great nineteenth-century adventures – a story of endurance, hardship, and heroism scarcely equaled at any time or place before or since. The disparity between what was being told and the manner of the telling was never more vivid than in the final moments of the piece, when the performers discussed the fatal Scott expedition – a talk of desolation and loss played out in a landscape of trackless white immensity – across a large white quilt on which they were busily stitching a map of Antarctica (Leverett 1979).

Akalaitis used film and slide projections to convey both the era of the explorers and their relationship to contemporary sites. In addition to serving as an evocation of the Antarctic landscape, the white walls also provided a projection screen for images that demystified the continent. Slides of the explorers' meager rations were projected onto the wall as Warrilow read Shackleton's description of the men's food fantasies. A movie showed a contemporary couple at Grand Central Station posing underneath a photomural of the Antarctic. The film then followed the couple to the penguin exhibit at the Coney Island Aquarium as a voice-over recounted an explorer's discovery of an Antarctic burial pool filled with frozen, dead penguins (Illustration 2.2). These scenes invoked the continuities and discontinuities of spectatorship and travel, of lives lived at different moments, of the erasure and construction of social memory, and the violence of institutionalized memorialization. Akalaitis's *Southern Exposure* was a collage of text, images, set, and costume that undermined a purely romantic mythology of Antarctica

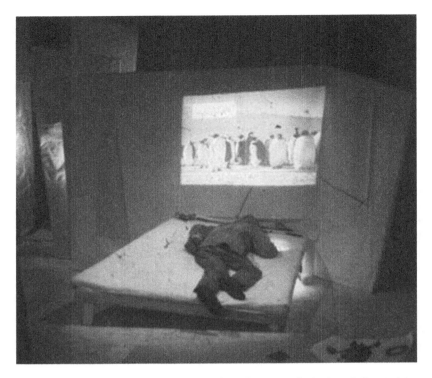

Illustration 2.2 David Warrilow in *Southern Exposure*, devised and directed by JoAnne Akalaitis. Photograph courtesy of Richard Schechner

(Saivetz 1993:67). Just as Shackleton and his colleagues explored the harsh realities of the continent itself, Akalaitis was exploring the end of the era of heroism and, perhaps, the cruelty of the continuing construction of history as conquest.

When *Southern Exposure* premiered at The Performing Garage in February 1979, it was understood by one critic as a documentary. Writing in the *Soho Weekly News*, James Leverett identified documentary as the method of what he called 'New Theater' for historical subjects, some of which was drawn from personal experience.

Documentation (and the increasingly refined technology of documenting) is now at the heart of a rediscovery of historical material by New Theater in this country. Here, however, the subject matter comes generally from the personal (private) world of the artists

instead of from the broader (public) sphere of world events. Spalding Gray and Elizabeth LeCompte's *Rumstick Road* is probably the most important example of this movement to date. This piece uses family slides and taped interviews to explore the mental derangement and suicide of Gray's mother.

Southern Exposure uses the same mechanisms (film and tape) and similar approaches (extreme fragmentation, musical structure and rigorous distancing) as *Rumstick* [*sic*]. Its subject, however, is conventionally historical (in *public* domain, so to speak) while the approach to the subject is intensely personal, in fact stubbornly restrictive in its privacy. From this opposition springs a strange tension causing contradictions and questions, but no resolutions.

(Leverett 1979)

Leverett had seen Spalding Gray's entire trilogy *Three Places in Rhode Island* (actually four productions), of which *Rumstick Road* was the second. Gray and LeCompte discussed their work as documentary and autobiography created from 'found' objects. Leverett, however, correctly understood the private world of the artist as being the subject of *Rumstick Road*. Akalaitis saw the third work of the trilogy, *Nyatt School* (1978), and was impressed with the way the set design worked metaphorically. Akalaitis was not so much interested in the personal for its own psychological significance, but as a window on the world of human ambition and codes of conduct. Leverett considered Akalaitis's work a new kind of history play because she staged conventional history through intensely personal details performed with a disjunction between what was being told and the manner of the telling. The effect of this was alienation without the super objective of social and political criticism. This art-about-art approach bothered Leverett because he felt the aesthetic accomplishments of the work surpassed any insight about the real reasons for the suffering of the explorers. Leverett's discomfort was perhaps also about the expectation of the performance of a text and the abandonment of Brechtian alienation leading to social and political inquiry in favor of alienation leading to heightened aesthetic consciousness. Gray and Akalaitis were focused on formal theatrical innovation – theatre as theatre capable of revealing personal and historical reality – not on theatre as an agent of social and political change. Akalaitis wanted the performers to communicate the perils of exploration and the kind of society that produced such expeditions in an objective manner without any political message.

Akalaitis considered *Southern Exposure* the story of the mentality of an era. The piece alternated between documenting the expedition

and portraying the stuffiness of Victorian bourgeois home life by formally understating the extreme situations and suffering of the explorers (Leverett 1979). Writing in the *New York Times*, theatre critic Mel Gussow claimed that the inconclusiveness of the work made it more a piece than a play. Gussow understood 'piece' to mean a work driven as much by imagery and scenic design as by language. In other words, *Southern Exposure* was not a performance of a dramatic text and as such did not follow the known pattern of introduction, development, and conclusion. Gussow's conventional expectations of what theatre should do shaped his critical reaction and limited his ability to perceive the new theatrical discourses that were forming in front of his eyes. At the same time, the way *Southern Exposure* played with iterations of a reality in the tiny constructed frame of theatre did not entirely escape Gussow, who wrote that the piece reminded him of a vision of something 'mounted behind glass in the American Museum of Natural History' (Gussow 1979).

Bonnie Marranca wrote about *Southern Exposure* as evidencing an 'interest in documentary' and Akalaitis as being 'more astute and like most knowledgeable theatre people highly skilled in technique and theories of performance and narrative' (Marranca 1979:41–2). Marranca's critical view of the piece focused on what she considered Akalaitis's excessive use of theatre techniques and technological precision at the expense of supplying a credible social context (41–2). 'Akalaitis reflects a mannerist, even decadent, phase of theatre, that appears as an infatuation with technique, unsupported by a world vision which can move her work beyond the surface' (41–2). Writing in the *Washington Review,* Byron Swift identified *Southern Exposure* as being about the unknown and about adventure by alternating between 'participation, as the players slowly move across the set in full arctic gear, buffeted by the winds, and commentary, as they talk to us from the bed' (Swift 1979). For Byron, the alternation between participation and commentary led spectators to consider the importance or lack thereof of this century's social view of the Shackleton expedition in terms of 'national glory and individual heroism' and something more personal, 'something to do with dreams, with suffering and with courage' (Swift 1979). As quoted in the *Soho Weekly News* in an article by William Harris, Akalaitis said, 'For a long time I had been thinking about doing a piece that had to do with adventure, not esthetics, not personal expression or contemporary New York art values. I wanted to do a piece that had to do with something bigger than us all' (Harris 1979). Just as Shackleton became a kind of political hero of exemplary leadership despite the sinking of

the uncannily named *Endurance*, the men on the expedition became known for their independent spiritual experience of a third presence, a presence about which T. S. Eliot wrote in *The Waste Land*.[21]
Leverett was by far the most astute critic of *Southern Exposure*, aware as he was of the troubled waters of documentary.

> What I am saying/questioning, finally [he wrote at the end of his review] is that when history becomes art it still remains history – that is, it still retains some of its own social-philosophical imperatives with the artifice. In *Southern Exposure*, I have located the art: It lies in the elegant conception of Joanne Akalaitis and the stunning execution by Ellen McElduff and David Warrilow. I have also found, or at least sensed, some of the imperatives. What remains fragmented and inchoate to me is the history itself – a sense of relation to the events and characters. The willful refusal to 'interpret' seems to me as questionable as willfully imposing an interpretation. The refusal is a relinquishment of responsibility to the subject which ultimately diminishes the work of art itself.
>
> (1979)

Refusing to 'interpret' in order to avoid 'willfully imposing' identifies a split that was occurring between theatre makers who privileged formal innovation over content and theatre makers intent upon creating work that prompted social change. The difference was between those who used the formal innovations of the 1960s as the foundation for a postmodern theatre and those who continued creating theatre with content shaped by social and political concerns. In the 1970s, some artists rejected *both* personal revelation and overt political positioning in favor of formal innovation. Formal innovation meant exploring theatre as theatre and exploiting its distinctive properties for the purpose of creating unique meanings. The techniques of this theatre became the dominant concern and lingua franca of theatre, even when exploring the relationship between individuals and history.

Autobiography, biography, and interviews: *Rumstick Road*

Spalding Gray's *Rumstick Road* (1977) originated in his close work with Elizabeth LeCompte when they were both members of The Performance Group (1967–80).[22] *Rumstick Road* is part two of the four-part autobiographical 'trilogy' focused on Gray's life, *Three Places in Rhode Island*.[23] (The trilogy's four productions were: *Sakonnet Point, Rumstick Road,*

Nyatt School, and *Point Judith*.) The conflation of the real with the fic-
tional in *Rumstick Road* and the role that documentary material plays in
constructing this work are instrumental in understanding the influence
of performance practices of this period on theatre of the real today.
In his work with The Performance Group, Gray participated in an
approach to performing in which the performer was asked to have the
'courage and technique to lay his mask aside and *show himself as he is
in the extreme situation of the action he is playing*' (Schechner 1973:126).[24]
The Performance Group's approach to acting was much closer to 'as
is' than 'as if': creating character occurred somewhere between the
character and 'work-on oneself.' The performer's experience could be
used as a basis both for the creation of character and for the creation of
the work as a whole. The interpretive domain of making a work came
as much from the performer's experience translated and transformed
into physical and scenic ideas as it did from the creation of a text.[25]
This approach was first used in The Performance Group in *Dionysus
in 69* (1968) when the actor playing Dionysus used his own name and
personal experience in the context of Euripides's *The Bacchae*, and then
in *Commune* (1970) when the performers began the piece with 'songs of
first encounter' about their first encounter with The Performance Group,
which they understood as their new world. In the collectively created
Commune, Gray – identified in the performance by his actual first name,
Spalding – described how he came from Rhode Island to wander into a
production of *Makbeth* (see Sainer 1997:130). At any moment, the per-
former's life experiences could be as important as, if not more important
than, the play text.

Gray used his theatrically mined personal experience in his auto-
biographical performances. Inasmuch as the performer's own knowl-
edge became the marker of identity, 'the self' became a core part of
the 'scenic givens of the production' (Schechner 1973:126). Whether
one characterizes that identity as a 'self' (suggesting an essence) or as
a 'persona' (suggesting a construct) is less important for the moment
than understanding that in this approach the *mise-en-scène* was not the
background for fictional characters but an exteriorization of the tension
between the actor as actor, his or her actions as performance, and his
or her real self. This performance equation informed Gray's conscious
use of the stage design, space, and props as extensions of the selves that
were the subject of *Rumstick Road*.

Rumstick Road was Gray's investigation of the circumstances of his
mother's suicide on 29 July 1967. To probe that event, Gray used live
and recorded telephone interviews, family photographs, and memory.

Director LeCompte described *Rumstick Road* as 'part dream, part non-literal imagery, and part factual documentary' in ways that blurred the divisions between these forms of consciousness and fact 'so that at these points the literal is indistinguishable from the figurative, [and] the factual from the fictive' (LeCompte 1978:83). This fusion was and still is a calculated part of LeCompte's *mise-en-scène* (83). In this regard, *Rumstick Road* foregrounded the problematic nature of the real as it exists in the archive and in memory as well as explored autobiography and nonfiction as conceptual ideas. Gray used his preoccupation with his own life to illuminate how ephemeral the real can seem, how memory can escape us, and how we might be haunted by the presence of the past, how one can live the past as an eternal present.

Rumstick Road signaled Gray's struggle with the narrative structures, themes, and rhetorical patterns of his own life. The piece was also a means for Gray to refuse his mother's psychiatrist's suggestion that Gray could very well be an inheritor of his mother's manic depressive illness. (Years later, this diagnosis proved correct but, as *Rumstick Road* suggested, one wonders how the psychiatrist may have contributed to Gray's depression and eventual suicide in 2004 by planting the seed of heredity in his mind.) Gray's unsentimental creation and performance of *Rumstick Road* unsettled customary psychological interpretation by simultaneously locating Gray's life as material for his performance *and* as performance itself – the actor as actor, a subject alongside the life the actor acts.[26]

According to Gray, the performer-centric *Rumstick Road* was partly attributable to Schechner's approach to actor training. 'He [Schechner] emphasized the performer, making him more than, or as important as, the text. That made him very unpopular with critics and playwrights, but he was a liberator from assembly line acting techniques. The way that I interpreted Schechner's theories was that I was free to do what I wanted, be who I was, and trust that the text would give this freedom a structure' (Gray 1979:33). Another understanding of the importance of performers' contributions to the making of a piece can be found in Schechner's essay 'Drama, Script, Theatre and Performance,' particularly with regard to his notion of 'script.' In this essay, Schechner notes how the practices of the post–World War II American and European avant-garde focus 'on the doing aspects of [staging a] script' and how the four terms in the title of the essay were being broken apart by theatre directors and performers (Schechner 1973:71). The 'unified [theatrical] event' is disassembled by directing the gaze of the spectators to structural seams of the performance, revealing the means of constructing

a work, an approach that would became a hallmark of The Wooster Group (73). Schechner's now well-known assertion that performance is a broad category of which drama, script, and theatre are parts disrupted long-established disciplinary approaches and hierarchies and was more generally part of the way theatre practitioners reconceptualized their contributions to making theatre. In this way of thinking, a performer is herself or a version of herself as well as a character onstage. A director can also be a set designer and playwright. A set can function as a character in the play. A text can be used for its auditory textures more than the meaning of its words. Action and image are as important as words. And words might not even be necessary.

In his essay, Schechner uses the word *script* to mean that which is encoded, persisting from enactment to enactment, not the text of a play, or at least not only the play text (1973:70). A script can be a choreography, the floor pattern of a dance, a series of gestures or tasks, a way of holding and moving the body, a song style or vocalizations. These might be memorized in the body or recorded on tape, film, or in notes. Over time, the term *script* morphed to *score*, as *script* is typically used in reference to the text of a play.[27]

Using the actors' physical action to structure *mise-en-scène* in combination with the psycho-physical work of The Performance Group gave Gray a foundational method of staging his personal life. While working on *Rumstick Road*, Gray asked questions that signaled a shift in aesthetics from regarding the real as something that was crucial to know and understand to regarding the real as a construction. 'Was my theatre acting a confession of the constant state of feeling my life was an act? What was the reality of myself on the other side of that 'act'?' (1979:33). In other words, Gray was asking whether theatre and life both consist of fragments of narratives, lit at certain moments, dark at others, and strung together by chance.

The text of *Rumstick Road* largely consists of Gray's audiotaped interviews with his paternal and maternal grandmothers, his father, and his mother's psychiatrist. Gray selected the portions of interview to be used, the performance props, and the personal photographs. LeCompte then used the interviews and props as items in what she considered a plotless sequencing of events. *Rumstick Road* was, in fact, not so much plotless as a work with an associational narrative structure created from montage. Everything in the work is thematically related. 'Spalding interviews his father, his father's mother, his mother's mother, and his mother's psychiatrist. He asks questions about his childhood, about his pet dogs, about his mother, her suicide, and what she was like. He remembers

events in his life and compares these memories with the memories of his family. He presses his father to tell him about the night his mother committed suicide' (LeCompte 1978:82). An indication of the careful selection of autobiographical details is that LeCompte and Gray did not mention in the work that it was not until Gray returned home from Mexico several months later that he learned of his mother's death. LeCompte's task-like iteration of narrative fragments was an assertion that Gray's life was silage for theatre, not psychoanalysis. As theatre, *Rumstick Road* was structured as a series of events, nothing more, nothing less. The intended subject was theatre as much as, if not more than, Gray's life.

Gray's life as theatre was not necessarily how audience members received *Rumstick Road*. During a post-performance discussion in 1980, when *Rumstick Road* was revived at the American Place Theatre, a spectator asked Gray about his vulnerability in his very personal portrayal of his mother. Gray replied that the spectator was really responding to the actor Libby Howe and the colors on the stage. He added, 'What happens onstage is not what I am feeling.' Gray's account of *Rumstick Road* foregrounded a play of images that are part dream, part autobiography, part documentary, in a way that highlighted their complicated nature, especially in relation to truth and identity. Here is Gray's account of how he created the physical score for *Rumstick Road* by balancing the dreamlike with what he calls documentary:

> *Rumstick Road* began to develop in two ways. First, it was a kind of surreal dream piece in which dream-like imagery grew out of group improvisations around the collected tapes and certain records of music I had chosen to represent aspects of my parents (Bach for my mother; Nelson Riddle for my father). We played with images, a color slide of my mother being projected on Libby Howes' body and moving up to cover her face. Howes doing a dance that she and Liz developed out of improvisations, set against a color slide projection of the house I grew up in on Rumstick Road. [Ron] Vawter and I lifting a red tent and 'flying' it out of a kind of picture window, done to a background of my grandmother's taped voice talking about my parents' relationship. These were some of the dream-like images.
>
> The second part of the piece was a more documentary presentation of the texts themselves. The piece moved from a childlike dream reality to a more adult factual representation of the tapes. There is the interview with my father, which we presented by having Vawter and myself sitting opposite each other and doing 'lipsync' to the

tape of my interview with my father. Vawter was performing his own version of the father role and I was performing myself. Another example of this documentary presentation was a tape recording of the psychiatrist who treated my mother. Bruce Porter, the fourth member of the cast, who acted as technician-performer and operated all the tapes from the center of the set, and in full view of the audience, had assisted me in making a tape of the telephone of my mother's psychiatrist who had treated her during her breakdown in 1966 and 1967.

We edited and played this tape in performance with my voice edited out so that I could actually speak the words in performance. It appeared that I was having an actual conversation with the psychiatrist. I changed some of my original words to make it sound as though I was making the call in the present. [...] These are some of the examples of the documentary aspects of performance.

(Gray 1978:91)

In *Rumstick Road* Gray played the actual tape recordings of interviews he conducted with his family members and his mother's psychiatrist, and LeCompte staged them as a simulation of the original interviews. *Rumstick Road* was an imagistic and surrealist autobiographical performance where fragments of memories were at one point translated into a song coming from a red tent as a woman slowly removed a white stocking from her extended leg. While Gray's performance and production was based on actual events and individuals in his life, many of the specific details the audience experienced – which were so powerful in performance – were theatrical inventions. The chase sequence between Gray and his father came from Gray's fantasies – perhaps psychologically true but not literally true. We were meant not to know. Either way, at the center of the performance was Spalding Gray *both* as fiction *and* as nonfiction.

In constructing *Rumstick Road*, Gray and LeCompte went well beyond Finley's announcement of dual identity as both Finley and the god Dionysus at the beginning of *Dionysus in 69*. In *Rumstick Road* it was as if Gray announced himself as a fiction through the use of nonfiction, an actor whose life was the subject he was about to play (Illustration 2.3). In this way Gray and LeCompte tried to vanquish the realist epistemology of the 1960s with its problematic sincerity and mandatory political critique in favor of a formal, apolitical postmodern theatre.

Throughout *Rumstick Road* Gray was the actor, the character, the subject, and the author, a constellation dramatically represented by the

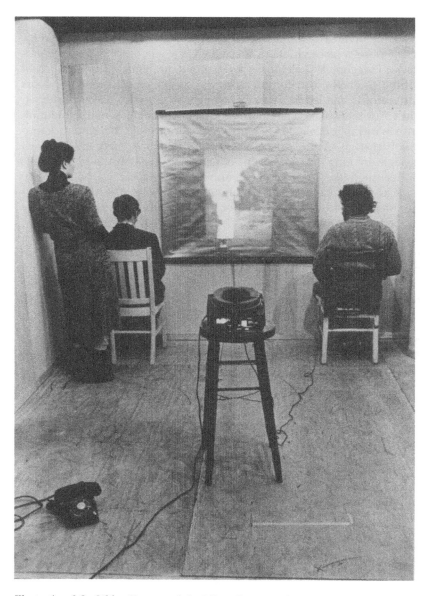

Illustration 2.3 Libby Howe and Spalding Gray watching projected images of Gray's family in *Rumstick Road* by Spalding Gray, directed by Liz LeCompte. Photograph courtesy of Richard Schechner

set designed by Jim Clayburgh. The set resembled a human head/brain: a sharply divided space, with two focal points (eyes) and in the 'bridge of the nose' a place visible to the audience where Bruce Porter, the production's technical director, operated sound and lights (Illustration 2.4). Behind and below this control room was a room with two interior doors with mirrors that led to a passageway between the two halves of the set. The entire set was like a phantasmagoric human being, situating the audience as metaphorically looking inside Spalding's brain, his autobiographical 'backstage.' As the action of *Rumstick Road* takes place inside Gray's head, everything onstage was in some respect an extension of him. This Frankenstein-like construction of the theatrical space was where Gray projected and enacted his reverie about his mother and his distrust of her psychiatrist and his father. In performance, members of the Gray family seemed to uncannily reproduce one another, socially and genetically. Seeing the family performed by Gray, Vawter, and Howes, an audience member might very well be confused about whose tongues are in whose bodies. As Gray's mother's psychiatrist unwittingly presents himself as a callous authority with cautionary but ultimately empty words for Gray, the institutionalization of mental health is deftly critiqued.

Illustration 2.4 Spalding Gray, Bruce Porter, and Libby Howe as the Woman in the Red Tent in *Rumstick Road* by Spalding Gray, directed by Liz LeCompte. Photograph courtesy of Richard Schechner

Playing the recorded interviews during *Rumstick Road* transformed the theatricality of the production into something authentic: 'this is them really speaking.' At the same time, the highly theatrical *mise-en-scène* placed these voices within the ambiguous fictional realm of theatre. What the audience heard was a tape recording of them 'having talked.' But what the audience saw was sheer theatre: Gray's family members were not 'really' speaking. Or rather, they were doing more than speaking – the staging gave their voices a supplementary actuality. For example, the voice of Grandmother Gray spoke about Spalding's excellent teeth as the masked Vawter pulled Spalding's mouth wide open, exposing his gums and teeth. *Rumstick Road* accomplished a conflation of the actual, the theatrical, and memory. The performance repositioned the tape recordings that happened in the past as if they were occurring in the present. That is, the people the spectators listened to were not present, but they were re-presented as 'being here now,' a universally practiced convention of theatre of the real. The ghost of Gray's mother was theatrically invoked when Howe sat in a chair in front of a projected photographic slide of Bette Gray, superimposing Bette Gray's face onto Howes. For a moment, Bette Gray was brought back to life. Then the created image was revealed for what it was: a slide image of a face projected on a real face, a transparent act of representation. Troubling the theatrical conflation of actor and character, while also folding them together, was a tangible reminder of what Schechner calls the 'as is' (as opposed to Stanislavsky's 'as if'). Part of the subject of *Rumstick Road* was revealing the ways in which theatre and psychology are both constructs by exposing the formal devices of their making. At the same time, in the closeted space of the theatre (the place of illusions), Gray re-created the real that haunted him and showed us how he did it.

In giving away the secret of his illusion, Gray made his theatre invoke the real precisely because he did not try to trick the audience into believing in the illusion, even as the illusion maintained its own force. In contrast to this exposure of the invention of the real was Ron Vawter's performance of Gray's deceased grandmother in a grotesque rubber, store-bought Halloween mask, creating a troubling masquerade of the past, the dead, and representation itself (Illustration 2.5). What was staged was both the reality of the illusion and the illusion of reality. The Halloween mask was the one glaring unrealistic device used in *Rumstick Road* and as such was strangely in synch and out of place at the same time. In synch as it mercilessly portrayed the difference of old age. Out of synch as the mask reached well beyond the real voices and images of other members of Gray's family. The use of the mask was a

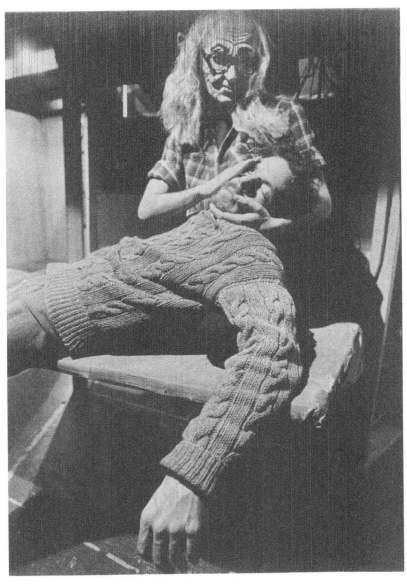

Illustration 2.5 Ron Vawter in grandmother mask examining Spalding Gray in *Rumstick Road* by Spalding Gray, directed by Liz LeCompte. Photograph courtesy of Richard Schechner

far cry from documentary in any conventional sense, but very much in keeping with the real as Gray interrogated it in *Rumstick Road*. The house, the tent, the tape recordings of Gray's family and Bette Gray's psychiatrist animated various aspects of Gray's states of mind and, most important, the past he was trying to reposition. In orthodox theatre, the play 'takes place' inside a set, but in *Rumstick Road* the set was alive, a body of action in itself. Actors, set, and props combined to relate something about Gray's mother, father, and grandmothers, and Gray's own attempt to replicate a certain extremely personal, strongly felt, yet ineffable experiential reality in material stage space. Other women literally stood in for Bette Gray, as when Howe took off her stockings in the red tent so clearly identified as Gray's extra-private domain (because the entire stage space was his private domain) or when the photo of Bette Gray was projected onto Howe. As in dreaming, the past haunted the trilogy. *Rumstick Road* critiqued the avant-garde's problematic efforts to blur the boundaries separating art and life. The objects of previous productions made appearances in Gray's subsequent work, a device that continued in the work of The Wooster Group.

Rumstick Road held a continuous commentary on theatre as a means of making meaning. Inasmuch as the combination of dream, nonliteral imagery, and autobiographical elements drew attention to the constructed dimensions of performance, what Gray and LeCompte accomplished was a highly self-conscious work that is better described as a meta-documentary than as a documentary about Gray's relationship to his mother and father. Real events and theatre fused in *Rumstick Road* in ways that destabilized assumptions about each. LeCompte wrote that the most significant development in theatre at the time was 'the combining of the playwright, director and designer in one person. The result was a wedding of text, theatre space, and movements of the performers where nothing *modified* anything else. Each part is equal in the transmission of the meaning of the piece. Unlike traditional theatre where the blocking, direction, and design all serve to modify or enhance the meaning of the verbal language, in *Rumstick Road* the text is a function and a component of the action and the space. Each part informs the other part in a continuous circuit' (LeCompte 1981:50). This evidently took a while to get across to critics and publishers. LeCompte lamented in the same essay that she was disappointed to see that the text for *Rumstick Road* was printed in *Performing Arts Journal* without the 'stage actions' she had included. 'I knew something was wrong – that the words of *Rumstick* were not a script for me, that the actions had as important a place in the system of things as the words, that *Rumstick Road* was being destroyed

and destroyed' (52). LeCompte, despite her apolitical theatre, inherited the 1960s proclivity for abandoning the authority of the playwright in favor of all aspects of the work being created in rehearsal.

The story that Gray sets out to reenact, animate, and embody is an imagistic conflation of memory, loss, desire, hatred, affection, and wonder at his childhood. It is a world of identifications where the inquiries of the artist Gray created the son Spalding, whose story is told through its physical staging. The 'journey' of *Rumstick Road* is a series of gyres, continuously circling, just like the performers chasing each other around the set, but never exactly landing on the suicide of Bette Gray. A skeptical, inquisitive, and sensitive Spalding tries to conduct a theatrical investigation into the suicide of his mother but is waylaid by his own theatre devices. Gray's subject remains himself as performer and auteur, even in the context of the narration of the events of his life. Like *Southern Exposure*, *Rumstick Road* is as much the story of a theatrical object, *Rumstick Road* itself, as it is the story of Gray's life. The Spalding of *Rumstick Road*, and the story he researched, documented, imagined, and invented could not be separated from its performance. In the performance Gray's constructed autobiographical persona lived both inside and outside his body: in the red tent, the house, the record player, the sheets, the telephone – and in the *Rumstick Road* set as a whole.

Everything and everyone Gray touched, recalled, and interviewed provided unique circumstantial evidence for a performance whose subject was embodied memory. While viewing a projected image of the house on Rumstick Road where he grew up, Gray identified the bedrooms using possessive pronouns ('theirs,' 'mine') and the living room where his mother had a visitation from 'Christ Jesus.' *Rumstick Road* bound Gray to his mother – as he made her efforts to understand her own life analogous to his efforts to understand the reasons for her suicide. In a powerful doubling of constructed personhood, the artist Gray played the role of Spalding in his own play about himself supported by the actual voices of his father, his mother's psychiatrist, and his grandmother. Only late in the piece is there mention of the garage where Bette Gray committed suicide by letting the car engine run in the enclosed space. In the slide of the house, the garage nestled among many trees is visible. 'Rumstick Road was a great green archway of elm trees in the summer until they got this illness,' Gray says (1979:96). The 'illness' to which he refers is itself doubled. At a literal level, it is the Dutch elm disease that ravaged trees across America, an illness that Spalding implicitly likened to the illness and death of his mother. The death of the trees and the death of Bette Gray remain mysterious and

absolute. They are out of reach, leaving Gray only with his memory and theatre (the place of seeing).

In *Rumstick Road* Gray took on the challenge of knowing himself in analytic terms in ways that made a circus of usual psychological explanations. Gray knew from the start that he was the one he sought. Gray's struggle against his father and his mother's psychiatrist was presented both as 'raw' – the actual words and voices of the men – and as 'treated,' carefully situated within and as part of a theatre piece. Gray knew what his father and the psychiatrist could not know: that their voices would be heard by audiences coming to the theatre to see *Rumstick Road*. Gray's encounters with his father and his mother's psychiatrist were captured by making them speak in Gray's realm – the theatre. This coup could not recuperate the absolute loss of his mother. Gray did not have her voice to broadcast. Nor could the many, many successful performances and monologues that followed immunize Gray against the fatal depression his mother suffered.[28]

Gray and LeCompte's methodology used both facts and their recollection to show how subjective realities are created from the material world. Personal testimony in *Rumstick Road* created an entire psychological world of one individual and a picture of the world that shaped that psychology. Gray's exploration of his personal identity as directed by LeCompte revised approaches to nonfiction and fiction, narrative and truth, and autobiography and theatre. Gray's sophisticated employment of documentary sources, coupled with memories, dreams, and fantasies, amounted to a staging of the real – Gray's real psychic state – an actual state as important as any objective reality.

Changes in the way the relationship between theatre and life was conceptualized in the latter half of the twentieth century enabled personal revelation to develop into new kinds of inquiries into social justice.[29] Using personal experience as a way to point to problems of social justice in public life contributed to new methods of making theatre that helped form the practice of theatre of the real as we have come to know it today. The interest in the documentary form evident in works by Gray, LeCompte, Akalaitis, Katz, and The Open Theatre was an attempt to introduce into theatre the same kind of transparency that reformers were calling for in political systems. This changed theatre – a genre that had developed clear boundaries separating backstage from onstage as well as wings and a front curtain: all means of concealment. Theatre of the real did away with the actual as well as the conceptual walls, wings, and curtains. What had previously been hidden by social conventions, and corruptions of delimited psychological understanding,

the 'theatrics' of corporations and governments, was challenged by a new theatre of the real based on notions of transparency. By the 1970s destroying the façade came to mean not only exposing government hypocrisy and corporate fraud, but also exposing the self to abolish any complicity in opaque systems of power. Disclosure of self mattered in ways that had nothing to do with the self. It mattered as a technique that paradoxically was meant to change the status quo. Disclosing the self was closely linked to the dictum that the 'personal is the political' a phrase deeply connected to changing the status quo: bringing down the government, subverting one's parents, and creating the world of the next generation. The documentary ideas evident in works in the 1960s and 1970s by Gray, LeCompte, Akalaitis, Katz, and The Open Theatre in the United States presented personal and theatrical transparency as a political act. It was no longer enough to narrate the truth (or what people thought was the truth), it had to be theatrically staged with transparent methods.

Performing scripted physical action to create reenactments; using the set as a character and personal experience as a means to stage larger social and political ideas; blurring the divisions between performer, playwright, and director, and employing technology to gather data and present it onstage: these are all foundational to theatre of the real, as is the use of verbatim documents. Productions created from this process meant to publicly disclose both personal and public truth in a manner that demanded social consciousness about the relationship of the individual to history and of history to the individual.

3
After the Fact: Memory, Experience, Technology

I thought I could do that in miniature. But then I thought,
this is real, this is real. But I can visualize what I saw with
miniature props and models. I needed to cope with it.
Herman Helle of Hotel Modern[1]

Recording ourselves, re-creating our experience and our narrative accounts of history, and remembering and memorializing the events of our own time and other times are central preoccupations of theatre of the real. Social order is created out of shared memory, and the creation and continuity of shared memory is a function of performances across the spectrum of theatre of the real where memory is treated as a cultural activity enacted with texts, images, and physical presence. Social memory, writes Paul Connerton in *How Societies Remember*, involves both memory and bodies. The creation of social memory is at work in bodily practices of both groups of people and individuals. Documentary evidence, Connerton writes, has a status comparable to the status of a text, but social memory is created and challenged through collective performative acts of individuals (1989:4). Recording individual memory of collective events in the form of performance shapes spectators' memories of events they may or may not have witnessed. Memory is used to form pictures, construct cases, make arguments, create historic ruptures, and situate the spectator in history. Memory as testimony, as proof, as evidence of experience, events, and history is at work in bodily practices, in textual inventions, and technological innovations.

Memory, however, is not is a stable domain of data stored as text and image. Memory is more of an interactive domain that is modified by its own telling, than it is a record of the past. The brain as filing cabinet is an inaccurate metaphor. Scientists have long contested the notion

that individuals have a reliable retrieval system of data. Researchers have found that about 75 percent of DNA-based exonerations happen in cases where witness memory was wrong.[2] According to the *New York Times*, in November 2011 the Supreme Court heard 'its first oral arguments in more than three decades that question the validity of using witness testimony, in a case involving a New Hampshire man convicted of theft, accused by a woman who saw him from a distance in the dead of night.'[3] Among the many things that alter memory are the person's emotions at the time of the event, social pressures that corrupt its retrieval, and even flourishes and details unknowingly added after the fact.[4]

> The editing of the past occurs without a person's realizing what has been forgotten [and what may be added]. In court, witnesses are asked to tell the truth and nothing but the truth. They think they do. Whether in a story told in a courtroom or at a dinner table, the mind is sometimes prone to blur the distinction between reality and fantasy. Brain scans of people recalling something they did not actually see have many similarities to brain scans of people dwelling on an actual memory.[5]

In fact, my memory of the order of the sketches in the cabaret in Tel Aviv, as recounted in my Introduction, was not initially entirely accurate. Responding to a draft of that portion of my Introduction, Atay Citron corrected me. He wrote: 'It is not that my memory is better than yours. It is not even the fact that I directed that show. We have a video documentation of the evening, and I show excerpts of it (including the two you write about) to my students every year in my cabaret class. That's why I can correct you.'[6] Atay is accurate, I assume. His memory takes precedence over mine because he has the video documentation. Using the interface between memory, experience, and technology is one typical way in which we now formulate memory. Technology, however, is not transparent and can completely omit the subject's experience of what is recorded. Nor can technology be understood as a singularly accurate record of experience. My memory of the cabaret is saturated with the death of my mother, which occurred five minutes after the performance was over. It is an emotionally true memory but, I have to concede, probably also an inaccurate one. In this concession I forfeit my memory to Atay's memory and to his repeated viewing and interpretation of the video record. Even so, in my mind's eye, I still see the events that evening as unfolding in the order in which I came to remember

them. Similarly, Jefferson Mays remembers being dismayed when viewing a video of his performance of *I Am My Own Wife* because although he always wore the same dress throughout his performance, when acting the character of the Stasi officer, he imagined himself costumed in black leather.[7] The actor's imaginary has to create the reality he wants to convey, no matter the real, material conditions in which he finds himself. At the same time, the reality the actor creates has to coexist with the worlds created by the playwright, director, and designers. Although the video of Mays's performance was a record of his material performance, it was not a record of Mays's performed imaginary, an imaginary that was, in fact, clearly signified in Mays's live performance. Memory is both a very fragile and persuasive record of experience.

The ideas performed before us on stages devoted to theatre of the real and its versions of history are made as much from memory as from fact. Memory demands complex negotiations in the minds of individuals, in the formation of communities and social life, and in the construction of national and global identifications. Even verbatim theatre relies on interviews that depend upon the memories of their participants, memories that construct an illusion of intimacy with history and the notion that history can be known primarily through quotidian individual experience. What can 'the truth and nothing but the truth' mean in a world of theatre created from interviews and interpretations of documents? Especially when scientific research on memory finds that editing of the past happens without a person's conscious knowledge, and that the mind can be unpredictably prone to blur the distinction between reality and fantasy? This chapter is devoted to a discussion of how the staging of memory creates records of human experience with aesthetic frames that select and condense reality in ways that participate in the construction of social and historical memory. The aesthetic framing I discuss here rests upon the fault line between documentary evidence and social memory as it reveals the negotiation between individual and historical knowledge. To illustrate one example of the ways in which memory flows from the individual to history and history to the individual, I begin my discussion with my personal experience of the September 11th, 2001, terrorist attacks on the World Trade Towers as I saw it from the window and terrace of my Greenwich Village apartment in New York City in relation to the televised version of the attacks. This is followed by an analysis of *History of the World – Part Eleven*, a live-animation simulation of the aircraft crashing into the towers on that day, created by Hotel Modern company member Herman Helle, who saw the attacks only on television. Finally, I discuss *Kamp* (2006)

also by members of Hotel Modern. *Kamp* is about the Holocaust, specifi-
cally events that took place at Auschwitz-Birkenau created more than
50 years after the events it depicts. *Kamp* does not have the experiential
basis of the first two works I discuss, nor do any company members
claim Jewish lineage or familial experience of the Holocaust. The work
uses both live performance and animated film and is an example of the
cusp between live experience and virtual reality that informs so much
contemporary theatre of the real.

September 11th

During the weeks after the terrorist attacks of September 11th, 2001
many of my students at New York University went home for a period
of time.[8] We – the faculty and administration – did not know whether
or not we were going to lose students from attrition over the course
of the semester after the attack. What we did not anticipate was that
the students who did leave New York City would quickly return to our
smoke-filled, traumatized environment plastered with homemade signs
of the missing, and rife with rumors of further attacks and bomb scares
resulting in periodic evacuations from the subway and many buildings.
The stated reason for the students' return, more often than not, was
that they could not tolerate the media portrayal of 9/11 from a vant-
age point outside the city. Their experience of 9/11, they asserted, was
completely apart from what they saw on television. Their return to the
city was precisely so they could cling to their experience and to others
who shared it.

I was at home in the center of Greenwich Village, working at my
computer, when the attacks occurred. I heard a chorus of construction
men yell, and then I heard a huge bang. Not one to rush to disaster, I sat
at my computer for a minute and then went to my husband, who was
watching television, and said, 'I think something really bad just hap-
pened.' Our neighbor was at our door the next second. He ushered my
husband and me onto our terrace, where we had a view of the World
Trade Center towers, one of which was on fire. It looked as though a
small plane had hit the tower. That it had been a commercial passenger
plane that slammed into the north World Trade Center tower at 8:46
a.m. was, at the moment, beyond imagination. The men I had heard
yelling were standing with their hands over their heads on the scaf-
folding and steel girders of what would become the new NYU Student
Union building. The first plane had flown very low, using LaGuardia
Place as its path.

All day I moved between the television room and the live spectacle of the flaming, and then collapsing, World Trade Center towers seen from our terrace. I needed the television to know what was happening and the unmediated view of the towers to confirm that the television reportage was about something real. The television both confirmed that what was happening was really happening and also contained the experience in its miniature box. On the screen of the television, the attack was horrific and also tiny and far away. Burning towers seen live from our terrace, burning towers seen on the television. Then my memory becomes less clear. I know that soon after the second plane hit at 9:03 a.m., I could no longer tolerate the view from our terrace. I could, however, sit in my bedroom and view the towers through the frame of a large picture window. The window frame seemed to confirm and contain the horror. Just as I was inside, so were those people who were trapped in the twin towers... inside. Like many, I did not understand what was going on until the Pentagon was hit at 9:37.

The circuit from the window to the television and occasionally to the terrace continued for the next few days. Only the most pressing needs made me leave my apartment. Shortly after the Pentagon was hit, I retrieved my daughter from her school nearby. Over the next few days, she took a daily position on the floor with her chin lifted up so she could gaze at the television reportage about the attacks as they flickered across the screen above her. One day she simply said that we had to go buy dog boots because the rescue dogs working at the now collapsed towers were getting burns on their feet. This is something we can do, I thought. The first pet store we found was owned by Iranians who looked stressed and scared. We asked to buy all their dog boots. They told us they had already donated all of them to the rescue dogs. We asked to buy several cases of dog food. That too, they said, was entirely gone, as they had donated all their dog food to the rescue effort. As we walked in the toxic air, my daughter commented that we were breathing in tiny particles of dead people who were now part of the ash suspended everywhere in lower Manhattan. Eventually we found a store where we bought thick socks to donate to the firemen and others working at the site.

My story is just one of millions. Everyone has their own 9/11 story. Writer and actor Marc Wolf made a documentary theatre piece, *The Road Home*, about 9/11 after his enormously successful play *Another American* (2000) – only to find out that everyone, including those who had no direct experience of the event itself, prefers their own 9/11 story. Thanks to the media, everyone also feels that, whether their experience was live or mediated, they did actually experience those moments, and that day.

History of the World – Part Eleven

I thought that what I saw in my mind's eye that day when I looked at the burning towers could not be comprehended or even known by anyone else. The silent horror of my imagination, I thought, was mine alone. But then I encountered on YouTube Hotel Modern's 4 minute and 20 second puppet film, *History of the World – Part Eleven* (2004), made by company member Herman Helle and accompanied by David Bowie's music *Heroes*. It was as if Helle had uploaded what I saw in my imagination on that fateful day.[9]

The film begins with an aerial shot over an urban skyline made of juice boxes, soft-drink cans, and then the camera focuses on a tight shot of the nose of a papier-mâché airplane flying over the buildings (Illustration 3.1). Inside the plane, clay puppet people – props, really, as they have no moving parts – are screaming. As the plane hits, the scene shifts to the vantage point of those inside the World Trade Center tower.

Illustration 3.1 History of the World – Part Eleven by Herman Helle. Photograph courtesy of Herman Helle

There are desks, chairs, water coolers, and paperwork. The handmade people with their contorted clay faces are posed frozen, screaming, running, and clasping one another. Still others have sunk down against the wall. Fire breaks out everywhere. A legion of clay office people marches downstairs. A man puppet jumps from a window. All the images are close-ups of what must have been – or, more accurately, of Helle's imagination and reconstruction of what must have been. They are real and not-real at the same time.

Helle wrote to me that he decided to keep his images very simple. 'Not too many details, just hints of office furniture, a model plane that's very obviously made of paper. I figured we had all seen the perfect Hollywood-style images on television. I needn't do them again (as if I could). You use your own imagination to fill in the details, to project what you've seen, or think you've seen, or want to see, onto the crude images. Suggestion is stronger than many details. The fewer the details, the more real it becomes. The shots are very short. Mostly ten frames per shot. I moved the lens of the camera over the model to simulate movement.'[10]

Perfect Hollywood-style images? There is more truth in this than meets the eye. Helle is referring to the limitations of a well-known style of visual language in which images of the real are enhanced, colorized, cleaned up, and generally manipulated for presentation without imperfections. The visual experience of 9/11 rapidly produced and reproduced in the media was focused on the spectacle of the exploding towers, especially the moment right after the second plane hit. The 17 minutes that elapsed between when the first and second tower were hit allowed for professional photographers to arrive on the scene. Almost all the photographs of the exploding tower that circulated in newspapers and on television were of the second impact. The well-framed color images told little about the suffering, the odor, the sound. What was not, could not have been shown on that first day was the tragic experience of most of the individuals in the towers at the time of the attacks.

The ways in which changes in technology create and inform representation, which in turn creates new knowledge, requires ethical consideration. Aerial photography offers a case in point: it provided a new kind of military intelligence, 'turning the battlefield into an object of vision of a (seemingly) all seeing eye, while it also introduced a kind of abstraction from the direct experience of this landscape by someone present within it' (Bleeker 2011:280). In 'Playing Soldiers at the Edge of Imagination', Maaike Bleeker observes that new technologies helped create a new type of heroic imagery portraying the glory and grandeur of modern warfare,

making it appear clean, civilized, and efficient (281). To help make her point, Bleeker quotes Bernd Hüppauf's essay 'Experiences of Modern Warfare and the Crisis of Representation':

> It [aerial photography] not only eliminated smells, noises and stimuli directed at the senses, but also projected an order onto an amorphous space by reducing the abundance of detail to restricted patterns of a surface texture. In photographs taken from a certain altitude objects of a certain minimum size will be represented; smaller objects, in particular human bodies, will not be there and cannot be made visible, even with magnifying glasses or through extreme enlargement. The morphology of the landscape of destruction, photographed from a plane, is the visual order of an abstract pattern.
>
> (281)

Helle's view of the World Trade Center towers in *History of the World – Part Eleven* rejects an exclusive depiction of the abstract spectacle of the towers exploding and burning, in favor of representing the excruciating human drama that took place aboard the planes and inside the towers. Helle's heroes are not glorious and grand, but inglorious and vulnerable as death smashes into them.

On September 11, 2001, Helle and his colleagues in Hotel Modern had gone to a theatre in Rotterdam to prepare for the evening's performance of *The Great War*, their work about World War I inspired by letters about life in the trenches, written by a soldier to his mother. An administrator called the company members upstairs, saying that something had happened and asked them to look at the television. While watching the television, they saw the second plane crash. Helle remembers thinking, 'I could do that in miniature but then I thought this is real, this is real.'[11] Faced with what then looked like the beginning of World War III, the company debated whether or not to perform *The Great War* that night. The show, which is full of miniature special effects, both sound and visual, including explosions and fire, was sold out for that evening. They decided to go on. Only half the ticket-holders showed up; evidently they understood the show as being about what had happened that day – a good example of how contexts outside the theatre can shape spectators' relationship to a particular theatrical event. The spectators viewed *The Great War* on the evening of September 11, 2001, as the first installment of what was now being played out on the world stage. What the company saw on television was 'what we were already doing. We were invoking the atmosphere of a battlefield. What we saw

on television was what we were about to do that evening in the theatre. But what was on television was real.'[12]

Helle made *History of the World – Part Eleven* over a three-year period from 2001 to 2004 accumulating the equivalence of about two months of work during that time. 'I made the work as a way of coping with what I saw,' he says.[13] But Helle did not see what he creates in his work. No one, save those who perished, saw what went on inside the plane or inside the doomed offices of the towers as they were hit. What Helle captured was a scenic imaginary that refers to the real in what appears to be a model of it. In making the work, Helle asked three questions: What would it be like to be in a building and see a plane coming at you? What would it be like to be in the plane? What would it be like for the hijacker who is accomplishing what he sought to do? The last question eventually led Helle to the music *Heroes* (1977) by David Bowie with its adrenaline-pumped hysteria, its musical excitement, and ethical ambiguity about the very idea of heroes who are often only designated as such when dead. 'At that time there was a lot of talk about heroes. The firefighters, of course. But I even heard other people that died in the buildings, the office people, being called heroes once or twice. And then it struck me that the hijackers, from the vantage point of their supporters and families, also were heroes.'[14]

Helle ended up making a simple model that focused more on visualizing an imaginary of what happened than on presenting literal verisimilitude. He used several planes, each about half a meter long. One plane was made of plastic, the others were made of papier-mâché so that Helle could set them on fire and crash them several times in order to film a variety of shots. The images Helle created refer to the contours of the city, the shape and form of New York, though made with very different materials. In *The Return of the Real* Hal Foster writes about two opposing models of representation emerging since the 1960s. One asserts that images refer to real things in the world, the other that images only represent other images.[15] As Foster points out, and as Helle demonstrates, this binary constrains our understanding of art – and, I want to add, of reality. Poststructuralists have wanted to separate depth of meaning from art, which is understood as endless simulacra. But many successful artists, such as Helle, still create work in order to mine depth of meaning. The models that Hotel Modern creates both refer to things in the real world and represent the images we already have of those things.

Helle's recurring use of the word *real* in his description of how he created his simulation indicates his own relational status as being between the real and the referent. With its clay people and juice-box city, *History*

of the World – Part Eleven is self-consciously not a realistic representation even as it is a chronicle, an illustration, and a history of the event it takes as its subject – *History of the World – Part Eleven* is a documentary of sorts. Helle was not looking to make Hollywood images, but he did exploit a Hollywood-type optical illusion in relation to pictorial space; the conventions of framing Helle used are ones with which we are familiar. Helle observes, 'We communicate with the visual language we have learned and know.'[16] This simple statement says a lot about how we come to know ourselves today. But there is also a contradiction in what Helle says, because it is not exactly what he did in *History of the World – Part Eleven*. Instead of an abstract and omniscient aerial viewpoint, Helle used an eye-level, eyewitness point of view to *show the first victims* of 9/11 on the planes and in the towers, as a way to focus on the catastrophe's unfolding human, not architectural devastation. Bleeker describes Hotel Modern as confronting war and destruction from a split perspective. 'The audience,' she writes, 'is put in the position of having to negotiate its relation to the atrocities represented on stage [as well as on film] and, by extension, its position with respect to the question of what might be at stake in particular ways of representing these atrocities, or claiming them to be unrepresentable' (2011:279). In creating a relationship to the referent that includes both the real and its simulations, Hotel Modern asserts that atrocities can be meaningfully and aesthetically represented precisely by repositioning the spectator's assumptions about the duality of the real and the simulated or reenacted.

As I sat on my bed that September 11 morning, looking at the World Trade Center towers through the frame of the picture window, I could not have been seeing something uniquely created by my own mind. Any empathetic person could have imagined what was going on inside those buildings. But the way I saw what I saw – in scenes with settings, movement, narratives, triumph, and tragedy – was in the visual and theatrical language I have learned and know. As Helle's *History of the World – Part Eleven* demonstrates, this language and learning is shared across at least some national boundaries. As a historical witness, I found the tragic narrative unbearable. A view framed by my bedroom window and by the television was the view I needed in order to tolerate my own imagination.

Most theatre of the real uses framing, whether verbal or visual. This framing is apart from the reality of the experience itself, as it has to do with aesthetics and modes of perception. As early as the late 1920s Ernst Jünger asserted that human perception was adapting to the vantage point of the camera lens (281). This was before film had fully entered popular

consciousness. Today, framing is often all we can do. The 9/11 attacks were a tragedy that presented itself first as a spectacle. The plot, if it can be called that, was revealed through repetition of the visual: the towers burning, collapsing, smoking, and the crowds gathering every day at the corner of Houston and West Broadway, looking south at what was no longer there. The frame was all that was left of a vanished, very familiar picture.

Dramaturgical structures also help us to 'know what we know.' Janelle Reinelt writes that for a public occurrence in everyday life to become theatricalized, several things must happen (2006:74). The event must be grave and significant, attracting a great deal of public attention; it must take a recognizably Aristotelian form in terms of protagonist-antagonist conflict and plot development. The event must also be a symbolic staging of some already known feature of national or local life in order to 'embody a kind of analogical critique of ways of living' (74). Reinelt's observations describe a number of documentary plays, but not the field of 'theatre of the real' as a whole. The form of drama that Aristotle wrote about is not universal, and a significant proportion of the theatre that engages the real in performance today is devised in ways that stand apart from Aristotelian dramatic structure.

Aristotle, as is well known, thought *Oedipus the King* by Sophocles was the perfect tragedy. Aristotle's formulation of protagonist, *agon* (conflict), and plot is exemplarily constructed in *Oedipus*, leading to the ideal aesthetic result of reversal of fortune and recognition of truth occurring at the same time, thereby creating a catharsis that provides spectators with a temporary respite from the moral indifference of the universe. Tragic forces are destructive beyond human justice and reason. Oedipus suffers a fate conferred upon him by the gods before his birth – a curse, actually, leveled against Laius, Oedipus's father. This fate is part of a chain of sins and reprisals dooming the paternal line from Labdacus onward. Oedipus's ability to rescue Thebes from the Sphinx and his determination to save Thebes from the plague cannot save him from his own fate in the family curse. Oedipus's fate is the determination of a cruel and absurd world that offers no moral respite, no acquittal. Refusing to recognize this absurd, relentless cruelty of 'nature' is perhaps the real metaphor of Oedipus's blindness as he pursues every action to try to undo with reason what has gone wrong outside the domain of reason. Oedipus solves the riddle of the Sphinx and much later the riddle he did not even know he faced: that of his own identity. Oedipus cannot stop the tragedy in which he stands at the center. Tragedy ends badly no matter what the protagonist does or feels. That is the principal characteristic of the genre. In its ancient

Greek form, tragedy breaks and bleeds its protagonists, and justice in its narrow human juridical sense is irrelevant. Unlike the social analysis of Brechtian theatre, tragedy offers no social or moral imaginary proposing how things might turn out differently. Oedipus unwittingly commits the heinous crimes of patricide and incest. He is existentially guilty; he must suffer for actions decreed by the gods before his birth. He inflicts his punishment on his own eyes with his own hand. Oedipus is his own prosecutor, defendant, judge, and torturer. He enacts a system he cannot successfully challenge or change. He learns the hard way that fate is a script already written. *Oedipus*'s tragic emphasis is on an already inscribed fate governing the lives of individuals.

Theatre of the real is not a tragic form. Inherent in theatre of the real is an implicit belief in agency, possible change, and the value of knowing something. Through the citation and reconstruction on stage of what audiences understand as real events, theatre of the real begs spectators to cultivate and use their moral imaginations. Spectators are implicitly asked to consider how things might be different. Through considering what happened and what went wrong, spectators are urged to arrive at an opinion regarding what might change. While theatre of the real may portray tragic events, more often than not, it attempts to intervene in tragedy's mindset of inevitability. Staging and replaying what has already happened creates the occasion for summary, examination, containment, and revision.

Theatre of the real engages the process of forming new memories both after and instead of the memory of the original events. The work of subsequent memory is to reinscribe, reform, and revise original memories in relation to the project of the current social and political communities in terms that anticipate possible new futures. Theatre is the result of the intentions of its creators and the opinion-forming gaze of its spectators, who function both as individuals and as members of communities. With the performance as the metonym of the real, we learn that we are the collective agents of our destinies precisely because murderous depravity, corruption, and greed, as well as moral imagination, honesty, and moderation – albeit all with their own rationale – are woven into every form of human interaction and institution. Unlike the story of Oedipus where suffering is fated beyond the agency of any human being, the events that unfold in theatre of the real result from the calculations and miscalculations of men and women, and can therefore potentially be reformed by human agency, human justice.

Much theatre of the real constructs vantage points for spectators that are fundamentally other than Aristotelian. Like *The Great War*, *History of*

the World – Part Eleven has no plot, no characters, no single protagonist, no catharsis. It is not a eulogy, nor does it construct the nationalistic sentiment that characterized so much post-9/11 writing and theatre. Planes crashed, people suffered, people died, the buildings collapsed.[17] *History of the World – Part Eleven*, like much theatre of the real, is built on a narrative logic that is visual, not literary. *History of the World – Part Eleven* is like a documentary but without documents, a virtual doppel-gänger. It is a mirror of both known and invented reality that gives form and image to sights seen and unseen.[18]

Today we construct reality as a circuit between the real and the vir-tual, leading to the imaginary. As he was in Rotterdam on September 11, Helle could only have seen the attack on the World Trade Center towers on television or on the Internet. Both media work within the confines of specific visual logic. Visual logic is key here. Hotel Modern describes their performances and the dramaturgical process of making them as focused simultaneously on the live *and* on what company member Pauline Kalker calls live-animation film.

> We don't work with a script written beforehand, we usually start by building the basic scale model. When it's finished we start work-ing with cameras and decide on the scenes that are included in the performance. Then we work out the models, puppets, and props in detail. With the content in our heads, the cameras in our hands and our eyes on the monitor we develop the screenplay. As we perform, the piece starts to breathe, we cut things, add things and sometimes change the order of scenes. The piece usually reaches its final form after we've performed it for about three weeks.[19]

Content, cameras, scenes, monitor, screenplay, and performance: this is the methodological mix that Hotel Modern uses to 'breathe' life into their work. 'We move between sham and reality, between documen-tary and fiction. We choose subjects from the reality around us which we then transform, and the subjects from the fictional world which we interweave with elements of reality,' says Helle.[20] Mixing reality, documentary and fiction, the live and the virtual is the methodological statement that describes the vanguard of theatre that lays claim to real-ity in the process of creating representation. *History of the World – Part Eleven* adapts mass media's reality-shaping use of fiction and nonfiction to its own ends: to portray history as no one witnessed it. Critiques of ways of living take different forms that correspond to innovations in art practices and changing cultural and political conflicts.

Writing about trauma, violence, and memory in post-9/11 theatre, Ilka Saal quotes Nancy Miller on the narrative strategy of the *Portraits of Grief* that the *New York Times* published from mid-September to mid-December, 2001. 'They [the portraits of grief] are crafted to serve as the microcosm of family life, of community values, of a valiant and, though wounded, *above all, happy* America. The domestic detail of the toothbrush comes to stand for the intimacy of the home, and the home for the nation's public life: the home front against the incursions of terrorism' (2011:359). Miller captures the ways in which public mourning promoted a patriotic surge after 9/11 that was hung on a scaffolding of idealized concepts of nation. Family, home, and community were summoned to unite against terrorism and to protect American exceptionalism and dominance.[21] 'You are either with us or against us,' said George W. Bush to Congress after 9/11. Bush's prescription for membership was also a war cry and a not-so-subtle coercion of thought aimed at forbidding and foreclosing dissent, debate, dispute, or discussion. That the military-industrial complex, with its increasing efficiency in the innumerable wars of the twentieth century, was playing a major role in determining community values seemed impossible to point out in the face of what seemed like an interminable unknown, the 'necessary' war on terror. Who did it? Is there a network of terrorists? How big is the network? Are there survivors? How many perished? Will there be more attacks? Should we (variously defined) leave? Are there terrorists in the city now?

Saal writes that most post-9/11 plays were 'aggressively clueless' because they were not able to create ethical narratives of trauma (2011:354).[22] Concerned with Judith Butler's notion that collective narrative framing produces explanation and exoneration in ways that ultimately determine what we are able to hear and understand, Saal looks at how different post-9/11 plays address ideas of self and other (353). Both narrative and visual framing conceptualize history and our responses to it. Framing provokes certain kinds of questions and historical inquiries, and omits others (353). Framing positions our responses to events in ways that structure individual and national plans of action and commemoration, and pose questions about traumatic suffering. In *History of the World – Part Eleven*, Helle prominently constructs eye-level views of the terrorists inside the planes that hit the twin towers. By including the terrorist perpetrators in his video, Helle visually acknowledges that there are those who might consider the terrorists heroes, even as the film mostly focuses on passengers and on those in the towers. *History of the World – Part Eleven* includes the traumatic suffering

of those outside American discourse. Even as Helle avoids mobilizing a vision of suffering that demands tribal retribution, the events he shows inside the planes and the towers are harrowing and violent, replete with undeserved suffering and death.

Works like those of Hotel Modern function as critical representations, as progenitors of analysis of information and meaning in a world that understands and invents itself with images, sound, action, narrative, and performance in a variety of media and environments, including the stage, the Internet, film, museums, the street, homes, schools, and conference rooms. The arts are where this invention of new knowledge takes place; it is where narratives and myths are given performative reality. In their own disciplinary contexts, the arts, especially theatre and film, provide the platforms by which information harvested from the sciences and the humanities is gathered, processed, and then disseminated to popular and mass audiences. In the twenty-first century, visual, auditory, performative, and verbal languages compete not only, or even mostly, to portray, debate, and analyze reality, but to significantly form the way perception interacts with what people understand as real. And perception, in the sense of observation, awareness, discernment, and insight, is instrumental in shaping the imagination that further shapes both artistic and scientific inquiry. Aesthetic innovations instigate change about how reality is understood and may also propose how it should be governed.

The effect of film and television on fundamental social processes is far-reaching. For example, take the impact of popular culture on the American legal system. According to law professor Richard K. Sherwin, 'legal meanings are flattening out as they yield to the compelling visual logic of film and TV images and the market forces that fuel their production. In consequence, the customary balance within the legal system among disparate forms of knowledge, discourse, and power is under great strain, and is at risk of breaking down' (2000:5). 'Customary balance' among diverse forms of knowledge and discourses is key to shaping democracies that function by egalitarian dialogic means, as opposed to the intimidation wielded by a singular dominant discourse. Sherwin gives the example of the erosion of the authority of a jury 'of one's peers' and the pressure against the knowledge brought into the courtroom by experts that occurs when the logic of popular culture determines the judicial process. In short, popular entertainment culture has become an extra-legal influence within the court room.

Under the influence of new modes of communication, however, these disparate forms of lay and expert knowledge, together with

their respective virtues are growing distorted. This is what we see when techniques of mass communication fold disparate meaning-making practices into the homogeneous stories and images of popular culture. It is what happens when the active, offscreen dimension of lived experience and the varieties of common sense that it produces give way to the passive, self-gratification-enhancing, and image-based logic of commercial media.

(2000:5)

Sherwin is writing about a collapse of the public sphere's 'meaning making practices,' what can also be identified as the public sphere's creation of narrative. 'The offscreen dimension of lived experience' is a startling phrase, as Sherwin proposes that lived experience can be marginalized as people capitulate to mass-media narrative logic and manipulation. The nuances of lay and expert knowledge – both operating in the traditional courtroom trial – are threatened by a homogeneity that seemingly produces 'self-satisfaction' in the form of a hunger for more of the same flattened versions of experience. Lawyers increasingly stage mediatized visual courtroom presentations in place of spoken testimony. Much of Hotel Modern's work, and work like theirs, disrupts flattened versions of mediatized experience through an inquiry of spectatorship by staging the live and the mediatized at the same time. Inquiry into our mediatized experience, the ways we know and write history, and our legal and theatrical epistemologies is part of the portfolio of theatre of the real as it locates itself both in the discourses of the real world and in those of theatre, technology, and new media.[23]

The metonymic logic of the juice-box and soft-drink-can city of *The History of the World – Part Eleven* is a Warholian urban landscape that gains unambiguous identity not only from the unmistakable shape of the World Trade Center towers but from what happens to the cardboard and aluminum city. Using the logic of jump-cut interpolations, Helle parodied mass-culture representation even as he used its debris to create it. The bond that Helle creates between the real and its representation is forged from the understanding that no matter the difference in materials, the ontology of the real and the reenacted, like the writing of history, proceeds from acts of the imagination in the forms of reiteration, representation, and narration.

The World Trade Center towers burning down the street from my home and the mediatized event were not separate domains. Each needed the other. Philip Auslander has made the observation that television can serve as 'evidence of an on-going reality outside of ourselves that we

can tap into any time we want to for as long as we want to – it is in this sense that we use television not just as an aesthetic medium, but for "company"' (Auslander 1992). Many people remember being told to 'turn on the television' on September 11th. On that day, television functioned as the narrator and as an authenticator of the reality. The television also provided contextual information that quickly situated the burning World Trade Center towers as part of a larger attack on the United States and then the 'war on terror.' Television's 24-hour need for 24-hour news was easily filled with incremental changes in the breaking story and repeated footage of the towers on fire, the towers collapsing, the search for survivors, the bravery of the firemen and rescue workers, and the identities of the terrorists. For those like Helle, television was *the means* by which real events elsewhere became known. For those like me, television confirmed that what was happening was real *in spite of* the fact that it was happening right in front of me. Soon enough, several television stations began to include the weather in Afghanistan in their nightly weather report as a reminder that we – Americans – were not only here in *eretz* United States, but also there in *eretz* Afghanistan – a terrorist 'homeland.'

Helle's response to 9/11 is unique in its materials and mode of realization, but not in its impulse. War-related performance culture occurs in tandem with war-based home entertainment video and computer games. Anyone can be a combatant in a variety of invented and historic wars and violent confrontations, transforming the couch in front of the television into a virtual frontline. As lived experience becomes blurred with simulations and simulations merge with lived experience, the public sphere can be coopted, as Sherwin describes, by mass media's image-based distancing from reality. But Sherwin is only half right. The inverse can be equally true. As lived experience becomes blurred with simulations, action in the public sphere can be instigated by social media's call for social action in the domain of lived experience. This was the case during the Arab Spring of 2011, which rapidly spread via Facebook.[24] The mediatized constructs recognition of the real.

Kamp

In terms of theatre, perhaps it is only at this moment in history that we can have a documentary without documents because theatre that presents reality by means of specific citations has become an operative idea, a mindset, a familiar way of framing the world that tells us this happened, this is real, this is the truth, or at least a part of the truth

because 'we are dealing with reality here.' *Kamp* (2006) is another work of Hotel Modern that exists between live experience and virtual reality but in very different ways from *History of the World – Part Eleven*. *Kamp* depicts a day and a night in Auschwitz-Birkenau using 3000 puppets, each the size of a finger (approximately eight centimeters), dressed in black-and-white concentration camp uniforms. *Kamp* simultaneously stages the Holocaust in the theatre *and* on live-animation film during the performance. Both the live performance and the film take place in real time. The live-animation film consists of sequences shot with four small cameras, whose images are projected on a large screen behind the playing area. Diminutive puppet faces are enlarged on the screen and given a more personal identity, and by extension, survival, through this technological magnification. Spectators see the puppets' faces and the events that happen in Auschwitz-Birkenau in close-ups captured by the camera *and* at a small distance in the theatre from the vantage point of looking down on many tiny puppets manipulated by the three puppeteers. The two domains of *Kamp*'s simultaneous live and virtual staging of the actions of emaciated, exhausted, and dehumanized puppet people inform one another. What is collectivized and perhaps dehumanized live is powerfully individuated on film. The film is a close-up of the live, and both the live and the film take place in front of the spectators. The environment for *Kamp* consists of what appears to be a painstaking scale model of Auschwitz-Birkenau. It is, in fact, not a scale model but an extraordinary combination and conflation of the two camps; the model is an approximation based on visual and experiential assessments, not mathematical measurements.[25] 'We started with scaling the puppets which had to be big enough to be seen by the audience. Then we adjusted the scale of the buildings. The problem was that the stage was not going to be big enough to show the whole camp using this scale. So the 'real' thing [the real stage set] had to be much bigger than what we are able to show on stage. There are more gas chambers and crematoria-buildings, and more barracks than are included in our model for instance,' explains company member Pauline Kalker.[26] An accurate scale model would result in an environment too small for spectators to see the action, as the model has to fit in the ten-by-ten-meter theatres where Hotel Modern typically performs.

Helle designed the model for *Kamp* using decisively homemade aesthetics, with materials such as cardboard boxes rescaled in miniature so that the puppeteers and the spectators loom large over the action and its environment. The camp gallows is a tiny, simple wooden post-and-lintel structure with wire hangman nooses (Illustration 3.2). The train

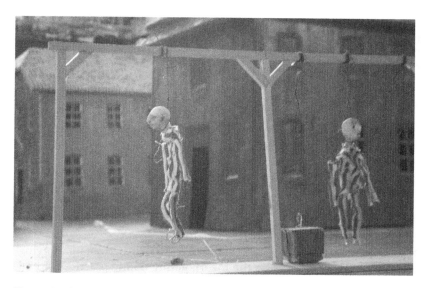

Illustration 3.2 Puppet inmates are hung in *Kamp* by Hotel Modern. Photograph
courtesy of Hotel Modern

that pulls into the camp to unload its doomed puppet passengers is not
unlike a child's model train. The sign *Arbeit Macht Frei* on top of the
gate to Auschwitz is splayed in a mockingly lyrical arch that lights up
during the foreboding night at the camp. There is the infamous guard
tower that stands over the train tracks in Birkenau. From the moment
spectators enter Hotel Modern's performance space, the camp onstage
is in plain view.

But whose memory does *Kamp* enact? Keeping traumatized memory
alive beyond the authoritative witnesses of the Holocaust has led
to attempts not only to record words and images but also to make
re-creations of the experience of the camps in order to build a new
generation of witnesses. Despite its use of live animation, *Kamp* is anti-
technological, because the labor of creating the work is painstakingly
exposed. Its positioning of spectators as a new generation of witnesses
to the Holocaust happens because the miniaturization and the 'thing-
ness' of the puppets and the environment are communicated as felt
experience in relation to the perception of difference of one's own size
in relation to that of puppets: large and powerful versus tiny and frail.

Kamp's simultaneous liveness and live-animation film forms its
particular way of producing meaning about the Holocaust. The use of

both live theatre and live-animation film intervenes in the division of the way theatre and film position spectators. In his discussion of bodily practices in relation to memory, Connerton points out theatre and film's different relationship to objects:

> In theatre, actors and spectators are present at the same time and in the same location; everything the audience see and hear is actively produced in their presence by human beings or props which are themselves present. In cinema, the actors were present when the spectators were absent (at the shooting [of the film]) and the actors are absent when the spectators are present (at the projection). [...] What defines the rules of looking specific to cinema is the absence of the object seen.
>
> (1989:78)

The difference Connerton describes is the difference between preserving versions of the past by using the incorporating bodily practices of oral culture as theatre does or by using the inscribing practices of what he calls 'literate culture' by means of both text and film (75).

In addition to Connerton's distinction between physical and literate culture we might consider that while actors and spectators are present in the theatre at the same time, not everything the spectators see and hear is produced in their presence. Alice Rayner writes about how the stage crew is responsible for managing the illusion of what passes for reality. The visible spaces in theatre, Rayner writes, are produced by the unseen presence of the backstage. Backstage – offstage, or 'ob-scene,' is the place where the secrets of staging the real thing operate (2001:538). The real world is typically understood as outside the theatre (536). But Rayner proposes that there is a real that is housed only in the theatre itself (537). The willing suspension of disbelief that enables spectators to receive what happens on stage as real comes with an ideological contract that 'prohibits an acknowledgement of the backstage life that includes the stage manager, light and sound operators, dressers, property managers, curtain pullers or make-up crews: the technicians and stage hands of theatrical production' (537).

Kamp uses both incorporation and inscription with its dual use of the live physical presence of the puppeteers and the simultaneous live-animation film. The performance demands that spectators see the objects, the puppets, as physically present both in the theatre *and* in the live-animation film as, contrary to Connerton's assertion, both the actors and the spectators are present at 'the shooting' of the film as it is

projected in the theatre. *Kamp* is post-illusionist theatre. 'We want the audience to see us. We deliberately do not dress in black. We do not think of our presence as an interruption but as part of how we are going to stage the work. We want to show the illusion and how it was reached,' explains Kalker.[27] This approach is in accord with Bertolt Brecht's desire to show the lighting instruments and the stage machinery, the 'work' of the theatre. The three members of Hotel Modern, Kalker, Helle, and Arlene Hoornweg, are at once the live puppeteer performers *and* the makers and witnesses of the live-animation film as well as the stage crew. They openly manipulate the puppets, the concentration camp environment, and the four miniature cameras used throughout the performance. 'Structurally, *Kamp* alternates sequences in which the puppeteers move within the set, preparing the figures for the next scene, with the scenes themselves' (Cherry 2011:110). Once the performance starts, the puppeteers manage everything that enters and leaves the stage until the performance is over. The members of Hotel Modern intentionally did away with the stage crew's conventional invisibility as they expose the labor of what they perform. *Kamp* is about approaching full disclosure and transparency of the process of making the live performance and the live-animation film (Illustration 3.3). They use bodily practice and

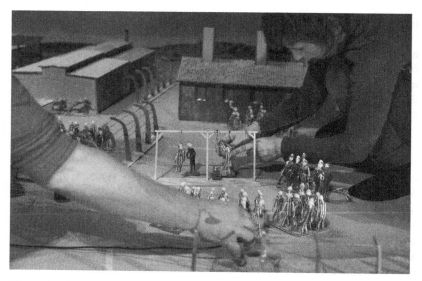

Illustration 3.3 Puppeteers stage the hanging of Puppet inmates in *Kamp* by Hotel Modern. Photograph courtesy of Hotel Modern

digital inscription, the techniques of oral and postmodern culture, to banish theatrical magic in ways that are meant to expose what the Nazis tried to hide – the labor of creating the alternative reality of the world of the camp.[28]

The productive tension of *Kamp* is one of visibility and absence, a theatrical tension crucial to theatre of the real in which the world outside the theatre is explicitly cited, quoted, simulated, and summoned in a variety of ways in addition to verbatim text: these include archival photos, film, and audio recordings, typical of productions such as *The Laramie Project* (2000); set pieces and objects, such as The Builders Association's use of artifacts from foreclosed houses in their piece *House / Divided* (2011); real clothing, as in the first production of *He Left Quietly* (2004) by Duma Kumalo and Yael Farber, where the clothes of those executed after spending years on death row at a prison in South Africa were piled onstage; and using the actual people to perform narratives of their own lives, as in performances by Rimini Protokoll. In addition to incorporation through bodily practice and inscription through literary, photographic and cinematic texts, theatre of the real can be made from memory contained in material objects.

Kamp reiterates and creates a cultural memory with its model of Auschwitz-Birkenau. In the same way the real Auschwitz and Birkenau function today as tourist sites of evidentiary status: the Holocaust happened and it happened here, on this ground, in these crematoria, and the other parts of the camps on display in their original geographical locations. More than a million people, mostly Jewish people, were outright killed, starved, and worked to death at Auschwitz-Birkenau. As a monument of the Holocaust and to those who perished in it, the camps draw over a million visitors each year. What does the performance of *Kamp* add to our relationship to a history, to a narrative of history that is already known? What can a theatre model of Auschwitz-Birkenau add to a world in which the actual camps still stand outside Krakow? What is the purpose of *Kamp*'s ritualized representation of history? What meanings does *Kamp* produce? Is it a work of memory, remembrance, mourning, moral education, national identity? Does miniaturization matter?

Kamp's careful miniature representation of the real is in the form of a foreboding physical environment, an environment both familiar and exotic. It gives the impression that what went on in Auschwitz-Birkenau can be reconstructed and comprehended, can even be held in one's hands, that it is an absolute memory that can be known and repeated. Television also presents a miniature representation of the

real, contained in the frame of a small (relative to what it presents) screen. Hotel Modern's artistic diminution of the genocidal reduction of the Jews and others who perished in the camps is one of the most disturbing aspects of the performance. *Kamp*'s seemingly precise environment is, in fact, architectural testimony in the form of a fantastic and surreal town (Illustration 3.4). In Kalker's words, 'By using [small] models you can show thousands of people and create a huge image of what happened. This was a city of death.'[29] The paradox of *Kamp* is that the model of Auschwitz-Birkenau presents the whole thing – but the whole thing reduced, adjusted, and changed. The performance is all the more unsettling for being enacted in miniature: a toy theatre, a perverted dollhouse theatre that reveals in a single scan an entire nightmare vision that undoes our fictional normal daily waking reality. *Kamp* makes the enormity of the Nazi enterprise seemingly completely visible – a remarkable accomplishment given that part of Nazi terror was to disappear people and then forbid public acknowledgment of the disappearance. Spectators are both immersed in the enormity of what happened in history 'there and then,' and are also ostensibly given the chance to see a portion of it in the present, here and now.

Illustration 3.4 Architectural reconstruction of Auschwitz in *Kamp* by Hotel Modern. Photo courtesy of Hotel Modern

Dual modes of presentation and interpretation inform much of the work of Hotel Modern, whose performances always involve Helle's models as well as puppets in ways that both provoke discomfort and provide a safety net in the form of the mode of play, albeit in this case very dark play, that is always part of theatrical reality. 'A re-creation with puppets is reassuring in that uncontrollable and horrible events are contained and made into something we can handle. We do not want to experience the real thing. The people who were in the camps had an experience different from *Kamp*.'[30]

True enough. Yet *Kamp* performs perspectives one cannot get while visiting the real camps. *Kamp* condenses the five years of Auschwitz-Birkenau into the representation of a day and a night in the duration of a one-hour performance. This time frame provides a dramaturgical clock, giving structure and rhythm to the events enacted. Kalker explains this reductive time frame as 'providing something familiar that people can recognize given that there are no characters.'[31] From another perspective, *Kamp*'s compression of years of sadistic extermination into a day and a night is an incisive commentary on the Nazis' atrocious parody of Jewish religion. In the hands of the Nazis the Jewish narrative of creation becomes its very opposite: seemingly endless destruction. The beginning of creation in the words of Genesis – 'And there was evening and there was morning – a first day' – becomes in *Kamp* the time-frame of annihilation.

The puppets are not made to surprise us with literal lifelikeness. Their clay puppet faces do not seem to have individual characterological significance.[32] Each puppet is like every other. Yet when looked at next to photographic images of the distorted faces of those who were murdered in the camps, the open-jawed and often open-eyed death faces of those piled in heaps in mass graves are not unlike the gashes of pain and terror that are the puppets' faces. In *Kamp*, asymmetrical holes are mouths, empty sockets stand in for eyes, and malformed lumps of clay signify noses. The puppets depicting the Nazis have the same clay faces but with different signification. On the inmates the facial deformations read horror and abuse, on the Nazis the deformations read cruelty and corruption.

The performance proceeds without words and in silence, with some notable exceptions. *Kamp* begins with a rousing song of German nationalism; wheels creak as a train pulls in and out of the camp and as inmates push corpses loaded on carts into ovens for cremation. A scraping sound is heard as an inmate pours Zyklon B into the vents of a gas chamber. The inmates make slurping noises as they drink watery soup ladled from a bucket. One starving prisoner sucks the remaining drops at the bottom

of a serving pail. A puppet orchestra plays the well-known Radetzky March as the inmates return from the factory. And at night, drunken German soldiers sway to a rousing folksong about a beautiful girl.

The puppeteers visibly manipulate the puppets performing violent acts on the inmates. At the beginning of the performance, four inmates are hanged. The puppeteers assemble hundreds of puppets to watch the hanging. An inmate is beaten to death by a guard. Sometimes the acts shown are not directly violent but cruel and impossible. An inmate repeatedly sweeps the dirt ground while a guard looks on. A guard puppet watching over the camp from a guard tower, his rifle ready, enacts the endemic surveillance of the camps. The guard tower is revisited by means of the live-animation film several times during the performance. The omnipresence of guards and cameras is replicated in Hotel Modern's panoptical situating of the spectators above the model of Auschwitz-Birkenau. *Kamp*, like much theatre of the real, is a record of events not experienced by its creators. To portray history as no one witnessed it is not the same as portraying history that did not occur.

Sometimes the puppeteers pick up and relocate large groups of puppets mounted on placards. As night descends on this dystopic *Our Town*, for example, a puppeteer deftly and matter-of-factly moves a placard of puppets from outside to inside a barrack. This puppeteer's instrumentalism in moving the prisoner puppets effectively conveys the stripping away of personal identity that was so much a part of the cruelty of camp existence – of the whole operation that constituted the Holocaust. In his review in *Theatre Journal*, James M. Cherry describes the way the puppeteers' actions create meaning:

> Interactions between puppeteer and figure [puppets] often created meaningful symbolism. In a vignette at the beginning of the piece, four prisoners were hanged at a gallows in the middle of the camp. Slowly, almost tenderly, a puppeteer placed small boxes under the gallows. Then the puppeteer placed the heads of the figures in nooses. Finally, the hand of a puppeteer reached over, in view of the camera and the audience, and pulled each block away one at a time. The hand appeared so large that it seemed almost God-like in scope, a parody of Michelangelo's *The Creation of Man*.
>
> (Cherry 2011:110)

Cherry's review describes how *Kamp* transforms spectators from watchers to witnesses as they see and experience the disjunction between the size of the puppets and the enormity of the cruelty raining down on them.

The giant hands of the puppeteers projected on the screen at the back of the stage, which Cherry likened to a parody of Michelangelo's *Creation of Man*, visually proposed that Nazis acted like gods and that spectators were not only witnesses but also metaphorically like accomplices in bringing the Holocaust into creation. Watching the puppeteers manipulate the puppets, seeing them move the cameras in the environment, and viewing the resulting projected film in real time exposes the labor of creating what we see on the stage. Spectators are positioned as accomplices as well as witnesses because they see what is going on from an omniscient point of view. The attending implicit assertion is that the Germans, the Polish, and the Allies knew that the Holocaust was happening, knew about the rail lines transporting millions to their deaths – knew it all and yet chose not to intervene by protesting or by bombing the train tracks to the camps.[33] Visibly staging the mechanics of how *Kamp* is created *reveals* history's laborers. *Kamp* demands that its spectators see what happened at Auschwitz-Birkenau as a product of the manipulation, planning, and use of enslaved labor of a massive fascist project created by human beings.

The puppeteers' careful movements – so as not to move or crush anything in the model environment – are a deliberate part of the *mise-en-scène*. With their large bodies in relation to the model and the puppets, the puppeteers manipulate the environment in ways that beckon spectators to consider living human beings – the performers we see making theatre and, by extension, ourselves – as history's corrupt and compassionate makers and players.

Kalker explains her personal relation to *Kamp* as a mourning ritual. 'For me performing the show is a way of taking care of the dead. I sometimes regard it as some kind of symbolic funeral because there was no funeral for all those who died there. When we, the performers, put the puppet bodies in the ovens, and we do that with a devoted concentration, and the audience looks at it with compassion for those who died, the show has elements of a respectful burial the victims never had.'[34]

Looming as large as the puppeteers in relation to the miniature environment when I saw *Kamp* at St Anne's Warehouse, Brooklyn, in June 2010 were the spectators in the risers looking down on the action. Observing the mute actions of the puppeteers and the puppets put the spectators in the position of those who *see* what is occurring but cannot (due to theatrical conventions) intervene. This lack of intervention, of course, mirrors what actually happened in the 1940s.

We wanted to perform the events 'live' as we literally wanted our spectators to 'face' the truth. The Nazis wanted to kill all these people

secretly. We wanted to reveal this secret again, in a way other than by film or pictures. We wanted to make the spectators direct eyewitnesses. We know this is hard for the audience. I feel a lot of respect for those who come to see the show, because they made the decision to open their eyes to these crimes that are unbearable to watch. Seeing it happen before your own eyes is deeply disturbing, and it is what the Nazis tried to avoid.

After the war, many people didn't want to listen to survivor stories, so the truth was buried again. We think it is important to open it up, to fight against the secrecy, the shame, and the natural reflex to close one's eyes to horrible things. Not every day, but a few times a year.[35]

The imperative to see is underscored in *Kamp*'s black-and-white live-animation film. The way the performers use the cameras is decisive. The close-ups that focus on individual actions, the searching horizontal pans of the camp, and the meditative long takes all operate with a narrative logic associated with the Holocaust's filmic representations. As with the model, *Kamp*'s film plays the role of citing the 'real,' as it is in the mode of a documentary. The camera frames memory, trauma, and 'truth' – paradoxically bringing these very close to the spectators *and* introducing an unbridgeable distance from what is being shown. Seeing something on film or television typically means that one is looking at something that has already happened, is already in the past, and cannot be undone. *Kamp* sometimes shows sequences of live performance and live-animation film simultaneously. At other times, parts of the performance such as inmates pushing corpses into ovens in the crematoria were only shown on film. The performative assertion of *Kamp*'s simultaneous live- and animated-action film has the frames of then and now not unlike the frames of 9/11 from my window and terrace and on the television. The division between then and now is analogous to a division between them and us. Unlike the way Hotel Modern summoned a perpetual present by showing the live and the recorded live simultaneously, the televised 9/11 attacks seemed to promise a future, albeit one of a hideous 24-hour news cycle, while the real towers burning, falling, and spewing smoke seemed to promise an end to it all.

One section of the live-animation film shows the material remains of the passengers in a slow-moving pan: tiny coats, shoes, jackets, and dresses; a stuffed animal; a menorah; and coins. The long take makes each object stand in for an individual loss, a particular murder, a death without eulogy. The cold eye of the camera scans what surely also looks

like doll paraphernalia even as it stands in for real people. The reflexivity of the camera work asks spectators to recognize themselves both in these puppet remains and in the theatrical actions performed by Hotel Modern's puppeteers. History is not only out there, the camera tells us, it is in us, it is of our making – we are making it even as we watch it, and it is, at least in part, theatre.

Part of this visual logic is related to how the Holocaust was filmed and edited. The liberation of the camps was filmed by Allied American and Russian soldiers who wanted to document their victory over an immoral and depraved enemy. The raw footage of the soldiers was deemed so 'unbelievable' in its unedited form that it needed to be made into a believable narrative. Some of this footage of the liberation of the camps was used in the film *Memories of the Camps*. Noted director Alfred Hitchcock participated in assembling the footage in 1945 (Jacobs 2010: 264). When *Memory of the Camps* was rediscovered in the 1980s, it was initially identified as a missing Hitchcock film, even though Hitchcock was only one of many persons contributing to the final version of the film.[36] Steven Jacobs discusses Hitchcock's films as full of objects charged with symbolic meanings that are created through close-ups, unedited tracking shots, and long takes (268). Hitchcock advised the other editors of *Memory of the Camps* to avoid any elaborate editing of the camp liberation footage, even though (or precisely because) early on people feared that the reality the Allied soldiers found in the camps was too horrific to be believed (269). Long unedited sequences became crucial to Holocaust films, as a way to avoid the accusation of filmic manipulation and to provoke the spectators' imaginations. This technique, Jacobs argues, became the way to visually connote memory in film (269).

Kamp's live-animation puppet film also constructs cultural memory. When a transport train pulls into the camp station and the camera ranges over the newly arrived cardboard cutout passengers, it is as if spectators are being asked to commit what they see to memory. The camera captures the motionless and distinct features of the exhausted transported cardboard people who are still wearing their own coats, hats, furs, pants, caps, scarves, and sweaters as they stand on the platform, some holding babies and the hands of children. This scene, like all the scenes in *Kamp,* is an evocation of memory that is not attributed to any specific individual or any particular individuated story. In the world of the performance of *Kamp*, an original does not exist, as the performers did not experience the Holocaust, nor do they use any specific person's story. Their research included visiting Auschwitz and Birkenau,

watching *Holocaust* by Claude Lanzmann, reading works of Primo Levi, and interviewing survivors. *Kamp* is a performance of cultural memory without testimony as we commonly understand it, without verbal testimony repeated verbatim. Like *The Investigation* by Peter Weiss, which the members of Hotel Modern say they did not read, *Kamp* makes singular incidents stand in for the experience of multitudes. In this way, *Kamp* constructs memory as if it were already 'ours' – memory in the form of a post-Holocaust collective 'we.' The spectators who have purchased tickets to the theatre become witnesses of unnamed witnesses and inmates of the world of the camps. The spectators become the repositories of history, gazing on an embodiment of memory represented as a condensed series of events performed by puppeteers, puppets, and an extraordinary environmental model made of cardboard. What an astonishing and uncanny situation, this silent performance of real stories without narrative attribution that opens up to untold numbers of stories unfolding in the seeming eternal present of the performance. It is as if spectators were asked to see an image of themselves reflected in the eyes of unnamed and invisible witnesses to history.

Freddie Rokem, though not writing about *Kamp*, explains a way of looking employed by Hotel Modern, where its representations of the Holocaust create a unique theatrical discourse that Rokem , following Tzvetan Todorov, calls the 'fantastic.' Rokem writes that this mode of representation has been used to depict the Holocaust since the 1980s (Rokem 1998:41–3). For Rokem, Todorov's idea of the fantastic is key to understanding how the documentary style can be combined with an anything-that-can-be-known approach.

In these performances the humiliating and painful stories from the past are retold in a documentary, realistic style. But they also contain elements that could be termed 'fantastic' in the sense Todorov gives to this genre or mode of presentation. According to Todorov, 'the very heart of the fantastic' appears when 'in a world which is indeed our world, the one we know, a world without devils, sylphides, or vampires, there occurs an event which cannot be explained by the laws of the same familiar world.'

(43)

Kamp's absence of actual voices forces each spectator to supply their own point of view, to listen to their own inner voices. These inner

voices – for the vast majority of spectators who did not personally experience Auschwitz-Birkenau – are constructed from collective memory. The construction of the memory of the spectators – memories formed through literature, photographs, film, and performance – is the performative core of *Kamp*. By presenting a collective experience to a collective public, the members of Hotel Modern turn spectators' attention to the question not only of what allowed the Holocaust to occur, not only to the admonition of 'never again,' but also to the construction of the circumstances in which things become known, or not, as the case may be.

Collective murder is presented to collective consciousness insofar as that consciousness can be assembled in a theatre. Hotel Modern's performers display the ways in which the group is trying to comprehend the Holocaust theatrically. 'We wanted to confront ourselves with what happened. In this action we take the audience with us. We had the feeling that this event which is both present and gone is a cocoon of time so we surrounded the space in white cloth,' says Kalker.[37]

Seeing, knowing, and acknowledging were forbidden by the Nazis in the world of the camps in ways that made the Holocaust seem, *to those caught in its horrific grasp as it was occurring*, to be an event without witnesses. Until the liberation, it was as if those in the camps were invisible to the outside world. From the world inside the camps, this lack of response affirmed and accentuated the Nazis' practice of dehumanization.

Kamp asks spectators to position themselves as witnesses to an event in the present that is a reconstruction of an event – a series of events, actually, remembered as a single event – in the past. This is achieved by the simultaneous staging of the virtual and the real, the transparency of the model as a model, the performers' visible manipulation of the puppets and all the actions that occur on the stage, the haunting nonverbal soundscape, and the physical relationship of the spectators and performers to the theatrical environment. *Kamp* positions spectators as the ones who must openly see, know, and acknowledge what is happening – and, through this, what happened – a conflation of present and past. In this ritualized environmental reenactment of social memory complex substitutions occur. The environment stands in for Auschwitz-Birkenau, the anonymous puppets for individual inmates, the puppeteers for the agents of history, and the spectators for those who knew what was going on yet did not intervene.

4
Apart from the Document: Representation of Jews and Jewishness

We are there; history is present – but not quite.

Ernst Van Alphen

Just as World War I compelled Piscator to create theatre about the disturbing reality of mass mechanized warfare, World War II provoked theatre artists to confront the challenge of representing the death industry of the Holocaust. Making the Holocaust the subject of art has raised challenging questions about the nature of ethical and aesthetic representations of history, especially in relation to the agreed-upon moral imperative to keep the memory of the Holocaust alive. The Holocaust is a recurring subject in theatre of the real, a subject that has become entwined with the formation of the state of Israel and Jewish people's relation to it. The field of Holocaust studies has contributed to our understanding of the implications of the ways in which narrative, representation, and testimony reenact historical events. The varieties of representation of Jews and Jewishness by both Jews and gentiles show not only a wide range of theatrical activity and style characteristic of the practice of theatre of the real, but also the stability and instability of the ways in which subject matter can be constituted.

Peter Weiss was among the first writers to deal with events of the Holocaust in dramatic form. Weiss notoriously encountered the difficulty of representing the Holocaust with his play *The Investigation*, arguably the most important documentary play of the twentieth century. Written as a dramatic portrayal of the Frankfurt Auschwitz trial that lasted from the end of 1963 through the summer of 1965, *The Investigation* comprises extracted and edited portions of the trial's testimony. Weiss attended portions of the trial, which were published verbatim in German newspapers. *The Investigation* was first staged as

a reading on 19 October 1965 on over a dozen stages in both East and West Germany. These simultaneous readings were staged to help prevent the Statute of Limitations on War Crimes in Germany from expiring that year. Weiss's play used the testimony of witnesses both for the prosecution and for the defense, the victims and the perpetrators, placing a special emphasis on the economy, efficiency, and magnitude of the Holocaust through the repeated use of numbers. In his preface to the play, Weiss lays down rules for production and performance. 'In the presentation of this play, no attempt should be made to reconstruct the courtroom before which the proceedings of the camp trial took place' (Weiss 1966).Weiss did not use the name of the camp where the atrocities on trial occurred, nor did he directly mention Jews or Jewish people, gypsies, homosexuals, specific political affiliations, religion, or race. The nine Witnesses in the play are designated only as numbered Witnesses. Only the murdered inmate Lili Tofler is named in the context of Witness testimony about the excessive mental cruelty that provoked her to beg to be shot. In the world of the play, Tofler stands for ethical disobedience, as she refused to reveal the name of the person to whom she sent a letter, at the cost of her own life. Within the world of the play, only one of the Accused, SS Corporal Stark, gives testimony about the nature and degree of discrimination against Jewish people, without naming them.

> Every third word we heard
> even back in grammar school
> was about
> how they
> were to blame for everything
> and how they
> ought to be weeded out
> It was hammered into us
> that this was for the good
> of our people.
>
> (Weiss 1966:180)

In his author's note, Weiss describes the Witnesses as 'mere speaking tubes,' as they stand in for what hundreds at the trial expressed (180). Only the Accused bear names, but not for the reason one might think.

Each of the 18 accused, on the other hand, represents a single and distinct figure. They bear names taken from the record of the actual

trial. The fact that they bear their own names is significant, since they also did so during the time of the events under consideration, while the prisoners had lost their names.

Yet the bearers of these names should not be accused once again in this drama.

To the author, they have lent their names which, with the drama, exist as symbols of a system that implicated in its guilt many others who never appeared in court.

(5)

The play is structured in 11 cantos with three sections each, all of which are without punctuation. *The Investigation* proceeds by numbers: numbers about everything, including measurements of cattle cars, space, food, time, people, cells, barracks, death records, and the increased efficiency in killing greater and greater numbers of people at a given time – and, of course, the people in camps, who are reduced to numbers. Critics attacked the play for using the bureaucratic language of the Nazis, for offering a catalogue of atrocity, and for being insensitive, 'artless, mechanical, and anti-theatrical' (Cohen 1998:2). Robert Cohen powerfully describes this criticism as founded, in part, on the culture of the emerging field of Holocaust studies and on a lack of understanding of the aesthetics of the German theatre culture of which Weiss was a part. Citing Lawrence Langer's *The Holocaust in the Literary Imagination* as a foundational text in the field of Holocaust studies, Cohen describes how a group of critics following Langer's lead rejected *The Investigation*.[1] The play, they asserted, is not even about the Jews, as they are neither named nor mentioned. The name of the concentration camp where the atrocities were committed is not even given. The names of the Witnesses are not given, thus enacting a double disappearance (see Cohen 1998).

To account for Langer's change of mind about *The Investigation*, and in the play's defense, Cohen asserts that *The Investigation* challenges the idea that literature – and, by extension, other mediums and styles of art – operate in a sphere different from that of other institutions of society. For Cohen, *The Investigation* 'blurs the boundaries between reality and its representation, between documents and their interpretation, between authentic persons and stage characters' (1998:3). Yet the specific devices Weiss used were understood by his critics as indications of Weiss's failure to use conventional mimetic representation in the form of fully rounded individual characters, naturalistic dialogue, an established dramatic structure, and a story line that culminates in a

conclusion or resolution with cathartic closure (Cohen 1998:3). At the end of *The Investigation*, there is no verdict. We do not learn the court's decision regarding the 18 Accused. In other words, as Cohen points out, Weiss's epic structure and his advice not to try to represent the Holocaust through set design or acting, as well as his radical condensation of years of trial records, were rejected by critics operating under the assumption that for the Holocaust to be accurately and truthfully represented, there needed to be 'personal guilt, fate, punishment and redemption, and resolution' (3).

In his essay 'Improvising the Document,' Alex Ferguson writes that it is not possible to transfer something from one time and place to another without radically altering it (2010:35). In documentary plays 'the "facts," such as they are, cannot be meaningfully separated from improvisatory acts, such as interviewing, remembering, transcribing, or translating – not to mention rehearsing and performing' (36). Ferguson characterizes documents with their assumed nonfictional stability as strange bedfellows with the improvisation necessary to stage them. Documentary theatre's allegiance to verbatim quotation must coexist with the improvisation of staging a play but also, Ferguson argues, with the process of memory and the contingencies of interviewing. In explaining how theatre treats documents, Ferguson points out that 'what ends up on stage is something different: an interpretation, a transmogrification, a creative act, and another truth – perhaps an unstable truth' (35). At every point in creating documentary or verbatim theatre, meaning is inevitably altered in the act of transfer from document to stage in ways that change the assumed stability of the document, memory, or word and the truth they contain. Although Ferguson is writing about documentary theatre, his observations hold equally for the larger domain of theatre of the real. Some theatre of the real makes assertions: that events are presented as they really happened; real sources are used; and nothing included is knowingly untrue. Truth – both factual and ethical, in the grand-human-scheme-of-things sense and in the sense of accuracy and legitimacy of particular cases – is the subject of these assertions. At the same time, the process of improvisation needed to write a documentary play and rehearse it for the stage is historically and culturally situated in specific approaches to making art and its reception.[2] The encounters that take place between the aesthetic conventions the writers, directors, and actors employ and/or reject form an understanding of the subject matter at hand. Add to this the historical, cultural, and political preoccupations of the moment, and the problems and possibilities of staging the real begin to appear.

Representations of Jewish people and Jewishness in theatre of the real have created a body of literature connected with historically situated performance practices that can both enhance and distort our knowledge of Jewish people and their experience.[3] Performance texts and theatrical practices are situated in styles that have their own aesthetic and historical significations. Viewing representation as its own form of reality – determined by convention, style, history, and technology – reminds us that both history and theatre are created and conceived by individuals like Weiss, acting in accordance with their own dramatic, theatrical, and performative objectives; narrative structures; and historiographic intentions. These objectives, structures, and intentions are created in the present through an iterative process that depends upon previous representations, whether imitated or rejected.

The Bible and the Holocaust feature repeatedly as Jewish identity markers in representations of Jews and Jewishness in theatre of the real in the late twentieth and early twenty-first centuries. History and memory are the building blocks of this theatre, even as history can systematically repress memory by asserting an authoritative account that consumes the oral culture of individuals and the collective memory of groups of people. By examining five works that use interviews as primary documents to portray Jewish identity, we can see similarities and differences in the representational strategies of Jews and Jewishness over a 33-year period, especially in relation to the Bible and the Holocaust. These works are linked by their subject matter, even though the original productions had very different stylistic concerns, stemming from diverse theatre practices with different kinds of aesthetic assumptions. *Annulla (An Autobiography)* (1977) by Emily Mann, *The Survivor and the Translator: A Solo Theatre Work about Not Having Experienced the Holocaust, by a Daughter of Concentration Camp Survivors* (1980) by Leeny Sack, *Fires in the Mirror* (1993) by Anna Deavere Smith, *Via Dolorosa* (1998) by David Hare, and *The Human Scale* (2010) by Lawrence Wright were all created from interviews with Jewish subjects and performed by a solo performer. The works premiered at venues including regional theatre, off-off-Broadway, off-Broadway, and Broadway. Given their shared subject matter, and despite their different literary and theatrical styles, these works all attempt to disassemble coded language and representation that has been used to enact racism, hate, and annihilation. As Elie Wiesel famously writes about language in *Night*:

I had many things to say. I did not have the words to say them. Painfully aware of my limitations, I watched helplessly as language

became an obstacle. It became clear that it would be necessary to invent a new language. But how was one to rehabilitate and transform words betrayed and perverted by the enemy? Hunger – thirst – fear – transport – selection – fire – chimney: these words all have intrinsic meaning, but in those times, they meant something else.

(Wiesel 1958:ix)

Wiesel's effort to show how the Nazis invented a universe apart from the one in which most people live their normal daily waking lives is a struggle to reveal and dismantle Nazi codes, in order to 'rehabilitate and transform' words and everything else perverted by the Nazis. The works discussed here also engage in the same project, but with different assumptions about, and approaches to, the iteration of the original events to which they refer.

The Survivor and the Translator

Sack's autobiographical one-woman show *The Survivor and the Translator*, directed by Steve Borst and first performed at the off-off-Broadway venue The Performing Garage, stages an attempt to recover language and experience through acts of translation. Sack's improvisatory rehearsal process began by sitting alone and naked, without words, under a rough blanket in an empty loft space.[4] Not finding any way out of this fear-provoking place of silent darkness made Sack bring a manual typewriter into the space to record her thoughts and feelings. The typewriter provided a means of translation from the naked experience of being alone with memory to the transcription of that memory into a record of experience that Sack could use to detail and intervene in the frightening history and family drama she had to face. From body to typewriter, from physical experience to words, from memories in Polish and in English came the idea of translation. Relying heavily on interviews Sack conducted with her maternal grandmother, Rachela Rachman, Sack's performance is part of the tradition of recovering, remembering, and recounting Holocaust narratives. Her performance also depended upon valuing personal narrative to construct character in the rehearsal and on familial testimony as a form of evidence.

The techniques Sack used to create *The Survivor and the Translator* as an act of translation came from Sack's training with The Performance Group. The Performance Group, like other group theatres formed during this period, encouraged actors to be themselves onstage and to use their own stories to make theatre, while acknowledging that these stage personas

were performed selves constructed and displayed for the theatre. What Sack presumed to be the performer's 'self' was the basis for both the character and the work as a whole. Performed in both Polish and English, Sack also used the language of a style of American theatre that developed when personal experience became an important part of the public forum.

The Survivor and the Translator makes one woman's familial experience its frame. The play begins with the call to Jewish women to light the Sabbath candles. The instructions for lighting the candles that Sack recites in the performance were handed to her on the street by a Lubavitcher Chasid. Although part of her heritage, the instructions came to her as 'found text' which she then combined with other contradictory texts. The instructions to light the Sabbath candles are interrupted by a German text from Nietzsche, a text from *The Last of the Just* by Andre Schwarz-Bart, and by Sack's own insertion of the names of ghettos and camps.

> First, light the candle. Then cover your eyes with your hands
> To hide the flame. At this point you recite the blessing:
> **WAS MICH NICHT UMBRINGT MACHT MICH
> STARKER.**
> That which does not kill me makes me stronger. And praised
> **Radom** be **Warszawa** the lord **Majdanek** and praised
> **Auschwitz** be **Buchenwald** the lord **Flossenberg** and
> praised **Dachau** be.
>
> (Sack 1990:125)[5]

Designed to usher in the peace of Shabbat, traditionally likened to a bride, the blessing separates sacred from mundane time. By breaking the Shabbat blessing and its metaphor of heavenly marriage with the names of concentration camps, Sack reveals a dark gap between religious experience and identity, and historical reality (Illustration 4.1). The lord in this prayer is not the magisterial Lord of the universe in Jewish prayer, but the lord of annihilation in the concentration camp universe of Majdanek. In the face of the Holocaust, Jewish beliefs and practice are irrelevant and impotent. The concentration camp universe perverted biblical law and its ritual practice. The light of the Sabbath candles becomes the fire of the chimney. The hope of renewal contained in the Shabbat blessing is destroyed.

In performance, Sack uses the words of the blessing to draw her into the Polish language of the Survivor (her grandmother's words coupled with her mother's accent) and to establish the different voice of the

Illustration 4.1 Leeny Sack holding a Shabbat candle in *The Survivor and the Translator* by Leeny Sack, directed by Steven Borst. Photograph by Stephen Siegel

Translator. The Translator is the fragmented and wounded-daughter portion of Sack's persona, which she created to carry out the performative task mandated by her family to 'tell the world' what happened. Sack's role is as a private familial translator and a cultural translator. She stands in the middle of her family's accounts of what happened, her own memories of what her family told her, her interviews of her grandmother, and the audiences to whom she needs to convey what it means to inherit the Holocaust. Shaped by the tension of an experience that cannot be assimilated and words that defy translation, *The Survivor and the Translator* is Sack's attempt to run through the inherited landscape of memory of her family's experience in the Holocaust. Fragments of memories are the only things that can be found.

By using a doubling of voices and identities, a confusion of narratives, and a conflation of memories, Sack entwines her identity with her grandmother's. However, she is careful to separate herself from her

grandmother by refusing to use seamless consecutive translation. This lapse in words and the delivery of their meaning replicates the struggle Sack went through to understand and embody a memory that was not hers. Memory, the performance asserts, cannot coherently be portrayed by words or their translation. With the Holocaust, the landscape of personal memory is too dark and lapses of memory too important for survival. Sack's performative task is to get the parts of the story that can be told, to 'incorporate' her grandmother's memory in her own psyche, including lapses of knowing and understanding. As Sack runs on the bed that is the main set piece of *The Survivor and the Translator*, as a symbol of both her family's journey to the camps and her own journey through her family history, we come to know how history can escape us. Growing up in the traumatized environment of barren yet immutable history, Sack feels she must also have been in Auschwitz. At one moment she asks a psychic, 'Was I there? In the War? A child, killed in the camps?' The psychic responds, 'No, I'm not getting anything on that' (Sack 1990:134). The blurring of experience that Sack articulates when she imagines she must have been in the Holocaust shows how her troubled demarcation of self is projected onto her environment.

Juxtaposing religious and cultural Judaism with the secular world of a psychic who sells a means to know the past makes both worlds seem to have gone mad. The advice of the psychic seems to provoke Sack when she pokes her head through the frame of the empty rocking chair to pose her question. What is important in this exchange with the psychic is Sack's search through her memory of her grandmother's memory, in her quest to find out about the Holocaust.

Through the layering of experience, Sack constructs the Holocaust as an irrefutable event contained in many sources in many different ways. 'Her approach to characterization is markedly different from Weiss's. Weiss's Witnesses are anonymous, presented as 'mere speaking tubes' for what hundreds expressed (Weiss 1966:5). The stage of *The Investigation* is the stage of history, even as its performative time is the here and now. *The Survivor and the Translator*, in contrast, is built from the stories of named members of Sack's family. It is a performance about one person's lone relationship to growing up with the traumatic memory of an event she did not experience. As she runs on the upstage steel-frame bed with black and white sheets, suitcase in her hand, Sack looks back in distress (Illustration 4.2). Her running makes the clanking sounds of a train as she urgently pounds her feet on the rickety frame. The metaphorical train moves through a landscape visible only to Sack. When the forbidding clatter of the train stops at its concentration camp

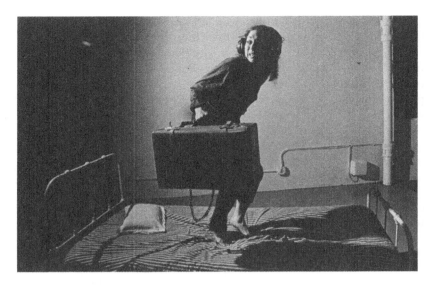

Illustration 4.2 Leeny Sack running on a bed that makes the clanking sound of a train in *The Survivor and the Translator* by Leeny Sack, directed by Steven Borst. Photograph by Stephen Siegel

destination, we meet the world 'betrayed and perverted' by the enemy. The preparation of fish for a Polish wedding becomes a murder, a Polish joke becomes a death sentence, and love for a boy becomes an unrequited desire for life unable to be lived.

Celebration, humor, and love are each given the death sentence of fear, racism, and loss of desire. Sack's physical actions stage the universe her text invokes and describes. Before the bed is transformed into a train, Sack uses it as a sign of home. While on the bed, she pulls a rope tied from the frame of the bed to the frame of an empty downstage rocking chair to make it rock as if occupied. When Sack crosses to the rocker, she slaps it and addresses her psychically present but physically absent grandmother. Toward the end of *The Survivor and the Translator*, we are returned both to the biblical universe invoked at the beginning of the piece and again to Sack's grandmother. Sack dons a wedding dress as if she were the Sabbath bride. But in her bridal dress, she ushers in, not the peace of Shabbat, but, finally, her grandmother's unbroken testimony – a testimony to which Sack is personally wedded.

Unlike Hotel Modern's *Kamp*, where memory is staged with architectural reconstruction and the silent action of the puppet perpetrators and

their victims, in *The Survivor and the Translator* memory is staged only from Sack's vantage point. *Kamp* stages the Holocaust as a world where there were no witnesses, while *The Survivor and the Translator* is a work about a familial lineage of witnessing and trauma. *The Survivor and the Translator* takes place in no place other than the stage. Even though there is a bed, a small table with a candle, and a rocking chair, these are not represented as the artifacts of a home but as the props of theatre. As with *The Investigation*, *The Survivor and the Translator* is staged to connote the arc of history and is meant to take place both in the theatre and on the stage of the spectators' minds. The home where Sack grew up is not alluded to. The home that housed the memories performed is not present. Geographical location remains ambiguous. There are only stages – the stage of history, and the stage of one's mind.

 The Survivor and the Translator is built around both the possibility and impossibility of translation: translation from one language to another, from one generation to another, from experience to prose, and from the imagination to the stage. Sack's story is personal to Sack's family, but also to millions of other families. Memory and formal memorials of the Holocaust are both intensely private and profoundly communal. Sack's nightmarish reverie of her grandmother's memory is part of her struggle to comprehend her place in the Holocaust. The memory of the experience is not Sack's, even as the history is. *The Survivor and the Translator* is about our relationship with history as much as it is about Sack's experience of her grandmother's experience of the Holocaust.

> From burning people.
> Please I ask you
> Can someone still believe in something?
> Can someone believe me about this?
> So who was
> Left
> For life.
> These are things that are never spoken
> Because no one can understand it
> And no one can help.
> About this
> Don't think.
> Don't speak.
> Nothing can help.

> (Sack 1990:151)

Sack's grandmother both refuses and embraces the act of witnessing her granddaughter is trying to accomplish, stating that the experience is beyond comprehension and remedy in an attempt to deny that memory and history are part of the same bundle of knowledge. Even as she would like to protect her granddaughter from her own experience, Sack's grandmother yields to her by telling her broken story. And Sack allows the story to remain broken until the very end of the piece. The narrative she tells is without chronological order. There is no transformational exchange between Sack and her grandmother or even Sack and the audience. The story told does not redeem subjectivity for either Sack or her grandmother. Sack is the embodiment of testimony, the source of historical information in service of meeting the moral responsibility to tell her family's story, to keep it alive.

Annulla (An Autobiography)

Like Sack, Emily Mann stages her own voice as an autobiographical interrogator of others' stories. Mann also refuses the repression of proper narrative order and structure in showing how difficult it is to get coherent memories that result in an entire story. In *Annulla (An Autobiography)* Mann's search for self-discovery begins with a journey poised at the beginning of her adult life: 'In 1974, the summer I left college, I went to England' (Mann 1997a:7).[6] *Annulla, An Autobiography* contrasts the lives of two people: Annulla, an eccentric Holocaust survivor who moved from country to country, learning seven languages, as she avoided the Nazis; and Mann, the author looking for her roots in the aftermath of the Holocaust. Annulla's account of Europe before the war, of Nazism, and of what life had become, is periodically interrupted by the offstage character designated as the Voice, a stand-in for Mann, who is also looking back at her life. The play proceeds through juxtaposing the Voice's personal and familial autobiography with Annulla's. As the Voice remembers her meeting with Annulla, she also recalls the ways in which her own life and family are marked by antisemitic atrocity. The Voice explains that she had to seek out someone else's relative, the aunt of her college roommate, to understand her own history, because her own grandmother had 'lost her language' (10). This loss, we learn at the outset of the play, occurred as a result of moving to America, leaving her grandmother without a mother tongue. The Polish of her youth was completely lost, as was the ability to express complex ideas, and she was left with half Yiddish and half English (7). The Voice's substitution of Annulla for her grandmother enables the Voice to situate herself within history.

Throughout *Annulla (An Autobiography)* Mann alludes to the ambiguous status of memory as testimony. Annulla tries to tell a coherent story and to finish her play in the face of a crisis of history and memory, in order to construct an identity in relation to that story. Mann's grandmother's loss of language replicates the disappearance of the place that was her home. It also creates a looming silence in contrast to Annulla's refusal to let stillness invade her prose or presence. In Ostroleka, where Mann's grandmother grew up, nothing was left. No graves, no synagogue, no family records, leaving the Voice with little family history to recover (1997a:26). The loss of both language and place is in opposition to Annulla's verbose stream-of-consciousness prose. Yet, for both Annulla and Mann's grandmother, the story is not easy to tell. Their stories fall apart due to loss of language and the loss of ability to control, shape, and edit one's narrative in a manner that is conventionally chronological, like the pages of a play.

> If there was a global matriarchy, you know, there would be no more of this evil. I have all the answers in my play! I wanted to read you some of my play. The pages are not numbered. Just before you came I dropped it... It's all out of order. It's too much of a mess now, maybe later I will read parts of it. (*Stands at table and looks at her script.*)
>
> (Mann 1997a:10)

Annulla is an unreliable narrator whose disorganized thoughts are portrayed by the metaphor of her eternally unfinished and unpaginated play, which is out of order and out of place on the floor.

As the Voice explains, Annulla, like the Voice's grandmother, also has a problem with language. Her life was lived on a wave of history that frequently moved her from place to place, resulting in the acquisition of seven languages – without any of them entirely being her own.

> In Galicia in her early teens, where her first language was what? Polish? Right. Then German. And then – and then Ukrainian. Then French with her governess, also Ruthenian, she spoke Ruthenian because the peasants who lived in the Carpathian Mountains near her summer home spoke Ruthenian. Then she went to Vienna where she started using German. Then to Germany. From Germany to Italy in her thirties. She learned Italian, and then escaped to England.
>
> (Mann 1997a:15)

As it is for Sack, the failure of language's ability to communicate is also Mann's subject as she attempts to write about a personal and historical

event that cannot be told in any form that resembles the conventions of familiar narratives. Attilio Favorini writes about Mann's approach to history and memory in *Annulla* as being intuitive rather than an explicit dramatization of their connection (2009:155).Mann's juxtaposition of monologues positions one who remembers from experience against one who cannot collect enough experience to remember. Favorini points out that Annulla seems to finish the Voice's sentences and echo her thoughts. 'In this assertion, we can discern both the void of witnessing that haunts the Holocaust and the seed of Mann's career-long determination to elicit testimony of trauma' (156).

In the off-Broadway production I saw in the late spring of 2006 at St Luke's Theatre in New York City, the associational and intuitive style of Mann's text was staged realistically in terms of acting, costume, and lighting and set design. The kitchen where the entire play takes place had a working stove. Both the role of Annulla and that of the Voice were played by actors, separating the autobiographical play from autobiographical performance. The earliest version of the play, originally titled *Annulla Allen: Autobiography of a Survivor (A Monologue)* premiered at the Guthrie Theatre in 1977 in a production directed by Mann. The Repertory Theatre of St Louis followed in 1985, with a production directed by Timothy Near. This was followed by a production in 1988 at the New Theater of Brooklyn that opened on the fiftieth anniversary of Kristallnacht. That all of these theatres are either off-Broadway or regional theatres is no accident. *Annulla* was staged in the style of American realism that has been typical of the majority of productions presented in these venues (Illustration 4.3).

Annulla speaks in a stream-of-consciousness, associating one thought with the next while talking to an unseen guest, assumed to be Mann, in her kitchen as she prepares chicken soup. In her Playwright's Note that prefaces the play, Mann states that the play consists of Annulla's 'own words told to me during the summer of 1974 in London, and my own words told to Timothy Near [who directed Annulla in 1985] over a decade later' (Mann 1997b:unpaginated). The Voice explains that her sense of responsibility to history came from her parents and from being Jewish. She knows the identity of every face, even of those she never met, in her family photographs (Mann 1997a:25). It is in this context that we learn about the letter. The Voice recounts:

The Nazis [...] came into Ostroleka and they said they wouldn't harm people if they would point out the Jews. So the neighbors who'd lived side by side with them forever and ever, harmoniously,

Illustration 4.3 Jacqueline Bertrand as Annulla with the manuscript of her unpaginated play on her lap in *Annulla* by Emily Mann and directed by Timothy Near. Photograph courtesy of The Repertory Theatre of St Louis

saved their own lives, I guess, and pointed everyone out. They were all herded into the town square. My great-grandfather unfortunately was a much-loved elder of the community, so he was... you know... taken by the beard and made to eat grass before they killed him and then the entire community was shot. And my mother remembers when my grandmother got the letter in America – telling her.

(25)

The letter is the only material document of the Voice's family that provides evidence of the Holocaust. As a document, the letter defies the loss of language and place as it puts into prose what happened to the whole community of Ostroleka. The disappearance of so much and so many haunts both Annulla and the Voice as they attempt to assemble their plays out of information that is everywhere and nowhere. As with *The Survivor and the Translator*, the Holocaust looms in *Annulla* as an event that defies language but defines a people. Defiance and definition

create a world in which lived experience becomes testimony about a world that no longer exists except in the collective memories of Jewish people.

The recurring symbolic order of *The Survivor and the Translator* and *Annulla* is one of presence and disappearance, history and annihilation. Both works confront the loss of language due both to trauma and to experience on the edge of normal human imagination. Like Wiesel in *Night,* in which he writes of the experience that redefined his past and created his future, both Sack and Mann also consider the Holocaust as the determining experience of the collective past of the Jewish people. Wiesel writes in the preface to the new translation of *Night,* 'Just as the past lingers in the present, all my writings after *Night,* including those that deal with biblical, Talmudic, or Hasidic themes, profoundly bear its stamp, and cannot be understood if one has not read this very first of my works' (2006:vii). Coupling the Holocaust with Judaism is a constituent component of post–World War II Jewish identity, an identity with which both Sack and Mann struggle in their works.

Fires in the Mirror

Other writers have also implicitly or explicitly linked the Holocaust with religious practice as the defining experience of Jewishness. One of the first monologues in *Fires in the Mirror* (1993), written and first performed at The Public Theatre by Anna Deavere Smith and directed by George C. Wolfe, is an 'Anonymous Lubavitcher Woman' describing why she cannot turn off her blaring radio on Shabbas (5). After explaining that dealing with electricity on Shabbas is forbidden, the woman describes leading her toddler to the radio with the hope that he might press the off button. 'We can't make the baby turn it off but if the baby, but if a child under three/ turns something on or turns something off it's not/ considered against the Torah' (7). She continues: 'you can have somebody who's not Jewish do a simple act [that does not follow Jewish law] like/ turning on the light or turning off the light, and I hope I have the law correct, but you can't ask them to do it directly' (7). It is a humorous scene in which the Woman, interviewed and performed by Smith with a stereotypical Brooklyn accent, is depicted as following Jewish law despite not being entirely sure of its logic. Following the observance of a law that appears to be ridiculous – not being able to turn off the radio because G-d somehow decrees it – is the play's first introduction to Jewish people. Even a secular Jewish person might very well laugh at this scene, which is also charming in many ways.

Fires in the Mirror is about the 1991 clash between Jews and blacks in Crown Heights after a black child, Gavin Cato, was hit and killed by the Rebbe's motorcade and a young Jewish scholar, Yankel Rosenbaum, was killed in retaliation. The Jews Smith portrays wear signs of 'being Jewish,' such as tallitot (prayer shawls), wigs, beards, and kippot (yarmulkes). They talk about adhering to what seems to non-Jews to be arcane laws – an attribute that is extended to all the Jewish people in the play. Rabbi Shea Hecht explains that he told his black neighbors the reasons he cannot have dinner with them. 'We can't use your ovens, we can't use your dishes, it's, it – it's not just a question of buying certain food, it's buying the food, preparing it in a certain way' (Smith 1993:110–11). By inference, Jewishness is enigmatic to outsiders and binding to Jews in ways that invoke prohibition from and admittance to tribal membership. No mention is made of the fact that observant Jews would also not eat in the homes of Jews whom they deem less observant. Smith marks the Jews of Crown Heights as 'other' even as she and her humorous portrayals enact real difference.

Like that of Sack, Smith's performance style can be traced back to the radical theatres of the 1960s, which gave rise to the solo work that emerged in the 1970s and was elaborated in the 1980s. Also foundational to Smith's work are the black theatre practices linked to the civil rights movement, which was highly theatrical in its own right. The Black Arts movement created new dramatic forms that staged the complexity of black identity from the perspective of black people. Some blacks felt comfortable being aligned with the many Jewish Americans fighting shoulder-to-shoulder for the civil rights of blacks, while others did not. What was the basis for Jewish people, who for all intents and purposes appeared to be privileged middle-class persons, to identify with oppressed black Americans? Was it because the Jewish annual Passover Seder celebration recounts the story of the Jewish people's enslavement and liberation, the Exodus from Egypt, and that the Old Testament story demands an end to slavery? Or did it have to do with the Talmudic passage in Pesachim 166b that states, 'In every generation one is obliged to regard himself as if he personally had come out from Egypt' (13)?

In *Fires in the Mirror* Smith performs Jews ranging from Aaron M. Bernstein and Rabbis Joseph Speilman and Sheah Hecht to Norman Rosenbaum and Rivkah Siegal, many of whom are portrayed in ways that underscore Jewish learning. Bernstein talks about mirrors as metaphors for seeing in literature (1993:13). When Letty Cottin Pogrebin is interviewed by Smith on the phone, Pogrebin elects to read a

devastating story from her book, *Deborah, Golda and Me*, about her mother's blond and blue-eyed cousin Isaac who, as the 'designated survivor' of his town, pushed his own family into the ovens at Auschwitz to validate his Aryan cover-up. Isaac fulfills his assignment to live to tell the story of what happened to his people. He tells as many as he can, and then dies. Isaac, like Annulla, who claims she escaped the Nazis because she was 'very beautiful,' is able to pass because he does not match the Jewish stereotype.[7]

Via Dolorosa

David Hare also obliquely refers to the question of 'what do Jews look like?' at the beginning of his monologue *Via Dolorosa* (Hare 1998). Like Smith, Hare begins with a humorous anecdote about Jews, specifically 'Jews who have turned their whole lives into an act of political defiance by establishing Jewish townships on hitherto Arab land' (5). Hare is, of course, referring to the Israeli settlers who establish settlements on contested land where they live according to rather strict interpretations of Jewish law. Hare's problem with what Jews look like is best expressed by the fact that Hare cannot imagine British actors playing Israelis, or Palestinians, for that matter. Without actors to play the parts, Hare concludes that the show must be a monologue.

> I could never write so-called 'scenes' which would one day be played by British actors on a British stage. British-Jewish actors – who in no way resemble Israelis – would seem ridiculous if they tried to enact little dramas opposite, say, a couple of Arabs and the odd light-skinned Pakistani – the only people in London available to play Palestinians. It seemed impossible that it would achieve anything you could call 'authentic.' Or 'real.'
>
> (Bar-Yosef 2007:262)

As Eitan Bar-Yosef points out, Hare's claim of stage-worthy representational impossibility exists despite Hare's history of representational reach in plays such as *Fanshen,* which was played by the entirely non-Asian Joint Stock Company (262).

Via Dolorosa became a solo performance vehicle for Hare that allowed him to publicly pontificate about his experience in a way that is half performed lecture and half theatre. Stephen Daldry, the director of *Via Dolorosa,* was able to get Hare to perform gestures; vary his levels, beats, vocal volume, and inflection; and adopt an isn't-it-so blue-eyed gaze at

the audience. Hare performed *Via Dolorosa* both at the Royal Court in Britain in 1998 and then on Broadway at the Booth Theatre in March 1999 to positive mainstream critical reception.

In his book *Acting Up*, about rehearsing and performing *Via Dolorosa*, Hare writes that the buildup of the work should be as follows: 'Bloke announces he can't act. Bloke tries a bit of acting but basically just talks. Bloke begins to act more and more when impersonating other people but remains himself. Bloke starts to act brilliantly' (1999:25). Like Smith, Hare presents many characters. Smith, however, gives us many characters performed by impersonating many voices. Hare gives us only his British voice even as he couches that voice in the views of others. In the video of the Broadway production, Hare appears more confident than brilliant. He does succeed at being evenhandedly unkind with a loving tone of parody. His performance is more admirable and highly respectable than it is a praiseworthy accomplishment. It is Hare's celebrity and great gift for writing that tips the scale in his favor, even as his performed presence seems, at times, contrite. The contrition, however, is met more than equally with a rush of words that are humorous, ironic, and serious, and always more about the surface than about summoning the complexity of the convictions, history, and suffering of those he observes. Unlike Sack and Mann, Hare leaves little room for caesura, for the pauses where we struggle to make sense of things and, perhaps, to consider the ways in which meaning may not be entirely within reach.

In *Acting Up*, Hare is acutely aware of offending with opinions that he wants to be careful to perform as not his own. After an early run-through Hare writes:

> I made one disastrous mistake. I said that I *realized* that the Jews did not belong in that part of the world, rather than saying that it *momentarily occurred* to me. The result, as I pointed out afterwards, would have been to change, and ruin, the meaning of the whole play. It would have turned me into an anti-Zionist. Stephen sweetly said, 'Well, you won't make the same mistake again.'
>
> (1999:11)

The performance begins with Hare walking across a bridge from the dark netherworld of backstage to the lit and constructed stage space, a walk that is a symbolic stand-in for his journey from England to the other-worldly Israel (Illustration 4.4). He is attracted to extreme situations, he tells us, because his homeland, like backstage, is so

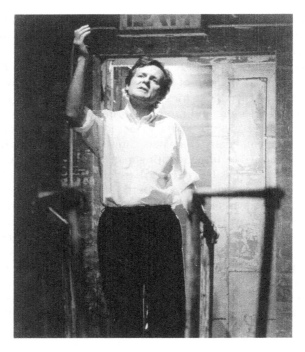

Illustration 4.4 David Hare on the bridgeway in *Via Dolorosa* by David Hare, directed by Stephen Daldry. Photograph courtesy of David Hare

dark and dreary and without action. The antidote is Israel, with its Mediterranean heat, and performing, with its high risk of personal public failure. Both are things Hare wants to try, he tells us at the beginning of the play, because 'I just want to see what it's like' (Hare 1998:3). For Hare, theatre is a 'habit of mind' devoted to 'putting words into other people's mouths,' with elaborate conventions in which 'people are played by other people whose profession it is to pretend to be other people' (3). Hare's declaration is an attempt to explain his decision to perform *Via Dolorosa* himself after his 1997 trip to Israel. The aim of his monologue travel diary is to tell the story 'about the wrenching effects on a person apparently without faith of meeting a whole lot of people who have only faith' (Hare 1999:7). For Hare, Israel defies playwriting. 'Asked to go to Israel, I think "And what? Go to Israel and write a play?"' (1998:3). As demonstrated in a video made of the Broadway production, Hare is a convincing lecturer

who seems, through contagious contact with Israelis and Palestinians, to have acquired a passion of his own.

> People always say that in England we lead shallow lives. Our lives must be shallow because we live in a country where nobody believes anything any more. My whole life, I've been told, 'Western civilization? An old bitch done in the teeth.' And so people say go to Israel, because in Israel at least people are fighting. In Israel, they are fighting for something they believe in.
>
> (1999:4).

And so Hare's account of Israel focuses on what is extreme, almost to the extent of being a parody; Hare portrays Israel as the antithesis of his own peaceful, polite, and boring British people and homeland.

> The fight. The struggle. The historic destiny. The return of the people. The cause: life therefore having a meaning and shape that eludes the rest of us in the endless wash of 'What the hell are we doing here?' In a single day, says an Israeli friend, he experiences events and emotions that would keep a Swede going for a year.
>
> (4)

The mad settlers, the emotional and overly intense and passionate Jews, and the persecuted people are met at the outset of *Via Dolorosa*. And, as one might expect, so are both the Holocaust and the Bible (Hare 1999:4–5). 'After the matchless catastrophe of the Holocaust rushed in the perfectly reasonable belief that they would never be safe until they had a country of their own' (4). Hare wonders, 'Is this a Biblical mission? Or is it a secular state?' (5). As can be expected, questioning the existence of a homeland for both Jews and Palestinians soon follows. Hare is slumming as he stays in a 'nasty hotel' in Tel Aviv and walks its 'litter-strewn streets.' His own epiphany occurs when he goes into the countryside, his own version of wandering in the desert, where suddenly he has the heretical thought that 'the Jews do not belong here' – the thought that Hare wants to make sure is not overly emphasized (12). Merely a passing thought.

Bar-Yosef eloquently writes about the ways in which *Via Dolorosa* presents performance as travel, as it attempts to replicate the physical, mental, and ideological aspects of Hare's journey. As such, it uses many of the conventions of the time-honored British travelogue. The monologue/travelogue moves from Tel Aviv to Jerusalem to the home of

Danny and Sarah Weiss in the settlement of Tikva for Shabbat. In a tone of disbelief meant to elicit laughter, Hare reports that when Danny finds out Hare is involved in theatre, he asks him if Trevor Nunn is any good (1999:13). Humor gives way to absurdity as Hare refers to the beginning of Shabbat, the separation of secular from sacred time, as 'the deadline' (14). The ironic and hyperbolic tone that Hare establishes from the beginning of the monologue prevents him from inquiring about the practice and trying to understand it. Unlike either an anthropologist or a journalist, Hare is not intent on knowing why the Sabbath is the most sacred day on the Jewish calendar. Similarly, he seems unaware that religious and political disagreements between Jews of all kinds, but especially Israelis, are underscored by the knowledge of sharing the same fate. What Hare refuses to consider is that just as dear old Blighty is a shared idea in which every 'English gent' is obliged to his neighbor, no matter his apparent class, so Israel is an idea that embraces Jewish people no matter their religious observance or place on the political spectrum.

The Bible is a recurring theme in *Via Dolorosa*. The famous Israeli novelist and intellectual David Grossman explains to Hare that the Six Day War provoked religious Jews to read the Bible as a 'contemporary operations manual' that has led not only to living in the land but to owning it (1999:7). Settler Danny Weiss says, 'God didn't promise the Jews Tel Aviv or Haifa. What he promised them was the land of Judaea and Samaria' (15). When asked about living in a small Jewish enclave in Hebron protected by 4000 soldiers, Weiss explains that Hebron is a holy Jewish place, as it is the first piece of land that Abraham bought and the very first recorded commercial transaction a Jewish person ever made (16). Hare performs Weiss's explanation in a tone of astonished gossip, a momentarily confidential 'Can you believe it?' Weiss's statement is, in fact, common knowledge among Jews. Hare writes as if there are no such places saturated with meaning upon which contemporary claims are made in Britain.

After failing to explicate the significance of the Bible for contemporary Israel, Hare's monologue arrives at the Holocaust via a visit to Yad Vashem, the Holocaust museum in Jerusalem that tells a story that does not end after World War II in 1945, but after 1948 with the founding of the state of Israel (1999:38). Most 'astonishing' for Hare was Himmler's point of view.

It is, Himmler says, 'natural tact' which prevents any German from speaking of what they are doing. Himmler knows it is hard work,

digging pits and throwing bodies into them. But what he is proud-
est of is that in doing this work his men have – the phrase resonates
down the century – his men have 'stayed decent,' and it is staying
decent 'that has made us hard.'

(38)

After his visit to Yad Vashem, Hare writes that we see only what we want
to see and that he, more than anyone is, at times, the worst of the lot
(1999:39). The devastating suffering of the Holocaust is situated in the
narrative as an apology for questioning the Jewish Bible, religious prac-
tice, and the right of Jewish people to a homeland in Israel. Hare's per-
formance of his trip to far-off Israel and Palestine is as much a journey
into memory, invention, and aesthetic convention as Sack's performance
of her grandmother's memory, Mann's adoption of Anulla's story as her
own, and Smith's performance of blacks and Jews – except that Hare has
no autobiographical tie to his subject. He poses as a grand secular guy
with a tongue-in-cheek story about those crazy, passionate, dramatic
Jews. The aesthetic convention of Hare's travelogue can be found in the
linear flow of his narrative, the autobiographical tone of his perform-
ance, and the styles of his venues, the West End and Broadway. Like
works of other British travel writers, *Via Dolorosa* ends with Hare back
at home where everything is familiar and where no weird religious or
political zealots hound his thoughts. From the vantage point of Hare's
return to his homeland, the foreign interloper in *Via Dolorosa* is none
other than Hare.

The term *Via Dolorosa* refers to the path of the 12 Stations of the Cross
and the events that beset Jesus as he dragged his heavy cross to his cruci-
fixion. Hare identifies Christianity as the religion of his homeland, even
as homeland is a 'not a word I've ever used' (1999:36). In Jerusalem's
Old City, the first eight Stations of the Cross on the Via Dolorosa are
surrounded by Arab shops selling postcards and other souvenirs. The
ninth through twelfth Stations of the Cross are located in the Church
of the Holy Sepulcher. Christian pilgrims from all over the world go to
Jerusalem to walk and pray along the path of the Stations of the Cross.[8]
For Hare, the spectacle of the pilgrims who share his own religious affili-
ation creates skepticism and a feeling of something lost. The stone on
which Jesus's body was placed after his death, Hare writes, may not be
in the right spot (37). Uncertain, Hare decides to do like the family next
to him and assume that 'X marks the spot.' He drops 'alarmingly' to his
knees in a posture of repentance and adoration beside the marble slab
(37). It is an act that Hare tells us about but does not perform on stage. It

is an act that mirrors Hare's journey to Israel and Palestine: an act without faith that signals a struggle to embrace something he finds suspect but fascinating. For Hare, Israel is a world out of reach of understanding and usual theatricalization. Hare's loss is both personal and political.

Curiously Hare assumes a hyperbolic stance both in his performance and in his prose, a salient characteristic of Jewish humor. At times, *Via Dolorosa* seems like it is 'of, by and for' Jews – a people who often enjoy gossip and jokes about other Jews. In this, Hare's posture is, at times, like that of a standup Jewish comic. No wonder his heart was not in the act of throwing himself on the sacred marble stone. He performs ambivalence about his own religion.

The emptiness of the dark, cold and boring British motherland that began the journey returns during the journey itself. The question of the loss of the empire and the British responsibility for generating animosity and distrust between Jews and Arabs haunts Hare's narrative. According to Bar-Yosef, Hare's trip to Israel was originally conceived as a three-play project in which a British, an Israeli, and a Palestinian would all write about the British Mandate period (1922–48) through which British colonization shaped the Middle East for decades. Instead, Hare wrote a solo performance about the Holocaust, the Bible, the settlers, politics, and his own uprootedness. Significantly, Hare says little about radical Islam in relation to Palestinians. In *Via Dolorosa* Palestinians are mostly minor characters who work as foils to the Jewish people. The devastating effect of Britain's own colonial past in the Middle East is absent in *Via Dolorosa* (1999:269). Unlike Sack, Mann, and Smith, Hare avoids history in order to satirize the present in totally entertaining and disturbing ways that traffic in stereotypes.

Theatre of the real intervenes in our understanding of the world through the particular distorting mirror of theatre. Its writers use the conventions of theatre to portray the real through individual imagination, narrative conventions, and aesthetic styles. The Holocaust is typically represented as grounded in a historic reality that challenges a Jewish belief in the bond between man and God and that serves as a justification for the state of Israel. The history of 2000 years of persecution, containment in ghettos and eviction, joyous ritual practice, survival, innovation, and study is more often than not omitted in favor of history as represented in the Bible, most often the Torah, and the resulting system of laws and observance about which nobody, not even Jewish people, seems to know too much.

Sack, Mann, Smith, and Hare all claim a special relationship to the real and to truth. Sack arrives at the truth by finally performing her

grandmother's testimony in an unbroken narrative uninterrupted by translation at the end of her performance. She performs as herself in a style of acting that posits that the actor's self can be performed. The off-stage Voice in *Annulla* comes to terms with her own history by recognizing how life goes by in a flash. The Voice recounts that her mother said, 'I feel like I've finally figured out how to live and it's going to be over' (Mann 1997a:29). The Voice remains an invisible offstage commentator that counters the aesthetic conventions of realism used onstage. Smith performs her theory of acting as potentially its own form of social justice by traveling the psychic distance to enact so many different people who are unlike her. Hare performs in the manner of paraphrasing those he met while all the while remaining himself.

Three of the plays present language in ways that mark the diaspora of Jewish people. Sack's grandmother and mother speak both Polish and English. Mann's grandmother lost her Polish and Yiddish after moving to America. Smith's phonetic mis-transliteration of Hebrew quotes Norman Rosenbaum's reproach about the murder of his brother: 'Al do lay ache so ache aylay alo dalmo' (1993:94).[9] Hare omits any mention of the multiple languages of contemporary Israelis. Hebrew, the official language of Israel, is mentioned only as an ancient language when Hare characterizes Benni Begin as 'trying to solve the problem of a notoriously difficult Ancient Hebrew message on a stone from the time of the destruction of the First Temple in 587 BC' (1999:22).

Sack refers to the Bible to underscore the contradiction between the beauty and promise of Judaism and the devastation of the Holocaust. Mann, like Sack, understands the Holocaust as an annihilation of both familial and Jewish history. In constructing stories from traumatized and imperfect memories, these artists confront what is known but cannot be spoken by those who know it. For Smith, the Holocaust is the determining historical event that shapes contemporary understanding of Jewish people. For Hare, the Holocaust is addressed as the Jewish rationale for the formation of the state of Israel and the Bible is the text that questionably determines the meaning of the land.

The Human Scale

Another view, that of a Pulitzer Prize-winning journalist, who also performed his travel to Israel, is instructive here. *The Human Scale* (2010) by Lawrence Wright and directed by Oscar Eustis, was first performed at the alternative theatre venue 3LD (Three Legged Dog). It is based on Wright's essay *Captives*, about the Israeli Palestinian conflict, which

appeared in the *New Yorker* (2009). Wright's performance manuscript begins with the stage directions:

> *A large screen dominates the back of the stage, forming a window into another world.*
>
> *Front stage left there is a desk with several reference books, various reports in binders and a large stack of papers that is the Goldstone Report.*
>
> *As the curtain opens, the stage is dark. 'Kol Nidre' by the Electric Prunes is playing. At 'Amen,' a video of Gilad Shalit appears.*
>
> *He is a gaunt young man with close-cropped hair wearing fatigues. This is his proof-of-life video. He holds up a Palestinian newspaper, and says, in Hebrew:*
>
> *'Shalom, I am Gilad, son of Aviva and Noam Shalit, brother of Hadas and Yoel, who lives in Mitzpe Hila. My identification number is 300097029.'*
>
> *Freeze the image as a spot comes up on the Narrator, sitting on the edge of the desk.*
>
> (Wright 2010:2)

And so we are off on a journey that attempts to explain the value Israelis and Jews everywhere place on bringing the abducted Israeli soldier Gilad Shalit home (Illustration 4.5). Wright's formidable exegesis includes a nuanced history of both Israelis and Palestinians, including atrocities, small and large, committed by both peoples. Inevitably Wright arrives at the Jewish Bible as a questionable source of history and rationale for a separate people.

> But it's also possible that none of this happened. That there was no Moses, no exodus from Egypt, no David, no Goliath, no Samson, no Nebuchadnezzar, no Babylonian Exile. There's little archeological evidence to support any of it. They may all be folk tales or legends. The meaning of every stone from that era is furiously contested. Even the great Diaspora itself is the subject of scholarly dispute [...].
>
> There are two conflicting stories, one told by religion and the other by science. Several genetic studies have shown that Jews and Palestinians are closely tied together.
>
> (2010:23)

Wright is not concerned with how the Bible has generated what to some seems like inscrutable religious observance, nor is he solely

Illustration 4.5 Lawrence Wright standing in front of two images of Gilad Shalit in *The Human Scale* by Lawrence Wright, directed by Oscar Eustis. Photograph by Joan Marcus

concerned with the ways it has been used as a source for the rationalization of the return of Jewish people to their homeland, especially since the 1967 War. In the manner of Greek tragedy, Wright writes about the ways in which the Bible forms a comprehensible and tragic backstory to present-day Israel and Palestine. Wright only arrives at science after telling us that in the Bible God cursed Gaza and that when the Lord wanted to chastise the Israelites, he handed them over to the Philistines, who may or may not be related to the contemporary Palestinians. 'The Philistine warrior Goliath terrorized the Israelites until David slew him with a sling and stone. Samson, a kind of monster, murders his wedding guests and slaughters a thousand Philistines with the jawbone of an ass' (21). Wright recounts biblical stories neither to cast aspersion on them nor to consign them to legend. He presents the ways in which the stories are the basis for belief systems. Wright reminds us of the indeterminacy of interpretation as it moves through time and different forms of inquiry, such as politics, science, journalism, and theatre.

Wright also mentions the Holocaust, but not as one might expect. After recounting how the Gaza Interior Minister and member of Parliament, Fathi Hamad, boasted that it was Hamas policy to use

civilians, even children, as human shields by stating, 'We desire death as you desire life.' Wright cites the Israeli deputy defense minister:

> Meantime, Matan Vilnai, Israeli's deputy defense minister, warned that the Gazans were bringing a 'Shoah' upon themselves, 'because we will use all our strength in every way we deem appropriate.'
> Just imagine. A Jew promising a holocaust. The word itself a synonym for the total valuelessness of life.
> And a Muslim boasting of the longing of his own people to die.
> (2010:33)

Here the Holocaust loses its reference solely as an occurrence against Jewish people. The Shoah, the preferred term in Israel, becomes a threat of destruction by a Jewish person against an enemy committed to death. Like Weiss, Wright situates the Holocaust as a specific and horrific event against the Jewish people and also as the creation of humans, a Golem capable of arising from any race or religion. There are no codes signifying the Jewish people or Jewishness as inscrutable, surreptitious, or even special. The publicity for *The Human Scale* advertised the performance as 'an unsparing and graphic exploration of the ongoing crisis in Gaza.' At the same time, the performance was characterized as focused on Gilad Shalit. 'Everybody knows it. But by now the Jew in the hands of Hamas had become so valuable in the minds of both his captors and his countrymen that he outweighed the entire Gaza population' (34).

On 27 December 2008, the first wave of F-16s raced across Gaza. 'Within 220 seconds, one hundred targets had been struck, including police stations, military installations, training camps' (2010: 34). By nightfall, Wright tells us, 280 were dead, 900 wounded (34). The continued attack destroyed Gaza's industrial and agricultural facilities, houses, mosques, and schools. Wright notes that the Israeli military tried to prevent civilian casualties by dropping 2.5 million pamphlets urging people to move away from planned attack areas (35).

Wright implies that the holocaust threatened by Matan Vilnai was delivered. Was it all preventable? To attempt to answer this impossible question, Wright returns to the Bible and to an idea of God, which he considers a problem.

> because the scale that weighs the value of human lives goes back to the idea that there is a God who judges some as dear and others as worthless. The God who demands of Muslims that they eliminate the Jews before Judgment Day. The God who tell Jews that he has

given them land that belongs to another. The God who chooses one people over another.

In the Bible, Numbers 21, there's a story of a Canaanite army that took some Israelite soldiers hostage. 'Israel made a vow to the Lord,' the Bible says.

'If you will deliver [the Canaanites] into our hands, we will totally destroy their cities.' The Lord listened to Israel's plea and gave the Canaanites over to them. They completely destroyed them and their towns; so the place was named Hormah.' This means 'devoted to destruction.'

The Bible doesn't say what happened to the hostages.

(2010:44)

Wright maintains that it did not have to happen. If only Hamas had stopped their rocket attacks on Israel and asked for a reasonable ransom for Shalit. Toward the end of the performance, a video flashes up on the screen inside the theatre showing the very end of Gilad Shalit's 'I am alive' video. Shalit's image flickers from some unknown place in Gaza, and he says, 'Thank you very much, and goodbye' (44). In Wright's hands, history can be known. On 11 October 2011 Gilad Shalit was released, after being held captive for five years, in exchange for 1027 Palestinian prisoners serving, in many cases, multiple life-term sentences in Israeli jails.

In *The Investigation,* Weiss used documents to tell a story that went beyond the subject of the Holocaust by creating an overarching critique of the ability of an efficient capitalist industrial-military complex to indoctrinate its ethos. Weiss does not link the Holocaust with Judaism or the Bible except to allude to the fact that the Nazis referred to all Jewish people as Abraham or Sarah.

In an interview with Paul Gray and Erika Munk after *The Investigation* had been staged as a reading and as a full production, Weiss commented on Ingmar Berman's assertion that people no longer need theatre, as there is so much drama surrounding them in their daily lives.

Bergman is absolutely right if he means the traditional theatre, which I also think is lost, as petrified as the bourgeois audience which goes to it. But there are new possibilities for a theatre which can take up the reality in and around each human life, and a renaissance is coming for theatre from vastly different and unexpected directions – at one side, the theatre of Happenings, and on the other extreme the theatre of documentation.

(1966:108)

Despite Weiss's claim that there are new possibilities for theatre that takes up reality, his anti-theatricality was expressed in his prohibition against representation in the form of reconstructing either the camp or the trial in staging *The Investigation*. What Weiss did not anticipate was the document, the interview, and the subject of documentary and the real acquiring new meaning in the live and material space of theatre.

Ferguson describes the stages that plays built with the testimony of living persons go through: the recollection of events from memory; recording of this memory; transcription of the recording; translation of the transcription when necessary; editing of the transcription; the artist's reconstruction of the edited transcription for the stage; and further adjustments as determined by the performers, the director, or even the specific venue (2010:35). All of this, Ferguson argues, demands improvisational, creative, and intuitive adjustments to make the document playable in a theatre. Like the performance, the document is the result of a chain of translational improvisations (37). To accommodate their subject, their performance and literary aesthetics, their notion of truth, their anticipated venues and consequent audiences, the authors and performers of the works I have discussed in this chapter construct different ideas about Jews and Jewishness, and the Jewish relationship to the Bible and to the Holocaust. These works collectively participate, despite different time periods, aesthetic styles, and theatre venues, in the ongoing debates about representation and the relationship between history and personal experience. In the hands of theatre artists, the story of Jewish people in relation to the Bible and the Holocaust has, in the postwar period, been a remarkably durable one. Using an array of indexical dramatic and theatrical indications of the past, such as memory, testimony, re-creation, photographs, and film, to signify reality and truth, similar narratives about Jewish people have been created. Like Weiss, Wright is an exception to this narrative convention, as he did not try to convey the feeling of history through the experience of an individual as much as he sought out the rationale for history's justification.

5
Occupying Public Space

Theatre humanises; all art humanises. It takes us away from the merely logical and rational. In the Israel-Palestine conflict there is often a very logical calculus of death and war – and you must step out of the constructs of that logic in order to construct a logic for peace.

Cindy and Craig Corrie (2005:28)

Theatre has no obligation to give a complete picture. Its only duty is to be honest. And what you get here is a stunning account of one woman's passionate response to a particular situation.

Michael Billington (2005)

With no attempt to set the violence in context, we are left with the impression of unarmed civilians being crushed by faceless militarists. Early on, Corrie makes a point of informing us that more Israelis have been killed in road accidents than in all the country's wars put together. As she jots down her thoughts in her notebook and fires off her e-mails to her parents, she declares that 'the vast majority of Palestinians right now, as far as I can tell, are engaging in Gandhian non-violent resistance.' Even the late Yassir Arafat might have blushed at that one.

Clive Davis (2005)

You'll never be able to get at the truth on the Internet.

Katharine Viner (2006)

Theatre's potential for making the world comprehensible is integral to its ability to occupy and constitute a public space. Special value is placed on theatre's power to create a new real, to make the real manifest and situate ideas in the realm of discursivity with images and sensations (see Reinelt 2006:71). Whether or not theatre of the real has a singular ability to change reality outside the theatre, it does contribute to formulating what we understand as reality. By contributing to debates and disputes in public life, theatre of the real participates in what we know and how we come to know it. Like other media that claim to have a special relationship to events in the real world, theatre of the real can make a generative and critical intervention in people's prejudices and the limitations of public understanding. Theatre of the real can also oversimplify, inflame prejudices, and support one-sided perspectives. Framed by public events and discourses that determine its reception, the occasions that have engendered the performance, and the political intensions of the artists, theatre of the real is dependent upon opinion even as it shapes it. This is because it occurs in relation to events about which people have varying degrees of information and misinformation. Add to this the transparency or lack thereof of the forms of documentation from which the theatre is created and we begin to approach its epistemological possibilities and limitations.

Verbatim theatre – the category of theatre of the real that uses verbatim quotation mostly from interviews, but sometimes also from documented public records such as inquiry and trial transcripts, public speeches, and private records such as diary entries, letters, and emails – has been used in the United Kingdom to help promote social change (see Paget 2010:173–93). Verbatim theatre has an emphasis on language and on summarizing large amounts of information by means of highly selective editing that helps to manage the enormity of history and the abundance of information produced by increasing documentation and its ever-expanding availability. It addresses what Attilio Favorini has identified as 'the enormities of history challenged anew, and relentlessly, the capacity of memory to frame or contain them' (2009:151). Post–9/11 theatre of the real tends to be deeply conversant with the explosion in personal technology and social media and with our ability to construct, perform, and upload ourselves, resulting in manipulated representations that are difficult to interpret.[1] The temporal sense of digital media's moving an image, vanishing as it appears, is coincidental with theatre's temporal progression. Digital media and theatre appear to be both real and stable *and* ephemeral at the same time. They capture the fleeting flow of memory while also mimicking its transient nature.

The British verbatim play *My Name Is Rachel Corrie* (2005), coedited by the actor and director Alan Rickman and an editor of the British newspaper the *Guardian*, Katharine Viner, challenges the value of the way theatre constructs history and memory. The play's problems of authorship, the opacity of the work of its editors, and the Internet discourse surrounding it have obscured the play's meaning. On 16 March 2003 Rachel Corrie (born 10 April 1979) was killed in Rafah, Gaza, at the height of the Second Intifada.[2] Corrie was crushed by a Caterpillar D9 armored bulldozer operated by the Israeli Defense Forces (IDF) while trying to protect the home of the Palestinian pharmacist, Samir Nasrallah, from demolition.[3] Working for the International Solidarity Movement (ISM), Corrie had gone to Rafah where the IDF was working to clear what they called a 'security zone' so as to destroy what they claimed was a network of tunnels for smuggling weapons from Egypt.[4] Beginning on 18 March 2003, two days after Corrie's death, the left-leaning UK newspaper the *Guardian* published a series of Corrie's emails, captioned as 'Rachel's War,' that she sent to family and friends dating from 7 February 2003. Some of these emails eventually served as portions of *My Name Is Rachel Corrie*, which opened at the Royal Court Theatre in London in April 2005 and won the Theatregoers' Choice Awards for Best Director and Best New Play, as well as Best Solo Performance for Megan Dodds who played Rachel Corrie. The entirety of the play was created from Corrie's letters, diary entries, and emails both before and during her time in Gaza. According to an article in *The Nation* by Philip Weiss, Corrie's family urgently felt the need to let the world know Corrie's view of what was going on in Gaza, a need they clearly felt would best be accommodated by the British press and by the ISM. They posted several of Rachel Corrie's last emails on the ISM website and gave permission for their publication in their entirety in the *Guardian*, eventually granting permission for their use in the creation of a play (Weiss 2006). The *Guardian* titled its first article about Rachel Corrie 'Rachel's War,' making the most of the idea of a young woman standing against Israel's actions in Gaza. This article (of 18 March 2003) appeared both in print and on the Internet in the newspaper's online edition (Corrie and Corrie 2005:28). The header for the article reads:

This weekend 23-year-old American peace activist Rachel Corrie was crushed to death by a bulldozer as she tried to prevent the Israeli army from destroying homes in the Gaza Strip. In a remarkable series of emails to her family, she explained why she was risking her life.

(28)

On the next day, 19 March 2003, another article in the *Guardian* reported that Corrie's memorial service was disrupted by the IDF. Pro-Palestinian activist Joe Smith from Kansas City was quoted as saying that the memorial service was accosted by a convoy of vehicles including a tank firing tear gas and the very bulldozer that killed Corrie. 'I don't think it was deliberate but it was pretty insensitive,' Smith concluded (in McGreal 2003).

With its mostly lone verbatim voice and singular view of history, *My Name is Rachel Corrie* became a lightning rod for competing accounts of Corrie's death and for public denouncements of Israel, Palestine, the IDF, and the ISM. The performance of *My Name is Rachel Corrie* gained notoriety as an occasion for political affiliation. This is because the play is the story of a young woman who traveled to Gaza to work toward ending the Israeli occupation set in the context of a one-sided view of the conflict between Israelis and Palestinians. Reception of the performance of the play has provoked debate about the Israeli-Palestinian conflict coupled with allegations about the British proclivity to see the conflict from a Palestinian perspective and the American proclivity to see the conflict from an Israeli perspective.[5]

The controversy provoked by *My Name Is Rachel Corrie* illustrates the potential problems regarding the reception of theatre that makes truth claims based upon the use of verbatim quotations.[6] Verbatim texts often conceal the editing decisions made during their construction, as well as the political affiliations and agendas of its editors, both of which are as integral to the creation of meaning as the sources quoted. *My Name Is Rachel Corrie* and the response to it make obvious the ways in which some forms of theatre that claim a relationship to the world outside the theatre can mimic, instead of interrogate, public discourse about the events it portrays – especially events that are already highly politicized and enacted in a variety of media. In the case of *My Name Is Rachel Corrie*, online journalism and YouTube played significant roles as public forums that provided additional information and served as platforms for trashing or valorizing the play, Rachel Corrie, Israelis, Palestinians and other associated groups, as well as assorted individuals.

At the time of her death Corrie had been in Gaza for 50 days. The stated reason for the Israeli policy of bulldozing houses and wells in Rafah, Gaza, was to create a no-man's-land between Egypt and the then-occupied Gaza in order to prevent the building of tunnels for weapons trade. The organization with which Corrie was affiliated, the ISM, has been alternately identified in the press as a Palestinian-led nonviolent organization, an independent group that sends foreigners into volatile

hot spots to assist Palestinians, an organization that works with groups that have supported killing Israeli civilians with suicide bombers, a group recruiting Westerners to serve as 'human shields' against Israeli aggression, and as an organization created to resist the Israeli occupation with nonviolent means. The ISM was founded when the United States and Israel vetoed a resolution submitted by the UN High Commissioner Mary Robinson to have a human rights monitoring force in Gaza after the start of the Second Intifada. On its website, which also features a clickable 'Join the Global Intifada,' the ISM defines itself:

> The International Solidarity Movement (ISM) is a Palestinian-led movement committed to resisting the Israeli apartheid in Palestine by using nonviolent, direct-action methods and principles. Founded by a small group of primarily Palestinian and Israeli activists in August 2001, ISM aims to support and strengthen the Palestinian popular resistance by providing the Palestinian people with two resources, international solidarity and an international voice with which to nonviolently resist an overwhelming military occupation force.
>
> (ISM 2010)

The competing descriptions of the ISM are a good indication of the intractable nature of the opposing points of view about the Israeli-Palestinian conflict and the permeable border between documentation and advocacy.

Corrie's death and the performance of the play that takes her name as its title became occasions for people holding opposing views about the Israeli-Palestinian conflict to continue to reduce complex and conflicting ideas about history, justice, and injustice into hate prose. Some claimed the play provided an underrepresented and truthful perspective. Others argued the play was an affront to Jewish history and to Israel. No one argued the play was a balanced and historically nuanced perspective that created a generative understanding of the conflict. The story of Rachel Corrie is not only her story.

Disagreement over the subject matter of the play has been part of the controversy. Is the play about Rachel Corrie's experience? It comes from her experience, but the story is much bigger and longer than her experience. Is the play the story of the political awakening of a young woman who demonstrated activist impulses from the time she was a little girl? Is it about the suffering of Palestinians in Gaza at the hands of Israelis? Are these the words of a young woman earnestly responding

to the suffering and poverty she saw or the words of a naïve activist in the grip of the mindset of terrorists?

> I spent the evening and this morning with a family on the front line in Hi Salam – who fixed me dinner – and have cable TV. The two front rooms of their house are unusable because gunshots have been fired through the walls, so the whole family sleeps in the parents' bedroom. I sleep on the floor next to the youngest daughter and we all share blankets.
>
> <div align="right">(Rickman and Viner 2005:34)</div>

Corrie does not mention the suffering of Israelis at the hands of Palestinian suicide bombers and from Qassam rockets expressly targeting civilians. Why wasn't this part of Corrie's consideration? Why are Palestinian and Israeli points of view about themselves absent from the play? What about the historic Israeli overtures to peace? Why wasn't Egypt's oppressive military rule of Gaza before the 1967 War and its subsequent border blockade part of the story? Where is the other side of the story? Where is the truth in a partial story?

Writing about the play in *The Nation* Philip Weiss reported:

> It had been the intention of the two collaborators, Alan Rickman and Katharine Viner, a *Guardian* editor, to flesh out Rachel Corrie's writings with others' words. The pages [of Corrie's writing] instantly changed their minds. 'We thought, she's done it on her own. Rachel's voice is the only voice you had to hear,' Viner says. The Corrie family, which holds the rights to the words, readily agreed. Rachel Corrie was the playwright. Any royalties would go to the Rachel Corrie Foundation for Peace and Justice. The London 'co-editors' then set to work winnowing the material, working with a slender blond actress, Megan Dodds, who resembles Corrie.
>
> <div align="right">(2006)</div>

The logic here is fascinating. The editors decide that Rachel has 'done it on her own' thus eliminating the need for other views or information. Importantly, the Corrie family was in agreement as they own the rights to Rachel's words. Thus Rachel became a posthumous playwright with the help of editing. This notion revises the idea of a playwright as someone who has wrought words into dramatic form with the deliberate intention of creating a specific structure of meaning. In addition to everything else it accomplished, Rickman and Viner's decision to take

credit only as editors exonerates them of responsibility for the controversial content of the drama.

Equally important, those who stand against Israel appropriated Rachel Corrie's name as a symbol of resistance. Palestinian Liberation Organization (PLO) leader Yasser Arafat conferred upon Corrie the sacred status of a martyr for the Palestinian cause and posthumously awarded her the Star of Bethlehem. The website Rachel Corrie Facts was reputedly created to provide additional information about the Israeli-Palestinian conflict.[7] A street was named after Corrie in Ramallah on the seventh anniversary of her death (see *Reuters* 2010). In June 2010, the Irish vessel named *Rachel Corrie*, with former UN High Commissioner Mary Robinson on board, headed out to break the Israeli blockade off the coast of Gaza by bringing humanitarian aid to Palestinians, setting sail from Ireland immediately after the disastrous 31 May 2010 Turkish Mari Marmora flotilla incident.[8] The *New York Times* reported that, 'Corrie's story has become a rallying cry for international anti-Israel activists' (Rubin 2010). Speaking to a small group of Palestinians on the seventh anniversary of Corrie's death, Cindy Corrie, Rachel's mother, reportedly said, 'I just want you to know that you do not stand alone. People are stepping up. They will not be silent' (in *AP* 2010).

Rachel Corrie on the Internet

In the new media landscape of the twenty-first century the old sequence of play, performance, and review is upended by immediately available competing postings from anyone who wants to declare their thoughts not only about the merits and aesthetics of theatre but also about its originating events, documents, and circumstances. Opinions abound, for example, about what 'really happened' to Rachel Corrie, opinions that harden into convictions about what *must* have happened without systematic consideration of the factual evidence and data. Anyone can become a judge handing down verdicts and making public pronouncements without benefit of a governing due diligence and due process that might follow a semblance of ethically bounded judicial behavior. In the Internet age, law is rejected in favor of opinion; a rush to opinion and judgment is the order of the day. The Internet offers a range of sane and wild opinion, an unedited mix of hearsay, fact, and fiction.

This was the case with regard to Rachel Corrie and 'her' play which were popular online topics on the Internet. On 10 November 2011 a Google search for 'Rachel Corrie' yielded 1,970,000 results; a Google search for '*My Name Is Rachel Corrie*' yielded 275,000. As the protagonist

and as the subject of the play Corrie has generated an ample Internet discourse of competing assertions about her worthiness, the value of the play, the nature of the Israeli-Palestinian conflict, and whether or not her death was an accident or murder. The tendency to favor the underdog gets played out amidst an increasingly accepted antisemitism on the one side and anti-Arab racism on the other. In the case of *My Name Is Rachel Corrie*, the politicized platforms of digital media provide the means for commentary by anyone who has access to the Internet, in ways that resituate the play and its reception very differently from the traditional performance, audience, and review triad. The order and timing of the elements of this triad were confusing from the outset. Craig and Cindy Corrie posted their daughter's emails on the ISM website within hours of her death. Major portions of what became the play were published online and in print nearly in their entirety in their original email form in the *Guardian*.

A YouTube search of 'Rachel Corrie' produces – among a plethora of material – clips of Corrie in Gaza, her presentation at her fifth grade press conference, Corrie before and after she was run over by the Caterpillar bulldozer, and interviews with Cindy and Craig Corrie. Some of these YouTube uploads are augmented by music. One clip titled 'Armed MC- Palestinian Martyr Rachel Corrie Dedication' is a montage of still images that, in addition to Corrie, includes Martin Luther King, Bobby Kennedy, John F. Kennedy, Gandhi, Malcolm X, and Princess Diana accompanied by the song 'The Same Chain' by Armed MC. Near the end of the clip Craig and Cindy Corrie are shown standing in front of a poster of Rachel, followed by the white on red block lettering of the poster for the play.[9] Some of the YouTube footage that makes claims about whether or not the bulldozer driver saw Corrie before he ran over her has contiguous images, while some of it is edited into discontinuous shots that make it impossible to draw conclusions based on the images. Another YouTube upload is a memorial photomontage of Corrie. Because the Internet actively offers its wares for an indefinite amount of time, a 'living history' is always being constructed.

The play

Rachel Corrie's parents, Craig and Cindy, found out about her death from their son-in-law, Kelly, who learned of her death from television.

> Kelly hesitated... 'I'm afraid we've had some very sad news.' Only then could Cindy hear our daughter Sarah sobbing in the

background. She and Kelly had seen scrolling at the bottom of their television screen: 'Olympia woman killed in Rafah, Gaza.'

(C. Corrie 2008:ix)

On the occasion of the premiere of *My Name is Rachel Corrie* in London, Craig and Cindy Corrie wrote an article for the *Guardian* in which they explained the effect their daughter's words had on their family.

Her emails home had had a powerful impact on our family, making us think about the situation in the Middle East in ways we had never done before. Without a direct connection to Israel and Palestine, we had not understood the devastating nature of the Palestinians' situation. Coming from the US, our allegiance and empathy had always been with the people of Israel.

After Rachel died we realised that her words were having a similar effect on others whose lives were being changed, as ours have been – not just by Rachel's death, but by the window her writing provided on the Palestinian experience and by her call to action.

(2005:28)

The Corries' shift in view point characterizes the intention of the play. From their perspective, Rachel's emails produced a previously unavailable understanding about the Middle East. Rachel's writing shifted the focus from the 'people of Israel' to 'the Palestinian experience.'

When Rachel arrived in Rafah, she entered a world of tanks, bulldozers, sniper towers, and checkpoints – a world of smashed greenhouses, crumbled homes, and a giant steel wall being constructed on the rubble near the border with Egypt. But she also entered a world of families – people resisting oppression by simply maintaining their own humanity as they struggled through the day-to-day activity of their lives under occupation. And as she entered this world, Rachel brought us with her through phone calls and e-mail.

(C. Corrie 2008:xv)

In *My Name is Rachel Corrie*, the first email published in the *Guardian* shows up in the middle of the play in a somewhat edited version. As a matter of politically charged dramaturgy, Rickman and Viner's editing of Corrie's emails and diary entries presents her as a young idealist who is a participant, witness, and chronicler of a momentous violation of human rights. In quoting Corrie's journal entries and emails verbatim,

Rickman and Viner designate Corrie's perspective and the perspectives of those with whom she communicates as unqualified truth. In performance, Corrie's writing is the primary text the audience hears. Even when a few other voices are included in the body of Corrie's emails, such as Corrie's mother and father, the governing perspective offered is that of Corrie. Cindy Corrie's email in which she writes that she is afraid of the possibility of Rachel being manipulated 'by one faction or another' is followed by an email from Rachel in which she describes being taken care of by Palestinian families. 'I am amazed at their strength in defending such a large degree of their humanity against the incredible horror occurring in their lives and against the constant presence of death. I think the word is dignity' (Rickman and Viner 2002:34–5).

Rickman and Viner's role in shaping Corrie's voice is anything but transparent. In an article in the *Guardian* appearing during the run of the play, Viner is quoted as saying that Corrie's parents gave her and Rickman their express permission to write a play using the 184 pages of Corrie's writings they sent to the editors via the Royal Court Theatre (Viner 2005:G2, 2). Rickman and Viner make a point of identifying themselves as editors, not authors, thereby emphasizing Corrie's authorship (in both the literal and figurative sense). This differentiation, along with the sanctioned transfer of representational authority from Corrie's family to Rickman and Viner, is one of the ways *My Name is Rachel Corrie* masks the complexity of the editors' narrative intervention. Rickman and Viner are not present within the world of the play even as they manage the construction of the representations of Corrie, Gaza, the Israelis, and the Palestinians, albeit with Corrie's words (see Viner 2005:G2, 2).

Rickman and Viner use popular conceptions of journalism that Lebanese artist-theorist Walid Raad critiques in his discussion of the representation of Lebanon in Maroun Baghdadi's film *Hors la vie* (1991) about a photojournalist held hostage in Beirut. Raad identifies several assumptions about documentary film that equally apply to the theatre of the real. Raad's observations about the problematic assumptions of documentary film include: (1) players in reality situations are uncorrupted observers of the events in which they find themselves; (2) the writers and protagonists of documentary are 'humanly and morally' committed to the stories they tell; (3) the events that documentary witnesses and records transcends local sociopolitical contexts and includes a 'universal' range of emotions such as outrage, joy, pain, mourning, and triumph; (4) the truth of what is represented is verified by spatial proximity to the situation, the authenticating assertion of 'having been

there' (see Raad 1996:65–82). Rickman and Viner work from these same assumptions. They wrote *My Name is Rachel Corrie* from the documents created by an eyewitness who they position as a morally right-thinking person compelled to tell a story in a manner that transcends local considerations. The editors assume the story will evoke an array of emotions experienced by people in other situations. They present their assemblage of Corrie's writings as ethically correct and objectively verifiable. At the end of the play the editors add Tom Dale's eyewitness account of Corrie's death. Dale's status of having been there is not a status shared by Rickman and Viner – yet they appropriate it. Because the witness was there, they assume, what he says is accurate; what he says is accurate because he was there.

Rickman and Viner function as author surrogates as they made all the decisions having to do with the selection, assemblage, and sequencing of Corrie's writing as provided by Corrie's family. They give the impression that the meaning they construct is what Corrie intended. Whether or not this is so is something we cannot determine. We can only assume that Rickman and Viner's view was formed, at least in part, by the very documents from which they created the play. They edited Corrie's words in accordance with the demands of theatre and also in accordance with their view of Corrie and the Israeli-Palestinian conflict as they understood it at the time they created the play. The result is a text edited according to the dramaturgical aims of Rickman and Viner and the social and political agenda of one type of documentary theatre, the kind that seeks to tell an untold story in first person in an attempt to get the 'whole truth.' Like Corrie, Rickman and Viner are not ideologically neutral.

Corrie's writings may or may not have been how Corrie would have represented herself in a play about her life and her experiences in Gaza. In the portion of the play identified in the stage directions as a journal entry, Corrie writes: 'You understand none of this is really true, because what I wrote today is true, but you'll read it tomorrow, or the next day, and my whole life will be different. Is that how life is, a new draft for every day, a new vision for each hour?' (Rickman and Viner 2005:5). The overall structure of *My Name is Rachel Corrie* is a collage of different kinds of writing from different periods in Corrie's life. There is a loose narrative progression starting with diary entries from when Corrie was a girl, to her adult journey in search of ways to promote social justice and her political awakening, to her death in Rafah, Gaza, announced by Tom Dale on a television monitor, followed by a videotape of Corrie at her school's Fifth Grade Press Conference on World Hunger when she

was a ten-year-old girl. Rickman and Viner use a number of narrative techniques such as *in media res*, backstory, foreshadowing, defamiliarization, and epiphany to structure Corrie's documents into a dramatic form. That these devices are so well used and easily identified indicates the degree to which Rickman and Viner understood and strategized Corrie's writing in terms of the demands of drama and theatre. 'Every morning I wake up in my red bedroom that seemed like genius when I painted it, but looks more and more like carnage these days,' says Corrie at the beginning of the play while in her bedroom in Olympia, Washington, with clothes and books everywhere. 'I wriggle around under my comforter trying to find a ball point, a Crayola, anything fast. I can hear the ceiling spit and gnash above me. Waiting for me to look, it can eat me. And I struggle for some socks and some boxers so I can make a run for it – but I haven't done laundry in a month and the other girl who lives in my room when I'm not here – the bad one who tends the garden of dirty cups and throws all the clothes around and tips over the ashtrays – the other bad girl hid all my pens while I was sleeping' (Rickman and Viner 2005:3). Corrie is in the red carnage of her bedroom, looking to make a run for it from a chaotic environment where she cannot find a pen – her tool to write what we will read of her life. 'And I try. I try to look at my fingers. I try to look at the floor with all the fashion magazines left by the bad other girl, to find one pen – just one pen. But I can't imagine where any pens might be, and trying to imagine, I get off guard for a minute and my eyes roll up toward the sky and I'm fucked now – I'm fucked – 'cause there is no sky. There's that ceiling up there and it has me now – 'cause I'm looking at it and it's going to rip me to pieces' (3). In this prescient prose, it is as if we have already experienced Corrie's death from her vantage point – under the bulldozer as it runs over her. A devouring ceiling rips her apart as her eyes roll up to meet that place where there is no sky.

In the published version of the play, the text is assembled in short segments of writing that usually begin with stage directions. Before the opening monologue, the stage direction states: 'Olympia, Washington. A bedroom. Clothes, books everywhere. Rachel lies on top of it all' (3). As 'she sits and faces us' we learn that Corrie's bedroom, and by analogy, other spaces where she may find herself, spaces where 'labours of love,' are also 'terrifying mirrors' (4). Terrifying mirrors of what? The future? Gaza? The loss of lives? The wrong choice? The oncoming bulldozer? The condition of Palestinians? 'I wonder why I didn't notice the awfulness of my room before [...] I glued things to the wall. My God, I glued things to my wall' (4). The emails and diary entries are not just the

memories of a young woman who died, but the prose of a dedicated journal writer discovering the world and her place in it.

All we know about what guided the editors' selection process comes from sources outside the play. Viner explains in a *Guardian* article: 'In developing this piece of theatre, we wanted to uncover the young woman behind the political symbol, beyond her death' (2005:G2, 2). Rickman, whose idea it was to turn Rachel's work into drama, commented: 'We were never going to paint Rachel as a golden saint or sentimentalise her, but we also needed to face the fact that she'd been demonised. We wanted to present a balanced portrait' (2). In this portrait the writers, 'hoped to find out what made Rachel Corrie different from the stereotype of today's consumerist, depoliticised youth' (2). Earlier in the same *Guardian* article, Viner describes how Corrie was vilified by Americans on websites with statements claiming she was naïve and acting in a situation she didn't understand, that 'she should burn in hell for an eternity'; 'Good riddance to bad rubbish' 'I'm thankful she died' (in Viner 2005:G2, 2). What Viner did not mention was that the vitriolic response to Corrie's death posted on the Internet was met with equally hateful online comments posted on the Internet about Israelis and Jewish people.

Corrie's death is foreshadowed throughout *My Name Is Rachel Corrie* – in her red devouring bedroom, in her dreams, and in her fears. As in a Greek tragedy, Corrie's death seems inevitable. Inevitable and circumstantial are strange cousins in this scheme. If Corrie's death was inevitable, then the IDF is responsible for it or Corrie chose it. If her death was circumstantial, then the IDF created the circumstances and Corrie chose to place herself in those circumstances, which everyone knew were dangerous. If the bulldozer driver knew he was running Corrie over, as Tom Dale asserts, then her death was murder. If not, it was accidental, manslaughter. Unequivocally, what happened is tragic. Near the time of her death Corrie seems to have been considering leaving Gaza. I write 'seems to have been considering' as what reads like a diary entry is undated, yet its placement in the play locates it near the time of her death. Corrie makes a list of choices that include returning to Olympia, going to Egypt, Dubai, Sweden, staying in Rafah, learning Arabic, and returning to Palestine (Rickman and Viner 2005:44). Imagining and then trying to decide upon a future momentarily shifts Corrie's death from the dramatic realm of foreshadowed tragedy to the possibility of hope, of a future, which is all the more tragically extinguished.

Rickman and Viner make their selection and arrangement of documents appear to be natural, inevitable, and comprehensive at the same

time that the play they have edited is built from a partial historical perspective and an already decided political persuasion. Where does 'history' start and finish in today's Israeli-Palestinian situation? The way Rickman and Viner structure Corrie's personal narrative is a diversion from the complexities of history in favor of championing one point of view, one opinion of justice, and one side of a complex story of violence and oppression. The play succeeds as a polemical drama of defiled justice because *My Name is Rachel Corrie* is not dialogic, nor is it historiography of the kind that lends itself to new understandings.

What were Rickman and Viner's criteria for the selection, order, and manner of presentation of Corrie's writing? Creating work from archival materials emphasizes nonfiction even while creating aesthetic imaginaries that claim a special factual legitimacy. The process is not always transparent. A short portion of text at the beginning of the play reads:

> The question here is always where to start the story. That's the first question. Trying to find a beginning, trying to impose order on the great psychotic fast-forward merry-go-round, and trying to impose order is the first step toward ending up in a park somewhere, painted blue, singing 'Row, row, row your boat' to an audience of saggy-lipped junkies and business people munching on oat-bran muffins.
>
> And that's how this story ends, good buddy, so if you are concerned with the logic and sequence of things and the crescendo of suspense up to a good shocker of an ending, you best be getting back to your video game and your amassing wealth. Leave the meaningless details to the poets and the photographers.
>
> And they're all meaningless details, my friend.
>
> (2005:4)

The problem of how to start the story that Corrie mentions is also the first problem the editors face: imposing order, finding continuity in details, and anticipating what the audience needs to know to understand Corrie's situation (from the editors' point of view). Being 'concerned with the logic and sequence of things and the crescendo of suspense' belongs to both the editors and to Corrie. Corrie's words read as a description of the difficulty of assembling, editing, and ordering her prose for the express purpose of creating 'truth' for a reader or an audience assumed to come from another reality – the reality of the drug-consuming, money-making, and muffin-eating population Corrie both addresses and denigrates. This audience, Rickman and Viner assert with their editing and ordering of text, sits comfortably in the theatre

expecting logical and sequential meaning conveyed with significant details and a shocking ending. Here again, Corrie's writing is prescient but we do not know why this is so. The editors seem to wonder along with the audience they address, how it came to pass that Corrie got so close to envisioning her own future. Is this really true – or are the editors carefully selecting portions of Corrie's writing and placing it in a context that when presented dramatically make it appear as if Corrie is second-sighted? This opening portion of text is not dated as some other selections are. Nor is this portion marked as a diary entry, a letter, or an email, each of which is a different mode of writing. In the world of the play, we do not know whether or not the opening prophetic statement was cobbled together from different kinds of writing and then presented as contiguous writing. The prose at the very beginning of the play is in a different voice than the portion that follows. The portion of text about truth, life-changing experience, and 'a new draft for every day' is identified as being written when Corrie was 12 years old, but has the tone and insight of someone much older (5). Listening in a theatre to a performance of *My Name is Rachel Corrie*, an audience member does not know where a particular portion of text comes from. The editors provide inconsistent identifications.

Referring to the work of director Moisés Kaufman, Stephen Bottoms argues that textual reflexivity during performance is the key to an ethics of documentary as it allows audiences to know the source of the document as the play is performed (2006:57). Citation and textual reflexivity may or may not assure ethics or objectivity. Identifying where texts come from sends the message that the text is authentic and real: documents are documents because they can be cited. Revealing the source of documents is meant and understood as legitimizing the sources. But identifying where something comes from is not enough. What readers and audiences infer from the documents can be, and most often is, undercut by the opacity of the selection and editing process. Sources can be misleading and corrupt as well as accurate and well intentioned – and everything in between. Documents are indicative only of certain kinds of reality.

In the published text of *My Name is Rachel Corrie*, the editors include the prose of two sections of documentary video footage that are in the final two scenes of the play: Dale's eyewitness account of Corrie's death and a speech that Corrie gave when she was ten years old, at her school's Fifth Grade Press Conference on World Hunger. For the eyewitness account, the stage directions state: 'From the TV, a recording of the transcript of an eyewitness account by Tom Dale' (Rickman and Viner 2005:51). For Corrie's speech the stage directions state: 'A video

of Rachel Corrie, aged ten, appears on the screen. This was recorded at her school's Fifth Grade Press Conference on World Hunger' (52). Everything audiences have heard about Corrie's life culminates in these two video clips that conclude the play. What do these moving images tell viewers? That Corrie was unjustly killed; that from an early age she was a socially and politically aware person on the right side of our epoch's ethical questions. What 'really happened' to Rachel Corrie is not the subject of Rickman and Viner's play, although their view of what really happened at the time of her death is clearly expressed by their inclusion of Dale's 'eyewitness' account.

> And as the mound of earth reached Rachel she obviously felt that in order to keep her balance, to keep her footing she had to climb on to the mound of earth to prevent being overwhelmed by it. When she did this it put her head and shoulders clearly above the top of the bulldozer blade and therefore clearly in the view of the bulldozer driver, so he knew absolutely that she was there.
>
> (51)

Through Dale, Rickman and Viner clearly state that Corrie was intentionally run over by a member of the Israeli military. This certainty drives not only the conclusion of *My Name is Rachel Corrie*, but also, retrospectively, the whole play. By placing Dale's assertion that the bulldozer driver saw Corrie at the end of the play, the editors give Dale's indictment of the bulldozer driver the dramaturgical weight of 'this is what really happened.' Dale's report reveals the 'truth' as part of the dramatic closure of the play. His testimony is immediately followed by the video of Corrie at her fifth grade press conference. In the theatre, we see an image of a girl, the ten-year-old Corrie, projected on a large screen earnestly speaking about her desire to end world hunger. In the text of the play, Corrie's words are arranged on the page as poetry:

> I'm here for other children.
> I'm here because I care.
> I'm here because children everywhere are suffering and
> Because forty thousand people die each day from hunger.
> I'm here because those people are mostly children.
> We have got to understand that the poor are all around us and
> we are ignoring them.
> We have got to understand that these deaths are preventable.
> We have got to understand that people in Third World

Countries think and care and smile and cry just like us.
We have got to understand that they dream our dreams and we
dream theirs.
We have got to understand that they are us. We are them.
My dream is to stop hunger by the year 2000.
My dream is to give the poor a chance.
My dream is to save the forty thousand people who die each day.
My dream can and will come true if we all look into the future
and see the light that shines there.
If we ignore hunger, that light will go out.
If we all help and work together, it will grow and burn free
with the potential of tomorrow.

(52)

Rickman and Viner's selection of this video monologue as the final
moment of the play drives their thesis that Corrie's innocent and
honorable past was crushed by an ignoble present; that her childhood
idealism was run over by adult realpolitik. Corrie's idealism is presented
as an irrefutable, straightforward, and transcendent truth. She was a
young person with a set of ideals who died in pursuit of those ideals.
My Name is Rachel Corrie closes by telling its audience that blameless
people, children even, are martyred in the pursuit of justice. Read apart
from the play, the view Corrie expresses at the end of the play is deeply
humanist. We are them. They are us. Their dreams are ours. Our dreams
are theirs.[10]

Showing Rachel Corrie at the end of the performance as an idealistic,
innocent child pleading to end hunger, identifying with the hungry,
gives audiences the kind of decency they expect of protagonists. After
learning from Dale the 'truth' about how Corrie was killed, we encoun-
ter her resurrection in the semblance of a living presence in the pro-
jected pixels of light and dark forming her image before us. No longer
played by an actor, Corrie's actual face confronts us in the theatre,
the 'real' Rachel Corrie. But this 'real presence' is an image, actually a
deformation of an image. It is something both real and unreal taking
the shape of a compelling illustration. It is displaced in time, location,
topic, and affect. Corrie's resurrected pixel image creates the presence of
an inspirational child who speaks to us from beyond the grave. Rickman
and Viner create the eternal present of an innocent child enunciating
in poetic language her grand plan to end suffering caused by hunger,
a child with a great compassion for other children, a child who has
something important to say to the world of not-so-innocent adults. As

this eternal child flickers on the screen in the theatre, rational discourse is disabled. Rickman and Viner's selection guarantees that audiences hear (Dale) and see (Corrie); that audiences know that Rachel Corrie did not deserve to die, and that she died for a just cause.

This powerful conclusion also collapses, effaces, and obfuscates both Corrie and the situations in which she was enmeshed. The presence of the video reminds us that the play was created with the permission of Corrie's parents and, as such, had to be created with great respect for the parents' understanding of the events of their daughter's life, pay heed to their suffering at their daughter's loss, and honor their daughter's work of letting the world know about Gaza and the Palestinian cause. Audiences attending *My Name is Rachel Corrie* are excused from having to engage complex and competing discourses about the Israeli-Palestinian conflict and from having to develop ways to improve their understanding in order to create progressive change. With the selection of this final video monologue and the pixilated image of Corrie that follows, the editors underscore the need for social justice in terms of sympathy for Palestinians who are subject to Israeli military incursions, and who are disenfranchised and penned-in geographically and economically. None of this is to deny that the performance of Corrie's innocence that ends the play works theatrically – it is emotionally effective theatre – but it functions at the expense of critical analysis by presenting a one-sided portrayal of the conflict that generated the situation in Rafah, Gaza, at the time of the writing. There is no indication that any Israeli has a morally compelling argument about the military actions in Rafah that should be heard.

In *My Name is Rachel Corrie* the assertion of the need for social justice is also the assertion of the even stronger conviction that it has been denied. Just before Dale's eyewitness report, Rickman and Viner place a correspondence (stage directions do not identify whether it is a letter or an email) from Corrie to her mother with a deeply disturbing beginning in which Corrie powerfully foreshadows her own death: 'I have bad nightmares about tanks and bulldozers outside our house, and you and me inside' (47). The nightmare is precipitated by a mistake in translation that made a Palestinian father take his two tiny children outside, within view of snipers, when he thought his home was going to be 'exploded' (47). It is in this epistolary monologue, written in response to something Corrie's mother had written to her but not included in the play, that Corrie first addresses Palestinian violence in response to Israeli military presence and economic control of Gaza. 'I thought a lot about what you said about Palestinian violence not helping the situation.' She

continues, '60,000 people from Rafah worked in Israel two years ago. Now only 600 can go there for jobs. [...] Sources of economic growth are all completely destroyed – the airport (runways demolished, totally closed); the border for trade with Egypt (now a sniper tower in the middle of the crossing); access to the ocean (completely cut off in the last two years)' (47). Beyond describing the economic devastation of Gaza, Corrie responds to her mother's comment about Palestinian violence against Israel in regard to international law:

So when someone says that any act of Palestinian violence justifies Israel's actions not only do I question that logic in light of international law and the right of people to legitimate armed struggle in defense of their land and their families; not only do I question that logic in light of the fourth Geneva Convention which prohibits collective punishment, prohibits the transfer of an occupying country's population into an occupied area, prohibits the expropriation of water resources and the destruction of civilian infrastructure such as farms; not only do I question that logic in light of the notion that fifty-year-old Russian guns and homemade explosives can have any impact on one of the world's largest militaries, backed by the world's only superpower, I also question that logic on the basis of common sense.

(48)

This is the last portion of text that addresses the Israeli-Palestinian conflict, making it the defining point of view of Corrie, of the editors, and of the play.[11]

Just as the questions Corrie asks are important, the questions she does not ask are equally important. What weapons were brought into Gaza through the tunnels between Rafah and Egypt? Why did the suicide bombers in both the First and the Second Intifada expressly target Israeli civilians, even children? Why did the Israeli government close the borders and prohibit workers from entering Israel? Does the majority of the Palestinian population believe in the Hamas Charter and its call for jihad against all Jews?[12] What is the relationship between the UN vote declaring that Israel is a legitimate state, a refuge for the Jewish people after World War II and the Holocaust, and the ongoing refusal of most Arab countries to recognize Israel? Who benefits from the prevention of Palestinian and Jewish coexistence? What are the views of Israelis and Palestinians working for coexistence? These questions all have more than one answer. The answers may not be satisfactory. However, their

near complete absence, no matter the editors' intentions or precisely because of the editors' intentions, is what made performances of *My Name is Rachel Corrie* an occasion for protests against the subject matter of the play.

My Name is Rachel Corrie is about both Rachel Corrie *and* a historical and political conflict marked by entrenched opposing opinions. The play's reception has largely been in relation to the subject of Gaza and the Israeli-Palestinian conflict, despite the fact that it does nothing to refigure ideas about the conflict. The conflicting historical narratives of Israelis and Palestinians are not mentioned, nor do the editors offer any Palestinian point of view different from Corrie's.

Ari Roth, the Artistic Director of Theatre J in Washington, observes that the very creation of Rachel Corrie as a dramatic persona can be understood as the usurpation of an entirely different identity:

> The creation of the dramatic protagonist, Rachel Corrie, is an unconscious, or very deliberate hijacking of the symbol of Anne Frank as icon of indiscriminate violence and victimization. Its emotional effectiveness serves to shove the icon of Anne Frank off the stage and replace it with a newly minted edition of our millennium's new martyr. *Shalom*, Anne Frank and *Ahalan*, Rachel Corrie.
>
> (Roth in Martin 2006b:13)

The accusation that Corrie has been intentionally cloaked in the mantel of Anne Frank is only one possible reading of *My Name is Rachel Corrie*, but an important one conveying what some in the Jewish community felt. The editors take the position that truth is not ambiguous and multifaceted because justice demands that we understand Corrie's presence in Gaza as a brave and necessary act and that, like Anne Frank, Corrie is wise beyond her years, an accomplished writer, and, finally, a martyr.

My Name is Rachel Corrie has helped focus public attention on the plight of the Palestinians in Gaza. It has not generated a pluralistic point of view or enabled the efforts of those Israelis and Palestinians who work for coexistence and peace. Perhaps the most progressive social, as opposed to economic, approach to the Israeli-Palestinian conflict avoids either endorsing or denigrating moral equivalencies. A progressive position is not for either side but for both: two different histories, two intertwined stories of the suffering of two peoples. *My Name is Rachel Corrie* does not propose empathy for both peoples. The play eliminates the diversity of both Israeli and Palestinian points of view. In this elimination of two narratives, two histories, two realities, *My Name is Rachel*

Corrie helps sustain already clashing historical and political narratives and consequent demands based on these narratives that have hobbled diplomatic endeavors at least since 1967, if not 1948.

My Name Is Rachel Corrie does not represent all of who Rachel Corrie was as a public figure; and much of Corrie's public stance that was edited out of the play is available on the Internet. Some of this material shows Corrie enunciating a much more radical and inflammatory point of view about Israel than is contained in the play. The play does not consider that, as a person working for ISM, Corrie was as ideologically situated as the driver of the bulldozer. Corrie and the driver of the bulldozer that killed her were both participants in a clash of views formulated over more than 60 years and fought over in many wars. But the bulldozer driver is alive and Corrie is dead. Corrie died in the midst of a radical but nonviolent act of defense.

My Name Is Rachel Corrie does not tell us that Corrie was not the only civilian to lose her life in Gaza. It does not condemn the horrible military phrase 'collateral damage' in the ongoing disputes in the area. Corrie is not the only person ever to experience injustice, corruption, partisanship, blind self-interest, revenge, hatred, or the enforcement of unethical rules. To be shocked by what happened to Corrie is to be blind to the historical continuities of injustice across nations, governments, and peoples. Yet not to be shocked and saddened, outraged about the frame of mind of war and intifada, declared or not, whenever they are used as a justification for killing, is to give up hope.

Unlike Anna Deavere Smith's *Fires in the Mirror* (1993), *My Name Is Rachel Corrie* does not shuttle between opposing ideas in the play. Nor is a different moral imagination part of the play. The picture Smith paints is of the history and circumstances that created the moment in 1991 in Crown Heights, New York, when riots broke out after Gavin Cato, a black child, was killed by a Rebbe's motorcade, and Yankel Rosenbaum, a young Jewish scholar, was killed in retaliation one hot, hot day. Smith redeems and respects all the voices even the ones that are prejudicial against blacks, prejudicial against Jews. She ethically cleaves to the loss at hand by including Norman Rosenbaum's overbearing grief at his brother's loss in a public speech that incriminates America, Mayor Dinkins, and Commissioner Brown. At the close of the play, Gavin Cato's father stands alone under a streetlight sobbing, incriminating the Jewish people and what they said to him (Smith 1993:138).

The moral imagination of Smith's play embraces the accounts of all the people she interviewed even as the stories they told contradicted and accused one another. What Smith did so deftly in *Fires in the*

Mirror was to capture the multiple voices, sensibilities, and histories between and among two different groups of people. Smith created a third reality by including outside considerations, both generative and inflammatory, about race and religious identity – including ideas about hair, clothing, food, community, and social life. Angela Davis, Ntozake Shange, Reverend Al Sharpton, Letty Cottin Pogrebin, Minister Conrad Mohammed, and Rabbi Joseph Spielman all provide perspectives that, when taken together, produce an understanding beyond the crisis at hand. As Cornel West writes in the Foreword to *Fires in the Mirror*, Smith gives us 'poignant portraits of the everyday human faces that get caught up in the situation' and forces us to critically examine our own parochial views (West 1993:xvii). Unlike *Fires in the Mirror*, the moral imagination of *My Name Is Rachel Corrie* is limited to Corrie's point of view as it was formed in Gaza during the 50 days she was there and by the unanswered questions surrounding the horrible and tragic circumstances of her death.

Without Craig and Cindy Corrie's delivery of Rachel's writings to the Royal Court Theatre there would be no play. Craig and Cindy Corrie are the recipients of Rachel's emails and the dramatic representatives of the world outside of Gaza. They function as the moral guardians of truth and justice and representatives of the abiding love of parents for their children. They sought justice in relation to their daughter's death and took up her cause in making the suffering of Palestinians more visible to the world.

In the Introduction to the collection of their daughter's journal entries, entitled *Let Me Stand Alone: The Journals of Rachel Corrie*, the Corries write that they did not know which selections Rachel would have wanted published.[13] 'The pieces included in this book were chosen for their literary merit, as well as for how they enhance the narrative. There is no way of knowing which selections Rachel would have considered finished, which she would have reworked, which she would have wanted published, and which she would now judge unfit to share. [...] We have made minimal edits and done so with great care – trying to determine what Rachel might have done had she been preparing the material for publication [...]' (C. Corrie 2008:xviii–xix).

The trials

The play initially served as a substitute for the trial that never happened. The day after Corrie was killed, Israeli Prime Minister Ariel Sharon promised President Bush a 'thorough, in-depth' investigation.

What happened instead was a closed military investigation concluding that the two soldiers who operated the D9R Caterpillar bulldozer did not see Corrie. It was later reported that the Israeli Military Police questioning of the bulldozer commander was cut short by a direct order from Major General Doron Almog, who stated that the witness being questioned should not say or write anything. The soldier was reportedly in the middle of saying that he did not see Corrie. The internal army investigation exonerated the bulldozer driver and concluded that the soldiers could not have seen Corrie (Khoury 2010).

On 25 March 2003, US Congressman Brian Baird introduced House Concurrent Resolution 111 calling for the US government to conduct an investigation into the death of Rachel Corrie, but the resolution expired in committee at the end of the 108th Congress. Corrie's parents brought a lawsuit for unspecified damages against Caterpillar Inc., the maker of the bulldozers that killed their daughter and destroyed houses in Gaza, stating that Caterpillar violated the Geneva Convention and American torture laws when knowingly allowing their bulldozes to be used for the demolition of Palestinian homes. Caterpillar claimed they were not responsible for how their equipment is used (Goldenberg 2005). The court ruled that it did not have jurisdiction over the case because they could not determine the government's ability to conduct foreign policy.

Seven years after Corrie's death, the wrongful death suit that her parents filed against the Israeli government finally went to court in Haifa, Israel. Corrie's parents and members of the ISM claimed Rachel was run over deliberately and that the Israeli government was responsible for the negligence of its soldiers and commanders who acted without requisite regard for the safety of unarmed citizens at the scene.[14] The Israeli military claims Corrie's death was an accident that happened in a dangerous war zone where Corrie should not have been. Israeli army spokesperson Lieutenant-Colonel Avital Leibovich told Reuters that tear gas and stun grenades had been fired as warnings to protesters to move out of the way (*Reuters* 2010). *Ma'an News Agency* in Bethlehem reported that on the first day of the trial, the court heard testimony from British activists with the ISM, Richard Purssell and Dale, both of whom described a bulldozer driving four meters over Rachel Corrie before reversing back over her. The Corries' lawyer Husein Abu Husein argued, 'The Israeli government is covering this up under the umbrella of combat activity, which absolves soldiers of responsibility.' The Israeli State Prosecutor's office laid out its case by stating, 'The driver of the bulldozer and his commander had a very limited field of vision, such that they had no possibility of seeing Ms. Corrie.' In the same article, Israel was reported

as claiming that the action of the bulldozer was a 'military action in the course of war' enabling the state to bear no responsibility (*Ma'an News* 2010). Craig and Cindy Corrie accused Israel of whitewashing its investigation into their daughter's death.

Ma'an News Agency published the most thorough account of the opening day of the trial containing the most background information.[15] Its reportage from the beginning of the trial is identical in portions to an article published in the *New York Times* in the United States and *Haaretz* in Israel, thanks largely to AP and Reuters (see Eldar 2010; Rubin 2010). The identical prose in the *New York Times* and Reuters reads:

> The family of an American activist who was fatally crushed by an Israeli bulldozer in Gaza accused Israel of whitewashing its investigation into the death Wednesday in the opening of a civil case against Israel.
> The parents of Rachel Corrie are seeking unspecified compensation from Israel's Defense Ministry for their daughter's death in 2003.
> (Rubin 2010)

The Corries' request to see the face of the person who drove the bulldozer that killed their daughter was denied by the State of Israel.

> Arguing that it was concerned about the security of the soldiers, the State of Israel requested that the bulldozer driver and certain other soldiers testify from behind a partition. The use of a partition blocks the Corrie family and the public from seeing the face and the body language of the bulldozer driver, and denies the Corrie family from seeing what Cindy describes as 'the whole person' of the driver. The district court judge granted Israel's request, and the Supreme Court denied the Corrie family's appeal.[16]

The Corries understood this denial as part of the injustice that killed their daughter.

> 'When our daughter was killed, the Israeli government promised a thorough, credible and transparent investigation into her death, and neither our family nor our government believes that standard has been met,' said Cindy Corrie. Indeed, in response to inquiries from the Corrie family to the U.S. government regarding the Israeli Military Police investigation, Colin Powell's Chief of Staff, Lawrence B. Wilkerson, stated in 2004, 'Your ultimate question, however, is a valid one, i.e., whether or not we view that report to have reflected

an investigation that was "thorough, credible, and transparent." I can answer your question without equivocation. No, we do not consider it so.' The testimony to date in the trial taking place in Haifa reinforces this conclusion.[17]

Closing arguments to the case were heard in July 2011. The Corrie family accused Israel of unlawfully and intentionally killing Rachel or of gross negligence. They sought $1 in symbolic damages. On 28 August 2012 Judge Oded Gershon of the Haifa District Court ruled that Rachel's death was a 'regrettable accident' that occurred during military activity in a combat zone where the US government warned its citizens not to go and that Israel bore no responsibility for wrongful death.

New York Theatre Workshop: censorship and protest

My Name is Rachel Corrie was scheduled to open at New York Theatre Workshop (NYTW) in March of 2006. According to the timeline New York Theatre Workshop circulated, the Board of Trustees talked in depth about the script and unanimously agreed to support NYTW artistic director Jim Nicola's decision to bring the production from London to NYTW. Alan Rickman visited NYTW on 20 January 2006 to explain how he, Katharine Viner, and the Royal Court Theatre created their marketing campaign including public relations, press, and imagery. The NYTW timeline states, 'According to Rickman, the play that he and Viner shaped from Rachel's words was about a young American idealist who made a commitment to engage in making the world a just and better place. He said they wanted the audience to suspend their own views and opinions about the larger political conflict so they could focus on Rachel' (in NYTW 2006). That same spring, Nicola had second thoughts about presenting the play, resulting in what he said was a postponement. It generated outrage. Nicola was accused of yielding to pressure from pro-Israeli Jewish individuals and groups and of canceling instead of delaying the opening. Nicola and Lynn Moffat, the managing director of NYTW at the time, contended that in light of a sequence of events – Ariel Sharon, the Prime Minister of Israel, falling into a coma and the election of Hamas, a group identified as a terrorist organization by the United States and the European Union – the theatre needed more time to consider how to best provide a context for presenting *My Name is Rachel Corrie*. Many vocal people concluded that the play was censored, not postponed by the NYTW, eliciting a worldwide storm of protest. On 20 March 2006,the date *My Name is Rachel Corrie* was originally due

to open at NYTW, in a radio interview with Nicola, Moffat, and Viner conducted by Amy Goodman of *Democracy Now*, Moffat asserted:

> We still want to produce the play, and the word 'indefinite,' we don't know where that word came from. We really – and we never canceled the play. We were having a conversation with our colleagues at the Royal Court about the difficulties that we were having, not only just with the research that we were doing about the project and about the play, but also about, you know, contracts and budgets and fundraising, and all that sort of stuff.
>
> (in *Democracy Now* 2006[18])

The contextualization Moffat thought was needed was post-performance discussions with scholars and members of different communities in order to help audiences appreciate the complexities of the situation represented in the play. Katharine Viner responded:

> Yeah. I mean, I'm actually not a co-producer of the play. I was just the co-editor, so – but as I understand it, we had everything set. Our tickets – our flight tickets were booked. I was due to fly out yesterday to New York. The production schedule was finalized. Both sides of the Atlantic had agreed on a press release that was going to go out to the press, announcing the production of *My Name is Rachel Corrie*, and then the Royal Court, as I was told, received a telephone call saying that the play was to be postponed indefinitely. That's where the phrase came from. We said we regarded that as a cancelation; because everything was ready, and there were barely – think it was five or six weeks to go. And then they asked us, the New York Theatre Workshop asked the Royal Court to give them time in order to work out how to present this 'postponement,' as they called it – 'cancelation,' as we took it to be – and we gave them that time.
>
> But then Mr. Nicola started giving quotes, saying it was actually a tentative arrangement, and we felt at that point that we had to go public with the story, because it was not a tentative arrangement. This was a definite arrangement. But, you know, I don't think – I think we could get into the, you know, 'You emailed on this day, you telephoned on this day' conversation, but actually there's a much bigger picture here and a much more important story, which is about the political smearing of Rachel Corrie, and there's no doubt that the New York Theatre Workshop was the victim of a political smear campaign.

And I could have – you know, I understand this about contextualization. I personally think that works of art should be able to stand on their own, and consultation isn't necessary. However, if that's how things are done in New York, then I understand why, you know, say, Jewish community groups may have been contacted. I don't quite understand why Arab American groups weren't contacted, and I also don't understand why I wasn't consulted. You know, I was brought in to do this play, because I understood the political context, and I know about narrative, but also mainly because I understand about the political context, and I could have warned the New York Theatre Workshop all about the misinformation there is about Rachel Corrie on the Internet. I could have told them why – I understand why that happens. She's a very powerful figure, and I could have helped them.

(in *Democracy Now* 2006)

Viner was surprised by the success of the play, which was the fastest sell-out at the Royal Court since *Look Back in Anger* 50 years earlier. And, she said at the top of the broadcast, that since they had gone public with the story of the cancelation of the play, a West End producer had stepped in to transfer the play to the West End in hope of '[...] a major commercial success, as well as a major artistic success' (in *Democracy Now* 2006). It is not clear whether or not announcing in the *Guardian* what NYTW claimed was a postponement as a cancelation was a strategic move to exploit publicity about the play and the life of Rachel Corrie in order to secure a transfer to a major theatre venue. Nor we will ever know if the PR consulting firm Finn Ruder, advised NYTW not to present the play. Citing *The Nation*, Goodman stated in the interview that Finn Ruder is known for having represented the state of Israel in the past. Moffat evaded Goodman's question about Finn Ruder's advice regarding *My Name is Rachel Corrie*. Viner was not asked about the timing of the cancelation of the play in relation to the announcement of its transfer to the West End. During the interview, Goodman read a letter to the *New York Times* signed by Harold Pinter, Gillian Slovo, and Stephen Fry, along with 18 others dated 20 March 2011.

We are Jewish writers who supported the Royal Court production of *My Name Is Rachel Corrie*. We are dismayed by the decision of the New York Theatre Workshop to cancel or postpone the play's production. We believe that this is an important play, particularly, perhaps,

for an American audience that too rarely has an opportunity to see and judge for itself the material it contends with.

(in *Democracy Now* 2006)

The play, they asserted, raised important issues about Israeli military activity in the Occupied Territories. Americans, they asserted, needed this lesson. They understood *My Name is Rachel Corrie* as not just the story of a young woman but an issue-based play with a moral. The Jewish writers did not consider the politics of presenting an issue-based play from a singular and admittedly a-historical perspective.

Nicola was right about one thing. His fear was that just presenting the play would align NYTW with a position on the conflict. What he did not understand early on was that *not* presenting the play would also align NYTW with a position on the conflict.

The reception of *My Name is Rachel Corrie* is not solely dependent upon its content, its structure, or its method of theatrical presentation. Corrie's story and its performance is nested in systems of meaning that include context, social circumstance, surrounding performative circumstances such as debates about Corrie and her actions, the Internet, and the *Guardian*'s publication of Corrie's emails. All of these, both independently and interacting with each other, shape both its text and its reception.

A killing without a trial; a play without a conclusion. Legal and theatrical enactments tell us a lot about the ritualized civic function of performance. Trials and theatre, close cousins dramaturgically, promote a discourse that provides spectators, both physically present and those who follow through many different kinds of reportage, the ability to perform their own citizenship through the participatory observation of ritualized debate. What happens when neither a trial nor the performance of a play occur? What forms do citizenship, protest, resistance, prejudice, and justice take when there is no public trial? Israel's private army inquiry and the reasons for NYTW failing to open the play are opaque. Can anyone say for sure that 'Jewish-Israeli pressure' resulted in the NYTW's postponement/cancelation of the play? Can anyone say for sure whether or not the bulldozer driver saw Rachel Corrie before running her down? Can we be certain that the controversy over postponement versus cancellation was not created as part of the showman's maxim that all publicity is good publicity, especially since it all led to a West End production?

My Name is Rachel Corrie did open in New York at the Minetta Lane Theatre in Greenwich Village on 15 October 2006 and ran until the end

of December. The moment was different. Reviews were polite but tepid. *New York Times* critic Ben Brantley, for example, noted two responses to the performance with which he could identify, on man snoring, another sobbing. For Brantley, the production was 'freighted with months of angry public argument, condemnation, celebration and prejudgment' all of which made 'many theatergoers wonder what all the shouting was about, especially in a town where one-person shows expressing extreme points of view are common theatrical fare.'[19]

The multiple layers of spectatorship and engagement that trials and theatre provide were threatened by the postponement or cancelation on the part of NYTW. Other theatres prevented the reenactment of *My Name Is Rachel Corrie*, including the Canadian Stage Company where the artistic director Martin Bragg changed his mind about including it in the theatre's 2007/8 subscription season. Bragg had found the script moving but when he saw the production at the Minetta Lane Theatre he had a change of heart. 'The truth is,' he is reported as saying, 'it just didn't seem as powerful onstage as it did on the page – and the audience wasn't buying it.'[20] As with NYTW, there was a competing version about why Bragg changed his mind. The alternate version is reported, without attribution, by 'CanStage' insiders:

Members of Bragg's board were alarmed by negative response from influential supporters of the theatre, especially Toronto's Jewish community, who were canvassed for their opinion. Many were dismayed and openly critical when confronted with the prospect of the city's flagship not-for-profit theatre producing a play that could be construed as anti-Semitic propaganda, especially during a frightening period when Israel's existence is threatened by Iran, Hezbollah, and Hamas.[21]

In the case of CanStage, two members of the Board did come forward publicly. Bluma Appel, who gave a major contribution to the theatre, was quoted as objecting not only to plays that would make Jews look bad but also to plays that were 'offensive to blacks or Muslims or white Christians.' Board member Jack Rose stated that even though he had not read or seen the play, he thought it would provoke a negative reaction in the Jewish community.

The story of the controversy about the play in the public forum often trumped the subject matter of the play itself. Rachel Corrie's untimely death was meaningful for a large public audience precisely because it occurred in the midst of an ongoing conflict with deeply divided

international supporters and detractors. Competing versions about Rachel Corrie and the way she died were met with competing versions of why the play was postponed or canceled by NYTW and CanStage.

Performance scholars emphasize the uniqueness of performance texts that examine the ways in which the world is theatrically created and critiqued. The facts, the underlying patterns and approaches, the assumptions and influences that are inevitably woven into theatre of the real tell us something about the zeitgeist of an era, the stance of the editors or authors, the performative circumstances that actually guide events and the debates about the events. The reception of *My Name is Rachel Corrie* was governed by the way memory and history can be irreconcilable. The story of the play became the story of the controversy the play provoked.

6
Seems Like I Can See Him Sometimes

The aide said that guys like me were 'in what we call the reality-based community,' which he defined as people who 'believe that solutions emerge from your judicious study of discernible reality.' I nodded and murmured something about enlightenment principles and empiricism. He cut me off. 'That's not the way the world really works anymore,' he continued. 'We're an empire now, and when we act, we create our own reality. And while you're studying that reality – judiciously, as you will – we'll act again, creating other new realities, which you can study too, and that's how things will sort out. We're history's actors... and you, all of you, will be left to just study what we do.

Ron Suskind[1]

Between the truth and lies there is a hair, and I am trying to cut this hair and as I do this I remember the words of the poet Al Akhtal Assaghir: 'He cries and laughs not for sadness or joy like a lover, no he draws a circle in the air and then erases it.'

Rabih Mroué[2]

Tom laughed uneasily, 'Well, maybe like Casy says, a fella ain't got a soul of his own, but on'y a piece of a big one – an' then –
'Then what, Tom?'
'Then it don' matter. Then I'll be all aroun' in the dark. I'll be ever'where – wherever you look. Wherever they's a fight

149

> *So hungry people can eat, I'll be there. Wherever they's*
> *a cop beatin' up a guy, I'll be there. If Casy knowed,*
> *why, I'll be in the way guys yell when they're mad an' –*
> *I'll be in the way kids laugh when they're hungry an'*
> *they know supper's ready. An' when our folks eat the*
> *stuff they raise an' live in the houses they build – why,*
> *I'll be there. See? God, I'm talkin' like Casy. Comes if*
> *thinkin' about him so much. Seems like I can see him*
> *sometimes.'*
>
> John Steinbeck

One evening in the fall of 2008 I attended the three-part participa-
tory theatre piece *Surrender: A Simulated War Deployment in Three Acts*
directed by Josh Fox of the International WOW Company. Putting aside
my antipathy for audience participation, I was certain that in order to
really experience this work I had to go alone. I thought being by myself
would, to a certain degree, disable my critical apparatus and allow me
to more fully participate in what I understood was to be a simulated
war experience. Not something I typically sign up for, *Surrender* began
with every audience member putting on army clothes. As I stood there
in fatigues and boots I felt ridiculous. I was so happy no one I knew
was there; and, contrarily, unhappy that I was alone. My feelings of
trepidation soon changed into astonishment at what I was asked to
do, and then rapidly deteriorated into half-tearful murmuring as the
evening wore on. As newly enlisted soldiers, we theatregoers had to
undergo basic combat training: marching, yelling, doing push-ups,
jumping jacks, sit-ups, saluting, and, finally, shooting guns. US Army
National Guardsman, Jason Christopher Hartley (Fox's coauthor) took
us through these drills. Hartley's voice carried absolute authority, deter-
mination, and intention. He scared the ... indolence right out of me
(Illustration 6.1).[3]

Audience members attending *Surrender* who did not want to put
their bodies on the line, on the ground, or in military fatigues could
be observers. While waiting outside the theatre in the induction line,
individuals were approached by 'enlisted persons' and informed of
their choice. We were strongly encouraged to participate. Observers
were ushered to the back of the Ohio Theatre warehouse space in
New York, while participants were issued uniforms and boots and taken
to a designated area closed off from view by hanging sheets, and ordered
to change – FAST. My colleague Jim Ball saw *Surrender* with Gelsey Bell

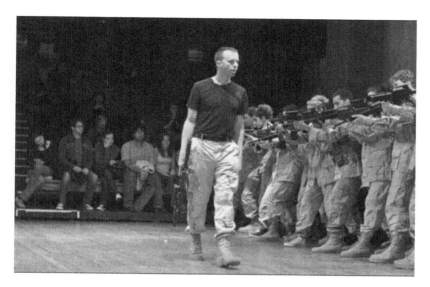

Illustration 6.1 Jason Christopher Hartley conducting basic training in *Surrender* by Josh Fox and Hartley, directed by Josh Fox. Photograph by Josh Fox

on a different night. About audience participation in *Surrender* Ball and Bell observe:

> Simultaneously [to the process of training], the division between actor and audience disappears quite literally before our eyes. Actors can be identified – they are the ones yelling at you for tying your shoes wrong, having your nametag hung incorrectly, or taking your time. And yet, that man in a uniform crossing through the space with purpose, is he an actor or an audience member that had taken on a role? The fourth wall separating actor and audience is here the hierarchal distance between officers and grunts.
>
> (Ball and Bell 2012:59)

Wearing identical uniforms, marching and exercising with a movement vocabulary of straight lines, both in space and on the body, did little to bond me with my fellow combatants. 'The FAQ sheet online that said there would be no strenuous activity was a lie,' snarled Hartley. The threat of transgression well beyond the usual conventions of theatre made me take refuge in the knowledge that I could set the limits of my

participation at any time. 'This is, after all, only theatre,' I thought. The sentiment was a pedestrian form of Gregory Bateson's 'The nip denotes the bite but does not denote what the bite denotes' (2000:180). I kept telling myself, 'this is play.' But not entirely make-believe.

When the fake M4 rifles were handed out, the quality of participation began to change. Ball and Bell attribute this to the particular kind of attention learning to use the guns demanded.

> In any situation, when you are feeling self-conscious or don't know what to do with yourself, the intricacies of getting to know an object and then taking care of it can fill the space. A gun is, literally, *the* loaded object, power personified, a superhuman extension of the body. In training, we are taught which side to shoot with (it is not as simple as being left- or right-handed), how to hold our rifle, and how to adjust our posture. Our plastic replica rifles are clearly fakes, but weigh more than expected: they feel like more than toys.
>
> (2012:60)

Ball and Bell observe the way the subject and the thing, whether real or fake, work together to create a new reality. They point out how our apprehension about and admiration for material objects affects our perception of a situation and, contrastingly, how the absence of real objects (when we are meant to pretend that the objects are real) can likewise change our perception of a performance. The toy guns confirmed that spectator-participants were a pseudo army in a performance space, playing a theatre war game that required a suspension of disbelief.

So when I entered the 'Iraqi village' as a soldier in a 'combat unit' that was 'clearing' the village and encountered a woman in the corner of a stage-set room wearing a veil, I was surprised at my thoughts and emotions. My job in my unit was to search everyone we encountered for weapons and forcibly interrogate them to obtain information. The instructions we were given were to search men 'everywhere' but not to touch women's breasts or genitals and not to remove their head coverings. We were warned that an ineffective search could lead to unit members getting shot and being 'evacuated to the hospital' a euphemism for being eliminated from participating in the war game that was *Surrender*. Confronted with the woman in a veil, I thought, for a moment, that she might have a weapon. Not wanting either my unit mates or myself to get killed, I thought it was better to search her just to be on the safe side. When I reached down to do so she burst out crying. Shaken but determined not to risk my unit's well-being, I carried out the task as

instructed and searched the antagonist as warm globs of tears flowed down her face. Her tears brought tears to my eyes. I found nothing. I was relieved.

Moving to the next part of the village, bombarded by the deafening sound of artillery explosions, machine guns, and helicopters, all the while keeping close to my combat unit members so as not to get killed or kidnapped, I began to think about the simulation in which I was engulfed. What would Iraqis suffering the real war waged by the US think if they knew we were playing the Iraq War in a Soho theatre in New York? My ethical trouble was not with the game but with the fact that the game was made from the real War in Iraq, the outcome of which was still uncertain as great violence continued during the Allied Forces' 'surge' in occupied Iraq. *Surrender*'s audience participation had some of the atmosphere of the real with its physical demands, formation of combat units, deafening noise, and body searches. At the same time it was nothing like war, even as it was a very serious form of theatrical play about a real war where reporters 'embedded' with the troops, filed graphic reports, photos, and videos.

In her essay 'Is That Real? An Exploration of What Is Real in a Performance Based on History,' Catherine Hughes points out that the word 'real' is used in relation to truthfulness, honesty, and to the feeling of experience (2011: 135). Hughes interprets this range of usage as relating to 'belief in the truth of the moment and in the honesty of the creators of that moment – such as the actor or the writer' (135). In the case of *Surrender*, whether or not Fox or Hartley's intentions were trustworthy was not as important as the relationship each participant had with her own participation. The fake M4 rifles, learning how to handle them, to shoot them, to carry them helped to usher in participation in the dark play of the performance. Participants in *Surrender* were in a play frame that was in conversation with analogous real events. The ritualized substitution of fake rifles for real rifles, spectators for real soldiers, and actors for Iraqis was structured to nod toward the larger political reality that contained and informed the theatrical reality: the War in Iraq where US soldiers were faced with 'enemy combatants' – and Iraqi people, both insurgents and civilians (also known as collateral damage) were dying. Consciousness of the play frame both reinforced and destabilized *Surrender*'s call for reality. It also signaled *Surrender*'s success at creating disturbed spectators who asked questions about the way systems of power work in combat situations.

The performances I discuss in this chapter both disrupt *and* construct aesthetic authenticity and documentary certainty. They are examples

of theatre of the real that is no longer focused solely on the notion of objective witnessing. By combining fiction and nonfiction they, in the words of Forsyth and Megson, 'situate historical truth as an embattled site of contestation' (2009:6). Josh Fox's *Surrender* (2008), The Builders Association's *House / Divided* (2011), and Rabih Mroué's *The Pixelated Revolution* (2011) exhibit how theatre of the real can explain and question the relationship between fact and fiction, aesthetic innovation, and political ideas. These three works expose entire mechanisms by which 'facts' are manufactured, vetted, and communicated. The creators of these performances all craft a relationship with the real by using presentational and representational strategies. *Surrender* is a re-performance of military training that deploys its audience-participants to Iraq. *House / Divided* treats fiction as nonfiction by using the American novel *The Grapes of Wrath* as historical source material and combines it with images of foreclosed homes from the housing foreclosure crisis that followed the stock market crash and verbatim text from Alan Greenspan, the former chairman of the Federal Reserve. *The Pixelated Revolution* assembles a fictional aesthetic manifesto built from nonfictional sources through an analysis of YouTube videos of the Syrian revolution. Each of these theatre works constructs powerful and entertaining inquiries into the relationship between aesthetic conventions, the positioning and involvement of spectators, and government policies, that is, politics.

Surrender

Typically a spectator becomes a spectator by locating herself outside the performance she is watching. This is an active choice. What happens when the spectator is also a performer? The creation of meaning in relation to receiving the performance does not stop. The performance as object of scrutiny now includes the self in a highly specialized circumstance. The self at play as a spectator/performer becomes a part of the construction of interpretation. Suspension of disbelief now includes the spectator/performer's own status. In my case this was, 'I agree to believe that I am a soldier' or 'I agree to disbelieve that I am not a soldier' while, of course, knowing full well that I am not a soldier even as I was, at times, invested in playing one. Live performance is always fully situated in the context of secular ritual such as the separation of spectators and performers, specialized language, behavior, and clothing, and hierarchies of spectatorship and participation even when attempting to defy that ritual – as, for example, when spectators are asked to take part in a performance. Fox exploited a general lack of knowledge about both basic

training and warfare in devising audience participation in *Surrender*. Part of the subject became the ability and willingness to play the ritualized game of the performance as if it were real or at least as if participation might have consequences outside the frame of theatre play.

Ball and Bell illustrate this point when they identify the ambiguous status of the fake M4 rifles as toys and yet simultaneously something more than toys. In his 'Introduction' to *Things*, Bill Brown writes about the status of things as being much more than inert instruments that we possess. The force that things have is socially and culturally determined.

The question is less about 'what things are in a given society' than about what claims on your attention and on your action are made on behalf of things. If society seems to impose itself on the 'corporeal imagination,' when and how does that imagination struggle against the imposition, and what role do things, physically or conceptually, play in the struggle? How does the effort to rethink things become an effort to *re*institute society?

(2004:9)

In *Surrender*, the status of the fake firearms was directly connected to the status of the real firearms that were being used in the Iraq War occurring at the same time. This was clearly demonstrated to me when Fox, who was present at every performance, came over during the second half of the show and put a real M4 rifle in my lap. The weight of it, the cold-metal feel of it, and the potential of its trigger made me think about the war in Iraq. The gun was fundamentally different from, but also related to, the status of the fake gun I had been carrying. One signaled play, the other the presence of actual violence and power. I was left alone with the gun, which I assumed was not loaded, until an actor took it from me and carried it away. Being handed the gun seemed a random occurrence that was not visited upon other audience members that evening.

After clearing the village, we sat down in rows on a descending stairway where a flight simulation projection played over our heads. At the sound of a plane engine, we were told we were headed home. When we disembarked, we were no longer in a combat zone but at a dance party where actors offered us free beer. I saw the village woman I had searched – but now she was dressed in a skimpy outfit happily dancing around the room. 'Ah,' I thought, 'her tears weren't real.' And then I thought, 'but mine were.' The thought betrayed a division between performers and participants/spectators; as an actor, she was suspect but

as a spectator I was sincere. She was a manipulator of experience and I was the recipient even as my designated role was as a pariticipant. The game we played was not unlike those used by the military to train soldiers for war. In 'Rehearsing the Warrior Ethos: "Theatre Immersion" and the Simulation of Theatres of War,' Scott Magelssen (2009) writes about how the armed forces have used theatre and performance techniques to expose combatants to the reality of war in places such as Iraq and Afghanistan. Entire villages – Disney World–like villages populated with costumed actors situated in real-life settings – provide the ersatz environment that serves as the training ground for a twin world thousands of miles away.

> The largest such facility is at the National Training Center (NTC) at Fort Irwin, a 1000-square-mile simulation of an Iraqi province in California's Mojave Desert – appropriately dubbed the 'Sandbox.' It is both a virtual space of play and experimentation, and a mirror reproduction of the real Iraq (also referred to as the 'Sandbox' by US troops). Ten months out of the year, battalions of soldiers are immersed into this full-size simulation, complete with nine working villages peopled with Arabic-speaking Iraqis engaged in quotidian business and social transactions. The townspeople are portrayed by Arabic-speaking Iraqi expatriates from Detroit, San Diego, and other cities with established Middle Eastern American populations. Alongside this, the soldiers are exposed to guerilla combat, convoy ambushes, IED (improvised explosive device) encounters, and televised beheadings. The American soldiers' job, over the course of two weeks in the Sandbox, is to learn to live and work sensitively with Iraqi civilians, to mediate in sectarian and ethnic conflicts, and to gain trust, all the while trying not to produce more insurgents by making mistakes. Over time, this kind of fighting disappeared – and today's wars are fought with virtual weapons so that people actually die but the killers do not experience killing them.
>
> (Magelssen 2009:48)

As with *Surrender*, the goal of NTC at Fort Irwin is to encounter the real by means of theatre. Participating in *Surrender*, however, is not a rehearsal or training for a future situation but an end in itself. *Surrender*, finally, is a theatre game made for a participating audience. It is a game based on a simulation; a game of a game. Unintentionally, the participants in *Surrender* are like the inhabitants of Plato's cave: twice removed from the real. Unlike the soldiers in the simulation at Fort Irwin who

are training to embody the warrior ethos as a response to future situations of war, the participants in *Surrender* are not preparing for an event outside the performance. They are enjoying themselves even as they are put through what to some is a frightening experience. But this is an experience of make-believe terror, as in an amusement park funhouse. The soldiers at Fort Irwin are being inoculated against the panic of real war by engaging in a simulation of it. By means of the Fort Irwin performance, the soldiers become... better soldiers. In *Surrender*, the audience both enjoys itself and learns more about how twenty-first-century war is prepared for and fought. At Fort Irwin, the soldiers are learning how to wage war. In *Surrender*, the audience is taking part in a Brechtian *lehrstuck*, a play for learning and a political statement. In both situations, participants are themselves, not specific characters beyond the archetype of soldier. The participants in *Surrender* are playacting being soldiers in simulated situations without real consequences, while the soldiers at Fort Irwin are playacting situations in simulated villages to prepare for future situations where they will play real soldiers in real theatres of war with potential deadly results.

In the third part of *Surrender* participants become spectators of and selected participants in a series of small episodes about veteran life after the war. A few audience members were asked to play Iraqi war veterans in short scenes by reading their parts from a teleprompter. The narratives were about how veterans were prevented from getting the physical and psychological health care they needed, about personal relationships falling apart, about being haunted by recurring violent images, and about an absurd disjunction between heroic war narratives and the lives of actual soldiers. Actors in animal costumes wandered around the stage as meat was grilled and hung on a downstage clothesline.

House / Divided

House / Divided, directed by Marianne Weems also conjoined the real with the simulated and the fictional. The burst of the housing bubble in 2007, the stock market crash, the bank and industry crisis, and the recession that followed prompted the creation of the work. Members of The Builders Association asked questions about the collapse of the American and global economic infrastructure, especially the loss of homes. They researched and considered the relationship among spaces, places, and material goods as well as virtual realities. What have houses come to mean as commodities in the global marketplace? How does something as abstract as prices on the stock market affect something

as real as a family's home? How did the extreme loss of wealth affect ordinary people? Have events like these happened before? The last question led company members to read John Steinbeck's 1939 Great Depression chronicle, *The Grapes of Wrath*.

Like *Surrender*, *House / Divided* is inhabited by cultural memory and narrative recycling. There's a sense of foreboding, a dread of a looming financial monster, an unseen predator consuming people, their livelihoods, and their homes. By using *The Grapes of Wrath* The Builders Association suggests that the same monster that terrorized the world with the Great Depression in the 1930s has come back to life in the first decade of the twenty-first century. At the beginning of the work, when the Omniscient Narrator quotes the character from *The Grapes of Wrath*, Pa Joad, trying to understand what has been said to him about why he is losing his land mirrors contemporary attempts to understand the most recent financial crisis:

> If a bank or a finance company owned the land, the owner man said, the Bank – or the Company – needs – wants – insists – must have – as though the Bank or the Company were a monster, with thought and feeling, which has ensnared them. The monster must have profits all the time or it dies; it can't stay one size.
> (Steinbeck as quoted by The Builders Association 2011)

The performance began with a house being assembled onstage. Stairs moved downstage, parts of the house suspended from the overhead fly space swirled into place, and then a pediment flew in as the whole structure was dressed by video projections that turned the edifice into a house on North 4th Street in Columbus, Ohio (Illustration 6.2). At other moments, with the help of another layer of video dressing, this house then became the house of Steinbeck's Joad family in *The Grapes of Wrath*: Ma, Pa, Uncle John, Tom, and Rose of Sharon.

The onstage house is both in the present and in the past, it is both material and animated created as it was from large chunks of several rooms and walls, cut straight out of the house on North 4th Street, and digital projection. So, too, the characters in *House / Divided* are contemporary and historical, real and fictional. The short, episodic, and fluid scenes were connected by digital transformations between past and present, of the house, and the temporal connotation of sound. At the end of scene 1, for example, the bell that Ma, a main character in *The Grapes of Wrath*, rings for dinner morphs into the opening bell of the New York Stock Exchange that begins scene 2. The illuminated stock

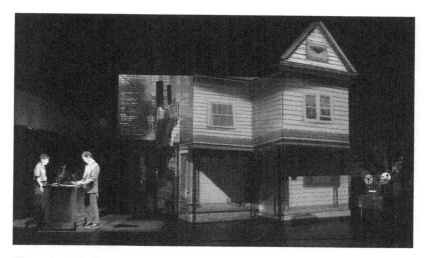

Illustration 6.2 Jess Barbagallo and Sean Donovan as traders and the onstage house dressed as the house on North 4th Street in *House / Divided*, devised by The Builders Association. Photograph by Jay LaPrete

ticker numbers that crawl across the traders' desk are like an army of termites as they creep across the stage and over the house to envelop and consume it (Illustration 6.3). The material reality of the house onstage, and by extension homes, becomes threatened by digitized allusions to securities, mortgages, promissory notes, subprime mortgages, and prestige rated zip codes.

Like the theatre itself, the real house on North 4th Street in Columbus, Ohio that *House / Divided* represents was occupied by dreams and vanquished desires, by memories and personal possessions, by financial stability and its loss. Set designers Neal Wilkinson and John Cleater got permission from the real estate firm that bought the house to take whatever they wanted from it. A bathtub, faucets, and personal items were brought into rehearsal and some made their way into the production as stage objects.[4] Although not all of the things the designers took were specifically used in the production, several artifacts, such as half of the bathtub, were part of the set and many of the smaller objects lived on a table backstage. According to Weems, The Builders Association began by rethinking property and territory, and what happens to houses abandoned as the consequence of unpaid mortgages. The production includes interviews with realtors explaining their professional relationship with foreclosed homes, and portions of the verbatim testimony

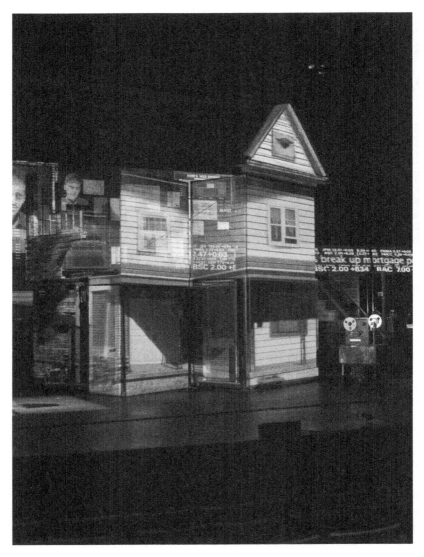

Illustration 6.3 The house with stock market numbers flickering across it in *House / Divided*, devised by The Builders Association, directed by Marianne Weems. Photograph by James Gibbs

given by former Federal Reserve chairman, Alan Greenspan (played at the beginning of the performance by Sean Donovan) to a congressional committee on 23 October 2008, in which Greenspan admitted that errors in regulation may have been a catalyst for the recession. Just before Greenspan's testimony is projected on the house at the end of the production, the scene cuts to the Omniscient Narrator who laments a sudden onslaught of rain strong enough to bring down great trees and threaten everything in its path. In response, the fictional Joad family scrambles to save themselves. The scene then cuts to Greenspan's huge looming image, as if he were speaking from a secreted place on high. His testimony is projected onto a central surface of the set that also is, at other moments, a projected wall of the real house on North 4th Street and the house of the fictional Joad family in *The Grapes of Wrath*:

> Before I begin by discussing the role of the Federal Reserve in our system, and the steps we've taken over the last ten years to respond to emerging questions in the housing and credit markets, I want to make this preliminary statement: Policymakers cannot predict the future. There is no way that the subprime crisis could have been predicted, and even now, there is no way of knowing how many more homes will end up underwater.
>
> (The Builders Association 2011)

Juxtaposing *The Grapes of Wrath* with Greenspan's speech established the relationship and relevance of the past to the present and created an eerie *déjà vu* perspective to the most recent foreclosure crisis and in so doing produced consciousness of the repetition of traumatic events. *House / Divided*, like other works by The Builders Association, is driven by the formal merger of live performance, architecture, video and film, and the weaving of contemporary interviews with literature from and facts about the Great Depression. The past that *House / Divided* portrays – a past of ordinary people, poor people suffering from an inequitable system, as the Joad family did – is a past that is recurring. The frame of the house, with everything 'house' implies – home, shelter, security, belonging, family, childhood, love, food, permanence, continuity, loss, and trauma – became the sign of the troubled foundation of the nation and a representation of all those who bore the consequences of Greenspan's miscalculations.

In performance, The Builders Association treats *The Grapes of Wrath* as an historical object that they recycle in the same manner they manipulate the onstage house; the novel is animated, enacted, and transformed

in ways that associate it with the economic crisis of 2008. Steinbeck began writing *The Grapes of Wrath* in response to a journalism assignment from *Life* magazine. Documentary photographer Horace Bristol and Steinbeck traveled together to California labor camps in the winter of 1937/8. Once on the ground in the midst of the misery he had come to document, Steinbeck dumped the *Life* magazine project in favor of writing a novel that was adapted for film. Some of Bristol's photographs were eventually published in *Life* magazine many years later next to stills from the 1940 film adaptation of Steinbeck's novel. Bristol's photographs had been used as references for casting and costuming for the film. Bristol titled his series of photographs *The Grapes of Wrath* to identify it with Steinbeck's 1939 novel and even retitled his image of a man (name unknown) chopping wood *'Tom Joad Chopping Wood'* after the pivotal character (played by Henry Fonda in the film) in Steinbeck's novel.[5] Bristol photographed people during The Great Depression in the emerging style of black and white documentary photography. Then Bristol shifted mode by using Steinbeck's characters' names to identify the people he photographed – a decision that signaled that Steinbeck's fiction had so captured the public imagination that 'nameless/identity less' real people and their situations would be made even 'more real' by assigning them well-known fictional names. The novel lent authenticity to what was all too real before the novel was even conceived, no less written. The historical work that *House / Divided* performs is to construct its own version of reality (or fiction?) based on actual people and their historical situation. Builders is doing the work both of Bristol and Steinbeck – adding still another twist to the real-as-fiction-as-real helix. The Builders Association underscores the need to establish a close relationship between fiction and nonfiction by positioning *The Grapes of Wrath* as *the* American Ur story or Master narrative of economic and social inequity – as cogent in the twenty-first century as it was in the twentieth. This fictional story is inseparable from the real times and people it represents.

Exploiting the nonfictional aspects of *The Grapes of Wrath* by using the fictional narrative as an indexical sign of the real, both past and present, is a method that The Builders Association uses throughout *House / Divided*. Even the uneasy sense of a predatory presence operates both as a metaphor and as something real. In *Grapes of Wrath* the predator is the bank that takes away the sharecroppers' land, and brings in the big Cats – the Caterpillar tractors--to demolish the pitiful houses. In the world of the performance, another big cat shows up in a foreclosed home. In scene 11, a call center receives a call reporting 'wild cats'

living in a house next door. As the caller tries to convince the person at the call center that there is indeed a mountain lion with kittens in the abandoned house, she walks into the house, says 'Hello Kitty!' drops her phone… and that's the last we hear from her. The idea for the scene came from a YouTube clip that a company member uploaded into the password-protected wiki blog that the company used to contain visual and textual ideas while developing the production. Nature makes an appearance in this scene, which occurs right in the middle of the play, in a way that is analogous to the way it operates in *The Grapes of Wrath*: the severe droughts in the United States in the 1930s killed the crops and took over the land, even moving sand and soil into the sharecropper shacks the way the mountain lions moved into the foreclosed homes. Unlike historical drama with its time lag between the now of the performance and the then of the historical event, *House / Divided* recombines the past and the present. The historical record, the archive, is not only in the past, it is also in the present – and we are living it. According to Weems, when company members watched the 1940 film version of *The Grapes of Wrath*: 'It became so clear that it was still such unbelievably contemporary material and that if you substitute the word "house" for "farm," the bank is the monster, it's the same story' (in Schechner 2012). The real is both then and now.

The Builders Association made *House / Divided* by integrating technology with live performance. 'No one in the company thinks textually,' Weems explains (Schechner 2012). Co-creator, writer, and dramaturg James Gibbs, who was trained as an architect at Cornell University, brings the technical ability of his for-profit D-Box company, which does animation, web design, architectural photography, and graphic design, to the way the work is conceptualized from the very beginning. By fusing architecture, fabric such as tent cloth, objects from the foreclosed home on North 4th Street, digitized imagery, interviews, and excerpts of preexisting text, The Builders Association reconstructs a lost ethos of the nation. Who have 'we' become? This question was not only answered by showing a prior object and recycling an old story but by creating an awareness of history with the temporal tools of theatre where the past and the present can coexist at the same time. Close to the very end of *House / Divided*, video footage of Greenspan as he testified to the congressional committee is projected. In one of the culminating statements of the performance he says, 'Well, remember that what an ideology is, is a conceptual framework for the way we deal with reality. Everyone has one. You have to – to exist, you need an ideology. The question is whether it is accurate or not' (The Builders Association 2011).

House / Divided avoids the many biblical allusions in *The Grapes of Wrath*, favoring instead the alternation of oral, statistical, and architectural languages. Post-2007 trader fast-talk, the Joad family's Oklahoma drawl, and Greenspan's Federal Reserve jargon predominate. In performance, Steinbeck's poetic language is set against flickering numeric abstractions signaling fluctuations in the price of stocks and bonds. This juxtaposition of languages is not unlike Steinbeck's strategy in *The Grapes of Wrath*, where the scenes with the Joad family are put into context by the omniscient Narrator's explanation of the era to which they belong. Steinbeck blamed the plight of the Joads on big bosses, unregulated capitalism, and God for sending drought and dust storms, and he provided some human compassion to balance the abundance of human cruelty in his narrative of a family's suffering and loss. A classic 'on the road' novel whose form is as old as *The Odyssey*, the main characters – Ma, Jim Casy, and Tom – articulate some 'unorthodox' humanist ideas about human relations that counter the world in which they find themselves. Jim Casy, a former preacher, proclaims that he does not believe in Jesus, but instead loves people. However, like Jesus, Casy lives among the poor and rejected and sacrifices himself for others. Alternating scenes from the novel with scenes of stock market number crunchers gives the work a larger-than-life meaning – biblical in feel. The title of the work is taken from Abraham Lincoln, an American president well-versed in the bible. Weems explained that the title, *House / Divided*, refers to a real repurposed foreclosed house in Columbus, Ohio, that became a physical and metaphorical space onstage *and* from the oft-quoted statistics of the Occupy Wall Street movement, referring to the economic disparity of the 1 percent versus the 99 percent in the United States.[6] The source of the phrase, however, in Abraham Lincoln's famous 16 June 1858 acceptance speech for his nomination to the Senate cannot be discounted. In that speech, Lincoln paraphrased Jesus in Mathew 12:25, the New Testament, that would have been recognized by those listening at the time.

> A house divided against itself cannot stand. I believe this government cannot endure, permanently, half slave and half free. I do not expect the Union to be dissolved – I do not expect the house to fall – but I do expect it will cease to be divided. It will become all one thing or all the other.[7]

By titling their work *House / Divided* The Builders Association suggests that just as the unity of the country once hinged on the question

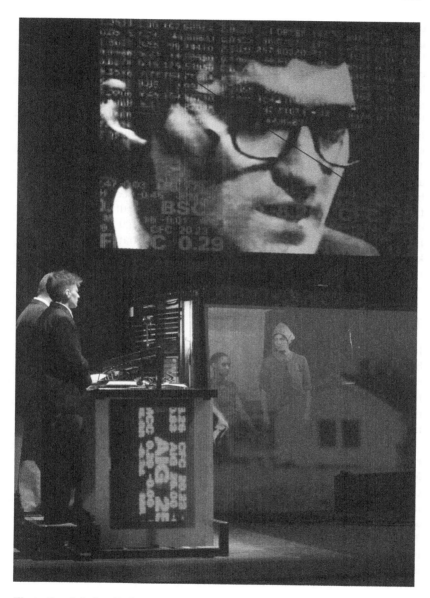

Illustration 6.4 Jess Barbagallo as a trader, LaToya Lewis as Rose of Sharon, Moe Angelos as Ma, and Sean Donovan as Alan Greenspan in *House / Divided* by The Builders Association, directed by Marianne Weems. Photograph by Jay LaPrete

of slavery, it now hinges on the question of economic disparity. The institutionalized and legal inequity of slavery in Civil War-era America has become the income and opportunity inequity of the twenty-first century. The poverty and cruelty of the Great Depression is seen again in those who have suffered foreclosure and been forcibly divided from their homes (Illustration 6.4). The poverty of today, the title proposes, has antecedents in the way the nation is economically structured. Inequality reinvents itself for different but analogous reasons: chattel slavery, wage slavery, foreclosure slavery. The 99 percent versus the 1 percent, the few rich against the many poor, the number crunchers against humanitarians, employers, and administrators against laborers, banks against those whose homes have been foreclosed. *House / Divided* tries to resurrect a long-promised, idealized, and still pending vision of America. The leviathan, the untamed creature that rattles the playhouse, is finally a body of ideas. These are ideas that we may already know, that we may have heard somewhere, ideas that may make us remember something, ideas that may put spectators in a condition of *déjà vu* about what they know and what they value.

The Pixelated Revolution

In his one-man show, *The Pixelated Revolution*, Rabih Mroué notes that both professional and freelance journalists are absent from the Syrian revolution, making it impossible to know what is going on, at least from the vantage point of Beirut where Mroué lives.[8] At the time Mroué made *The Pixelated Revolution*, in the autumn of 2011, the only available information about the demonstrations came from Syria's official news channel and protesters' images uploaded to the Internet – images that were originating outside of governmental and institutional regulation. Mroué's lecture/performance is part investigation, part explanation, part operating manual, and part homage to those who have lost their lives fighting for change in Syria. Born out of a detailed and forensic analysis of the Syrian protesters' uploaded YouTube videos and images *The Pixelated Revolution* is an exegesis on the aesthetics of revolution in a post-9/11 Internet world. The importance of the videos and clips is not to be underestimated, Mroué told his spectators, as there is an increasing demand for them by media outlets whose journalists are denied direct access and an increasing willingness to broadcast them on official programs.

Walking casually onto the stage of the Baryshnikov Art Center, Mroué seated himself at a downstage-right white table with the upstage left

corner artfully angled toward the large screen that occupied the back of the playing area. An Apple laptop computer was at Mroué's right and a reading light and glass of water were at his left (Illustration 6.5). Mroué began his lecture/performance by stating that it all began with the sentence: 'The Syrian protesters are recording their own death' (2012).

> So I found myself inside the Internet travelling from one site to another, looking for facts and evidence that could tell me more about death in Syria today. I wanted to see and I wanted to know more, although, we all know that this world, the Internet, is constantly changing and evolving. It is a world that is loose, uncontrollable. Its sites and locations are exposed to all sorts of assaults and mutilations, from viruses and hacking procedures to incomplete, fragmented and distorted downloads. It is an impure and sinful world, full of rumors and unspoken words. Nevertheless, it is still a world of temptation and seduction, of lust and deceit and of betrayal.
>
> (Mroué 2012)

Throughout his performance Mroué sat at the table, sometimes looking at the spectators, sometimes at his computer, sometimes as his

Illustration 6.5 Rabih Mroué in *The Pixelated Revolution*. Photograph by Ernesto Donegana

manuscript, and sometimes glancing over his left shoulder at the large upstage screen where the images and videos that are the subject of his performance were projected. Mroué, an excellent actor, shaded his performance with many subtle and fleeting emotions: a flicker of sadness when first mentioning the deaths of Syrian protesters; tenaciousness in his efforts to find some fragments of truth about the protesters' plight; anger at injustice. Mroué's style of acting is to present himself as an entirely trustworthy performer and researcher. Stunning ideas were casually explicated with unassuming modesty; Mroué barely looked up as he pointed out the similarity between the camera tripod of the establishment and the tripod that stabilizes their automatic weapons – one of his many exceedingly incisive observations. The stability of the tripod is the same as the intention of the state to remain in power. With observations like these, Mroué easily won over spectators to his careful and compelling theory of how the circumstances of the revolution created an aesthetic of necessity.

Focusing on the moments of the Syrian uprising that can only be known from what has been uploaded to the Internet, Mroué scrutinized the images and YouTube videos as fleeting testaments to unseen protesters' life-risking attempts to prove that what they saw actually happened, and as brief digital memorials. At the same time, he posed the question, 'How should we read these videos?' Mroué's answer to this question was in the form of a proposal that we consider the videos as evidence of a new kind of aesthetic that seeks to document events in ways that go beyond the evidence of the actual places and occurrence of the revolution. There are two kinds of shooting, Mroué informed his audience: shooting with a camera and shooting with a rifle. 'One shoots for his life and one shoots for the life of his regime' (2012). Both can have dire consequences. Protesters, who have used the digital video recording capacity in their mobile phones to document demonstrations and conflict, have become the targets of government soldiers for doing so. In this case, Mroué fitted together a relationship between two kinds of shooting: shooting to record and shooting to kill.

One video that Mroué narrated to guide what spectators should look for, was just one minute and 23 seconds long.[9] He pointed out a sniper on a low floor of a building in a residential neighborhood. Another shooter was on a high floor of another building across the street in what was probably the inside of an apartment, holding his mobile phone and filming what was happening outside. The video began with the sound of a gunshot followed by a rapid succession of images of rooftops, balconies, walls, windows, and different buildings until the eye that was the

camera spotted the sniper lurking behind a wall. The eye that was the camera creating the vision of the sniper lost him. Then the sniper came into view again with his military rifle aimed at the camera. The image shook as if the eye could not believe what it was seeing. The sniper fixed on his target, the man with the mobile phone camera. The lens of their eyes seemed to meet and then the sniper matter-of-factly shot his gun hitting his target. He took a shot, hitting his target. The eye, the man, the mobile phone fell to the ground as the image spun toward the ceiling. Mroué translated the voice of the cameraman, who had been hit, as saying, 'I am wounded, I am wounded.'

Then silence. The image stopped. It was not clear whether or not the cameraman was dead. It is as if spectators had witnessed, if not death, then near death without ever seeing the person who was hit. Spectators were placed in the subject position of the person with the mobile phone camera and saw what his eyes saw. The double shootings yielded double meanings. The video images attempt to make the details of the resistance known to the world via the Internet *and* to provide evidence of the government's intent to kill. Through his performance as both a professional actor, trained to modulate emotions and affect, and as a social actor, a member of society, Mroué presented and performed what was happening in Syria from the demonstrators' political and aesthetic vantage points. Of course there were and now are other sources of information about Syria besides the civilian amateur videos. Some of them came out of Damascus. *The New York Times* published an article by Anthony Shadid in January 2012, for example, that quoted President Bashar al-Assad, who the demonstrators are demanding step down. 'In a speech at Damascus University the Syrian president called the protesters traitors and characterized their actions as a foreign-backed plot. The UN,' Shadid wrote, 'estimated the death toll of Syria's "relentless crackdown" at 5000. Both the defecting security forces and the bombing attacks in Damascus emboldened the protesters, and so resistance to President Bashar al-Asad's 11-year rule continues' (Shadid 2012). Even as Mr Assad spoke, the death toll appeared to rise again. 'The Local Coordination Committees said on Tuesday that 30 people were killed, including 16 in the eastern city of Deir al-Zour; there was no way to independently confirm the figures.' Shadid was reporting from Beirut, Lebanon, where Mroué lives. At the end of the article the *Times* notes: 'Hwaida Saad in Beirut and a *New York Times* reporter in Damascus contributed to this report' (Shadid 2012). Two journalists in Beirut, the other was an undercover journalist in Damascus. The necessary anonymity of one of the journalists and of his geographic location underscores Mroué's

assertion that, in this case, unregulated reportage via platforms such as YouTube has become an important competition to conventional media. It may be, Mroué proposed, the only way to glimpse what is happening in politically fraught places in the world especially in relation to government attempts to control information.[10]

The Internet clarifies, revises, and obscures the possibilities of memory, history, and memorialization that have been associated with place. Other than lacking location, Internet sites such as YouTube are deemed *illegitimate* sources of information, precisely for the reasons Mroué asks his spectators to consider them as legitimate. The Internet is not fact-checked, no sources are verified, and there is no governing ethical code of reportage or information. It is subject to hacking, its images can be unauthored and unauthorized. The Internet is its own Greek tragedy and comedy; it is 'a world of temptation and seduction, of lust and deceit and of betrayal' and of humor and satire (Mroué 2012). What Mroué performs has no connection to a specific physical place in Syria. He does not mention the names of any cities such as Homs or Damascus. Nor does he mention the delicate balance between Christians, Alawites, secularists, and Islamicists. This is because Mroué's subject is the aesthetics of the resistance in Syria as a deliberate product of an uncensored eye that one cannot get from official sources:

> I assume that what the protesters in Syria are seeing, when they are participating in a demonstration, is the exact same thing that they are filming and watching directly on the tiny screen of their mobile phones, that they are using 'here and now.' I mean that they are not looking around and then they choose a certain scene or angle to shoot. But they are all the time looking through the camera and shooting at the same time. So the eye and the lens of the camera are practically watching the same thing. It is the exact same thing that we will see later, on the Internet or on television, but at a different time and place. It is as if the camera and the eye have become united in the same body, I mean the camera has become an integral part of the body. Its lens and its memory have replaced the retina of the eye and the brain. In other words, their cameras are not cameras, but eyes implanted in their hands; an optical prosthesis.
>
> (2012)

The Pixelated Revolution points out how everyday recordings can suddenly be treated acts of resistance and transgressions that have to be eliminated. The surveillance Mroué refers to is not constant and

panoptic. The surveillance of and by both the Syrian Ba'athists and their opposition is a surreptitious pop-up surveillance. There is not one eye scanning the landscape but many eyes, all looking for and trying to capture other eyes. The target of security forces is no longer people with guns with the intent to kill, but people with mobile phones with the intent to record. The target of people with mobile phones is people with guns, and their intent is to stop the killing by recording it. Recording has become lethal to both its users and its subjects. The gun is pitted against the camera as a weapon of war and revolution, and this confrontation of weapons and of aesthetics has resulted in ideological shifts. Mroué reads the aesthetics of the images that Syrian protesters, both Muslim and secular, create as an assertion that death is not solely in the hands of G-d, it is also in the hands of people with hand-held recording instruments and their guns. The protesters' images consistently aim to show the faces of their killers, to show them as murderers. Mroué concludes that the protesters' aesthetic techniques assert that even though the revolutionaries are sometimes referred to as Salafists, the revolution in Syria is not an Islamic revolution; it is not a resistance driven by religious ideology. It is a revolution driven by the desire for democracy as evidenced in the mobile phone digital video recordings of death as murder committed by men, not by an act of God.

There are, however, two competing approaches to the aesthetics of the image, Mroué told his audience. One approach posits that a clear image can become official, eternal, and immortal. This was the approach and the aim of the timed attacks on the World Trade Center. The first plane that slammed into the North tower summoned recorders to the site in time for the second plane's attack on the South tower. The other approach holds that a clear image is antagonistic to the revolution, that there should be no preparation, no possibility of a tripod standing as the symbol of recording readiness. No staging for the media. Mroué told his audience:

> The protesters are aware that the revolution cannot and should not be televised. Consequently, there are no rehearsals in their revolution, and no preparations for a larger and more important event. They are recording a transient event, which will never last. Their shots are not meant to immortalize a moment or an event, but rather a small portion of their daily frustration, fragments of a diary that might one day be used in the writing of an alternative history.

(2012)

Mroué's belief that Syrian protesters are filming the same thing they are seeing results not only from what the cameras capture but also from the repeated aesthetic of the images. Close to the beginning of his performance, Mroué informed his spectators that he would compare digital and low-resolution images with some professional films to create a distance from emotion and immediate reactions. His analysis led him to assemble a cinematic manifesto, 'a fictional list of advice and directions on how to film manifestations' that is also a reflection on the methods of the Syrian protesters' short films (2012).

The list included: shoot from the back to hide the identity of protesters; carry banners backwards so cameras shooting from the back can see what they say; take long shots from afar so as not to reveal the identity of the protesters; film faces of assaulters; write the date and place of the manifestation; music should not be used; the sounds must be real; filming must be done on location in the here and now; do not use tripods; use handheld cameras; and, do not use special lighting. He offered more general advice, including: use mobile phone cameras because they are lightweight; be wary of surveillance cameras on government and institutional buildings; try to film the street address for the sake of veracity; do not care about the quality of the image; and, place the strap of the camera around your neck in case you have to run.

Mroué's fictional manifesto – fictional because it is an aesthetic manifesto based on the practices Mroué observed as already in existing videos – positions itself at a distance from the conventional aesthetics of making video and film in order to point out the veracity of the handheld, homemade, low-resolution, and unpremeditated images of the Syrian revolution. His performative assertion is that the spontaneously made and minimally produced YouTube videos of the Syrian demonstrations documented what was happening with deliberate aesthetic devices resulting from politically savvy survival techniques. Conventional journalistic credibility is absent because at that time and in the context of the Syrian revolution, authenticity could only exist separate from official organizations and sanctioned sources. The grainy, low-resolution scanning shots of the two short videos that Mroué showed his spectators yield images that not only countered the reports of the state but upended assumptions about the aesthetics of credible images. The purpose of 'looking' has transformed as it has changed hands. Mobile phone cameras are merchandized as equipment for making positive and friendly images of family and friends for family and friends. In *The Pixelated Revolution* the camera is a device for documenting death, even one's own death, and the reality of social and political

events – what is happening (or has already happened) with an aesthetic that reveals the circumstances of the protesters *not* shown on camera. The Syrian recordings uploaded to YouTube are a new form of anonymous testimony that is sanctioned precisely for its anonymity *and* for its refusal of silence and invisibility in what Mroué refers to as video letters – letters to the world that claim this has happened, is continuing to happen, cannot be denied. *The Pixelated Revolution* also asserted the real in theatrical terms. The digital images in combination with Mroué's presence as performer, researcher, and writer claim the possibility of truth and authenticity, and their abiding absence at the same time.

Mroué presented terrible violence without showing it. *The Pixelated Revolution* never literally showed a YouTube video of anyone dying even as it presented what may have been two actual deaths. Toward the end of his performance, Mroué showed a 14-second video uploaded to YouTube by Syrian activists.[11] A slow-moving tank entered an intersection at the end of a road, stopped midway, and rotated its big gun 45 degrees. Behind the nozzle of the gun were the invisible eyes of the man in the tank. The invisible man in the tank faced the lens of the cameraman from whose position the whole scene was shot. The gun fired and the camera, the eye, the man fell and appeared to have died. A flash of color erupted. What was this? A descent into death? Then the scene was over; the video was finished. The only sound in the video was the sound of the tank cannon shooting the cameraman. The scene was real but incomplete, Mroué told us. The spectators in the theatre and the cameraman witnessed the tank and its gun, its eye, its lens, and the invisible man inside. They were invited to experience the power of the state whose action the man in the tank performed along with the cameraman Mroué led his spectators to believe recorded his own death.

From a certain perspective, Mroué's *The Pixelated Revolution* is the most real of the three works discussed in this chapter. *Surrender* is simulation, *House / Divided* is digital reconstruction. *The Pixelated Revolution* is actual 'unprofessional' footage, projected and analyzed by Mroué to demonstrate something about the nature of the events in Syria not as interpreted by journalists, but as video disseminated via social media. The YouTube video he shows has not been vetted; it is 'shot' and then 'broadcast.' Mroué's abstinence from editing the footage he shows makes it appear plain that what is happening in Syria is not entirely known. These short seemingly uncensored YouTube uploads, Mroué implicitly says, is all that we have of political reality. Interpretation is in the hands of Mroué as a kind of *deus ex machina* author/auteur. This is unlike Fox's director-dramaturg role in *Surrender* and Weems's *Wizard of Oz* Professor

Marvel role in the stunningly sophisticated digital account of *House /
Divided*. Mroué employs the simplest and commonest of means; a com-
puter open on a table to provide what appears to be authentication of
Mroué's footage as real, as coming from where he says it comes from.
Even as he uses devices and footage most everyone in his audience also
has access to, he 'projects' – literally and figuratively – the inconsistency
of the Arab Spring's most recent outcome. Is this entertainment? Is it
politics? Does the audience become witnesses? Is it real?

In Fox's *Surrender* the audience not only participates, it becomes
co-author. What happens to individual participants gives tone to the
entire piece. Fox and his team of actors serve both as actors, and as 'mas-
ters of the game.' Audience members are inducted into *Surrender* in a
manner analogous to how a new recruit is inducted into the armed forces:
voluntarily, and yet once inside, they are 'forced' to do as they are told. To
refuse is both to reject the game that is at the core of *Surrender*, and to opt
out of the critique of the US 'mission' in Iraq and Afghanistan.

Builders Association's *House / Divided* at first seems a world away from
Surrender. The work mixes the genres of the novel and photojournalism
with historiography to narrate a kind of new civil war in America, an
economic clash where the rich get richer on the backs of the middle
class and poor. Fox traffics in simulation – the theatre is not *really* the
battlefield; participants are not *actually* shooting rifles. The Builders
Association shows us the 'house on North Fourth Street,' they quote
from *Grapes of Wrath*, and by means of the digital magic Builders is
known for, they conflate the loss of homes during the Great Depression
with the contemporary mortgage crisis and with stockbrokers as Ma
Joad's dinner bell announces both dinner and the opening and closing
of a day on the New York Stock Exchange. The reality of the '1 percent
vs. the 99 percent' enacted by the demonstrations of Occupy Wall Street
infiltrates the no-longer fictional space of the theatre. Both works sum-
mon the American dream even as they portray its collapse by staging
our participation in the creation of expendable realities.

Like Josh Fox and Jason Christopher Hartley, and The Builders
Association, Mroué creates an aesthetic and analytical discourse that
represents the real in order to call it into question. They all straddle
fiction and nonfiction, performance and documentation, and entertain-
ment and edification. Mroué's use of mixed media is now the norm;
performance, video, photographs, stage design, and text all operate
together to demonstrate something about the Syrian revolution, about
alternative methods of dissemination of political information, about
the Internet, about the revolution's methods and about performance as

a means of staging analyses of complex realities. Mroué also shows the thin line that can sometimes separate the factual from the invented and how the rawest data can be molded into various shapes.

Like the other works I discuss in this book, *Surrender, House / Divided,* and *The Pixelated Revolution* intend for spectators to reconsider the world around them on the basis of the theatrical experiences these works offer. Different political, social, and national contexts have contributed to innovations in writing, performing, and directing theatre of the real. In the global circulation of theatre of the real, diverse streams of practice are influencing one another. World War II, the nuclear holocaust and the Nazi Holocaust, the social and political upheavals of the 1960s, the gay rights movement, the Israeli Palestinian conflict, racial clashes, the terrorist attack on the World Trade towers, the War in Iraq, the housing foreclosure crisis, and the Syrian revolution is the range of subject matter of the international work I have analyzed in this book. The specific works I discuss here are examples of how a theatrical movement can create new forms of social memory and different kinds of inquiries into social justice and its lack thereof. Productions created from this process aim to publicly disclose both personal and public truth in a manner that forms social consciousness about the relation of the individual to history and history to the individual.

Theatre of the real stages memory and history to scrutinize and also to invent the people and forces making history. It constructs and reconstructs personal and social memory from the raw data of experience by using specific theatrical methods to examine the difference between documentary evidence as fact and social memory as invention. Theatre of the real uses framing to negotiate differences between individual knowledge based on memories that are always in the process of being formed and reformed, and historical knowledge that is always in the process of being revisited and revised. Staging memory and history has helped create new versions of human experience. The difference is unstable between individual knowledge based on memory and historical knowledge that is always being revisited and revised. Theatre of the real's confounding of lived experience, constructed memories, and virtual reality apprises us that our ways of knowing have changed and are continuing to change. The process now seems unending. Tracking these epistemological shifts in both lived and mediatized experiences reveals the dislocation of 'primary reality' in favor of something else difficult to name. The difficulty is that we do not yet know what is emerging. Archiving 'real life' – what people do and say – keeps alive as primary data what previously had a life only as memory. Archives, both personal

and institutional, have created records enabling iterative processes that depend upon previous representations. The circulation of representation that archives enable has created the need for careful attention to narrative structures and historiographical intentions so that repetition of the same ideas does not occur in an unexamined way. Theatre of the real can radically moderate complexity in ways that can either lead to change for the better or the worse or support the status quo.

The realist epistemology of theatre of the real has prompted the development of transparent theatrical methods far beyond what Brecht imagined. What is hidden by social conventions and a limited understanding of how corporations and governments 'theatricalize' their role in the world is being challenged by theatre of the real that asks spectators to take a much more critical stance in relation to the 'information.' The propaganda of governments, businesses, and even academic institutions, often advertises transparency while practicing opacity. At least since the 1960s, revealing something has become as important as changing something; makers of theatre of the real have worked to reveal the instruments of deception, injustice, and discrimination and are equally capable of creating their own instruments of the same. Revealing something about the self, society, and politics is deeply connected to the development of a new performance theory and the invention of theatrical techniques. Contemporary makers of theatre of the real work with an aesthetics of revelation assuming that subject matter cannot be transparent if the methods used to present it are opaque. They show their spectators some of the complex ways the relationship between theatre and life can be conceptualized, performed and reperformed. The question is not only what happens to history when it is made into art, but what happens to art when it makes history.

Artists who both document and challenge conventional notions of accuracy, authenticity, and fact by analyzing, disrupting, and subverting the aesthetic conventions that underlie documentary certainty are on the cusp of a global world different from the one that Ron Suskind described in the epigraph to this chapter. They are a part of a theatre of the real community, creating ways to understand personal, social, and political phenomena by means of aesthetic invention, intervention, and implementation.

Notes

1 Theatre of the Real: An Overview

1. In her essay 'The Promise of Documentary,' Janelle Reinelt (2009) cites Stella Bruzzi on the awareness of the spectator of the status of reality, implicitly making the case that quotation marks need not accompany the word 'real' every time it is written. I agree and will not place the word 'real' in quotation marks through the rest of this book. 'Real' in quotation marks insinuates that the real is not real. Real (without quotation marks) insinuates that the real is real. Since much of my discussion is precisely about the real's ambiguity, I have elected not to use quotation marks.

2. There are many, many published dramatic documentary texts that compete with more conventional historical accounts. Some of these texts that are explicitly about history include: *The Deputy* by Rolf Hochhuth (first performed and published 1963) about Pope Pius XII and the Catholic Church's complicity in the Nazi extermination of the Jewish people; *The Investigation* (first performed in 1965, English publication 1966) by Peter Weiss about the Frankfurt Auschwitz trials, *In White America* (first performed in 1963, published in 1965) by Martin Duberman about racism in America, famously performed in 1964 by The Free Southern Theatre in the still segregated and racist Deep South; *Inquest* (first performed in 1970) by Donald Freed about the trial of Julius and Ethel Rosenberg; *Year One of the Empire* (first published in 1973 and first performed in 1980) by Elinor Fuchs and Joyce Antler about the US's first land war in Asia, the Philippine War fought between 1899 and 1902; and, Emily Mann's *Annulla, An Autobiography* (1977) and *Still Life* (1979) about a Holocaust survivor and the Vietnam War, respectively. Further, *Between God and Man: A Judgment on War Crimes* (first performed in 1970, published in Japanese in 1972, translated and published in English in 1979) by Kinoshira Junji about the Tokyo war crimes trials after World War II is an important and little mentioned contribution to documentary literature from Japan.

3. Jefferson Mays interview, 29 November 2011.

4. Jefferson Mays interview, 29 November 2011.

5. Dancing does not have the same real/performed binary as theatre as it directly engages the body by employing weight, volume, force, rhythm, and velocity, without having to use either text or character. It is experienced immediately in real time and place without the necessity of referring to other times and places. See Martin (1994).

6. The *New York Times* headline, 'Reality, Fiction and Points Between,' is an example of reality and fiction rather than fiction and nonfiction as the oppositional reference points. See Hale (2009).

7. A wonderful example of a popular culture history of ideas ably staged via the use of technology is exemplified in the production of *Romeo and Juliet* by The Nature Theatre of Oklahoma. The performance was created from a series of phone calls to people who were asked to tell the story of *Romeo and Juliet* from

beginning to end. Not one person interviewed was able to remember the plot precisely, resulting in a revelation of attitudes toward the play, Shakespeare, classicism, and love that, when taken together, created a new and hilarious plot about our relationship to plays, poetry, and performance, and whose instruction is considered necessary for knowledge and enlightenment. I saw *Romeo and Juliet* on 28 December 2009 as performed by Anne Gridley and Robert M. Johanson, and conceived and directed by Pavol Liska and Kelly Copper, with set design by Peter Nigrini.

8. See http://techcrunch.com/2010/04/22/facebook-edgerank/ (accessed 28 December 2011).
9. According to Gary Dawson, documentary theatre evolved from a neorealist production style, which can be traced to paradigm shifts stemming from Charles Darwin and naturalism and its cause-and-effect logic. In the nineteenth century novelist Emile Zola wanted artists to search for truth with the detachment of scientists.

2 The Theatricalization of Public and Private Life

1. 'We rejected realism as passé artistically, and as a function of "The State,"' writes Joan MacIntosh, a founding member of The Performance Group.
2. The status of the real informing the object (documents, photographs, film footage, newsprint, Internet, audiotape, and so forth) depends on a realist epistemology, knowing based on the assumption that reality exists.
3. The Stonewall riots were spontaneous, violent demonstrations against a police raid that took place in the early morning hours of 28 June 1969 at the Stonewall Inn in Greenwich Village. In a dramatic resistance to police that overflowed into the streets, gays and lesbians fought back against a police raid and the government-sponsored system that supported such raids. The Stonewall riots became the defining event that marked the start of the gay rights movement in the United States.
4. *The Connection* ran off-off-Broadway for 722 performances and won three Obies.
5. In the winter of 2009 the theatre company Rude Mechanicals reconstructed *Dionysus in 69* and played it in Austin, Texas. The work was a critical success with sold-out houses and much audience participation.
6. Joan MacIntosh, personal correspondence with the author, 26 July 2011. 'Bill Finley wrote his text, including his scenes with Pentheus, based on the idea (and RS [Richard Schechner] may have a different memory of this) that Dionysus represented the ecstatic, inchoate, fluid, androgynous, polymorphous perverse, wine, drunkenness, etc., whereas Pentheus was 'The State,' order, tradition, etc.. The idea was that Pentheus should speak the Greek and Dionysus speak in the contemporary vernacular, since we were drawing direct parallels to the sex, drugs, and rock and roll of the late 60's, and the pitfalls of such unchecked passion and ecstasy.'
7. While Schechner did a few devised productions with The Performance Group – such as *Commune* (1970) – most of his directing has consisted of staging well-known plays.
8. Joan MacIntosh, personal correspondence with the author 27 July 2011.

9. http://www.time.com/time/magazine/article/0,9171,840426-1,00.html, accessed 2 September 2011.
10. In the case of Martin Luther King Jr., whose assassination was not recorded on film, the company began with his 'I have a dream' speech and portrayed King's assassination after the first phrase.
11. Chaikin worked with The Living Theatre when they were performing Jack Gelber's *The Connection* at their theatre on Fourteenth Street and Sixth Avenue, New York, on 15 July 1959.
12. In 1967 Katz wrote his first two documentary plays, both about fugitive slaves: *Inquest at Christiana* and *The Dispute over the Ownership of Anthony Burns*. Both works were broadcast on radio station WBAI-FM (New York).
13. In Kaufman's 1997 production of *Gross Indecency: The Three Trials of Oscar Wilde*, a chorus of young men in Victorian underwear held up the books from which they were quoting. In *The Laramie Project* Kaufman and the Tectonic Theatre Company narrated the story of traveling to Laramie, Wyoming, to conduct the interviews that made up the work, as they related the many stories of the citizens of the town where Matthew Sheppard was murdered for being gay.
14. In a personal correspondence with the author on 26 December 2009, Katz wrote that he remembers the director of *Coming Out!* David Roggensack telling him in 1972 that Joe Chaikin had seen the play and was impressed by the 'fluidity and the originality of the staging.' Katz 'was surprised and skeptical, because however much I liked the look of the milk crates and the fluidity they allowed, I thought that this was already an old staging technique in off off off-Broadway theaters' (Katz 2009a).
15. In a personal correspondence with the author on 19 November 2009, Katz wrote, 'It seems relevant that I had read about Martin Duberman's play *In White America*, though I don't believe I'd seen it. But that was the model for *Coming Out!* (I am not sure if Marty used poems and other literary materials, but his compilation of "documents" in a broad sense was my inspiration)' (Katz 2009b).
16. Feingold includes in his list of sources for documentary plays 'excerpts from news reports, speeches, historical commentary, and documents, interspersed with first person reminiscences, excerpts from relevant works of fiction, and so forth' ([1972] 1975).
17. Paula Kay Pierce directed productions in small theatres in New York until the mid-1980s.
18. In a personal correspondence with the author on 26 December 2009, Katz wrote, 'I wanted a pseudonym that suggested it was a pseudonym' (Katz 2009a).
19. Akalaitis, David Warrilow, and Ellen McElduff received a *Village Voice* Obie Special Citation for *Southern Exposure* in 1979.
20. I saw *Southern Exposure: A Theatre Piece* at least twice at The Performing Garage on Wooster Street in Soho, New York, in 1979.

21. Who is the third who walks always beside you?
 When I count, there are only you and I together
 But when I look ahead up the white road

> There is always another one walking beside you
> Gliding wrapt in a brown mantle, hooded
> I do not know whether a man or a woman
> – But who is that on the other side of you?
>
> *The Waste Land*, lines 359–65

22. I saw *Rumstick Road* at The Performing Garage on Wooster Street in Soho.
23. Gray enlisted LeCompte as his director, Ron Vawter and Libby Howe as his co-performers, Jim Clayburgh as designer, and Bruce Porter as technical operator.
24. 'Drama, Script, Theatre and Performance' was first published in *TDR* 17, 3 (1973).It was first republished in *Essays on Performance Theory 1970–1976* (1977: Drama Book Specialists). Subsequent publication was in *Performance Theory: Revised and Expanded Edition* (1988: Routledge), and then in *Performance Theory* (London: Routledge, 2003). In this essay, I cite the 1973 publication.
25. In a 26 July 2011 email to the author Joan MacIntosh wrote: 'We/I was very influenced by Artaud's *The Theatre and its Double*, and by Brecht, who conceived of his actors as storytellers so that you would never lose the fact that there were actors on stage telling the story of someone else, embodying it, but not "be-ing" it. As you know, he was intent on creating a theatre without illusion, the kind which had been in Germany before he began his work.'
26. There are four characters: Spud, played by Spalding Gray; Woman, played by Libby Howes; Operator, played by Bruce Porter; and Man, played by Ron Vawter.
27. In a 15 September 2008 email Joan MacIntosh described her approach to creating the score of her performance: 'We did extensive psychophysical and vocal exercises as part of our actor training. When I prepared a role, I discovered, or uncovered a deeply personal "score" in rehearsal, which like stringing pearls on a necklace, grew as I added new moments that I wanted to keep as part of the score, or necklace.'
28. As much as Gray would have liked to situate his work outside a psychological exploration of his past, at least a portion of his audience received his work as exactly that – a memory play. Although the formal inquiries of Gray and LeCompte would eventually continue in The Wooster Group, the tendency to read *Rumstick Road* as a personal work is an indication of how powerfully autobiography asserts itself. Gray suffered a debilitating and permanent injury to his head and hip in a car crash. This was followed by a deep depression from which his doctors tried to rescue him by means of electric shock treatments. Then in the winter of 2004, after seeing the film *Big Fish*, about a son's displeasure with his father's tall stories, Gray committed suicide by drowning on 10 January 2004.
29. In his *Introduction to Dan Kwong: From Inner Worlds to Outer Space*, Robert Vorlicky makes the observation that Spalding Gray's autoperformance work that begins with *Sex and Death to the Age of 14* is atypical of straight, white males. Autoperformance, as Vorlicky writes about it, is a subcategory of solo performance in which performers locate their performance and their lives at the center of the work.

3 After the Fact: Memory, Experience, Technology

1. Phone interview with author, 4 August 2010.
2. http://www.nytimes.com/2011/11/29/health/the-certainty-of-memory-has-its-day-in-court.html?src=recg (accessed 1 December 2011).
3. Ibid.
4. Ibid.
5. Ibid.
6. What had I got wrong? According to Atay, and assuming he is correct, I conflated two different sketches into one. I had not remembered all the music and had mistakenly remembered the 'stop the blood' portion of the performance as being the last sketch of evening when it was, in fact, followed by two more sketches. Atay, email to author, 14 November 2011.
7 Interview with author, 29 November 2011.
8. The New York University Senate Meeting Minutes of 4 October 2001 reported that more than 3500 NYU students were evacuated from dorms in lower Manhattan and relocated in hotels, the Cole Sports Center, or with other students. In addition, some members of the faculty took students into their homes. A student of mine lived with us from October through December, when she went home for semester break. NYU's Information Technology Services reported that 500,000 emails were sent from the university on September 11th, 300,000 more than usual for a single day. At study-abroad sites all US and NYU flags were removed as a precaution. There was no significant student attrition following 9/11. The number of early-decision applications for the 2002 freshman class was only slightly below the 2001 level. The geographic distribution of the early-decision pool did not significantly change.
9. See http://www.youtube.com/watch?v=g41BBLryUsk (accessed 9 July 2010).
10. Email to author, 26 July 2010.
11. Phone interview with author, 4 August 2010.
12. Phone interview with author, 4 August 2010.
13. Phone interview with author, 4 August 2010.
14. Email to author, 21 August 2010.
15. See Foster 1996: 27–8.
16. Phone interview with author, 4 August 2010.
17. The design of the 107-story World Trade Center towers was in defiance of engineering and architectural wisdom. The architectural design of Minoru Yamazaki, with the engineering of Leslie Robertson, eliminated interior columns. A tight mesh of steel on the surface of the towers provided support and resistance loads against the force of the wind, the anticipated threat to the towers. The designers even calculated the possible effects of an airplane crashing into the towers, concluding that the towers would remain intact. What they did not consider was how fast lightweight steel melts when subjected to burning jet fuel.
18. Other works by Hotel Modern use both digital technology and live performance simultaneously in documentary puppet portrayals. See my discussion of *Kamp*, later in this chapter.
19. http://www.hotelmodern.nl/flash_en/x_library/library.html (accessed 15 July 2010).

20. Ibid.
21. Home would soon become a failing metaphor, with the financial turndown and the subsequent epidemic of foreclosures.
22. Ilke Saal writes that the expression of an ethics of vulnerability has not come easily to American theatre. The great discourses of theatre closely engaged with politics, economics, and social foundations seem missing after 9/11. Saal examines three works among the many post-9/11 dramas: Ann Nelson's *The Guys* (2001), Neil LaButte's *Mercy Seat* (2002), and Karen Finley's *Make Love* (2003). The works of Nelson and LaButte are respectively characterized as an affirmation of nationhood and/or sarcastic questioning of the state of the nation. For Saal, only Finley's *Make Love* moves beyond an account of suffering.
23. Hans-Thies Lehmann (2006) writes about the real in *Postdramatic Theatre* as an 'irruption' in a closed fictive universe, including conventional disruptions such as direct address and asides. The real as Lehmann refers to it is the unscripted, that which appears to be unscripted, and that which is performatively different from the fictional reality of the stage. Lehmann also notes, as I did in my 2006 special issue of *TDR* on documentary theatre (Martin 2006b), that theatre is a gathering place, a real social event occurring in everyday life.
24. Nehad Salaila, the chief critic of *Al-Ahram* in Cairo, wrote during the Arab Spring, 'Though most of the performances I have seen lately do not generically qualify as documentary theatre and were neither consciously intended nor billed as such, they were uniformly, at least in part, concerned with putting real life scenes and experiences on stage in a variety of forms. Invariably, and however technically unsophisticated, or intellectually naïve, as some of them indeed were, they indirectly led one to question the relationship between facts and their interpretation by people as truth and/or reality, the role of the media in shaping our images of the self and understanding of facts, and the difference between "reality", personally and concretely experienced, and "reality" mediated through writing and the aesthetics of theatrical representation.'
25. Telephone interview with Pauline Kalker, 6 July 2011.
26. Email to author, 25 July 2011.
27. Email to author, 25 July 2011.
28. Not everything in *Kamp* is shown to the spectators. There is the unseen sound designer, Ruud van der Pluijm, who performs some of the sound live and manages all of it offstage. Some of the lighting is controlled from a light board.
29. Email to author, 25 July 2011.
30. Email to author, 25 July 2011.
31. Pauline Kalker, telephone interview with the author, 6 July 2011.
32. In a telephone interview on 6 July 2011, Kalker stated that after *The Great War*, which is about World War I, the company thought they should look at World War II. Kalker told me that her grandfather, Joseph Emanuel, who was Jewish, perished in Auschwitz. As very little was known about his story, it could serve as the basis for this piece. At the same time, Kalker did not want to tell someone else's story. For Kalker, telling only one story also meant not telling the whole story and Hotel Modern wanted to show the whole event.

Models give a wider vision, enabling spectators to see a whole city or a whole room, for example.

33. The Allies' decision was based on saving the bombs to annihilate the German Army in order to win the war.
34. Email to author, 7 July 2011.
35. Email to author, 7 July 2011.
36. Although *Memory of the Camps* originated as a project in February 1945 under the auspices of the Psychological Warfare Division of SHAEF (Supreme Headquarters Allied Expeditionary Force), it was not shown until 7 May 1985, to mark the fortieth anniversary of the liberation. The hour-long documentary is constructed from footage shot by the service and newsreel cameramen accompanying the British, American, and Russian armies liberating German concentration camps.
37. Pauline Kalker, telephone interview with the author, 6 July 2011.

4 Apart From the Document: Representation of Jews and Jewishness

1. Cohen writes, 'Over more than a decade other books which came to constitute the emerging discourse on the ethics and aesthetics of the Holocaust in literature followed Langer's example in rejecting Weiss's play ever more radically, among them Alvin H. Rosenfeld's *A Double Dying*, Sidra DeKoven Ezrahi's *By Words Alone* and James E. Young's *Writing and Rewriting the Holocaust*. The attacks of these critics on *The Investigation* and its author are startling in their ferocity' (Cohen 1998:44).
2. Ferguson points out that even recalling and transcribing memories is an act of improvisation in that it is an active attempt to sort out and understand something (Ferguson 2010:36).
3. Jewish people, of course, do not hold one view. The subject of who is Jewish has been hotly debated, especially in Israel, where the economic incentives for making *aliyah*, meaning moving to Israel, have resulted in people who may not be Jewish claiming Jewish identity.
4. I saw *The Survivor and the Translator* at The Performing Garage at least twice during its first run in 1980. To write this essay, I have also referred to a rehearsal tape during the first run and to the published text of the piece.
5. The Jewish Sabbath begins at sundown on Friday and ends at sundown on Saturday. The Sabbath is considered a gift from G-d; a day of rest from labor. The actual Jewish prayer for marking this sacred day is: 'Blessed are you, Lord, our God, sovereign of the universe, Who has sanctified us with His commandments and commanded us, to light the lights of Shabbat. Amen.'
6. An early version of the play, entitled *Annulla Allen: Autobiography of a Survivor (A Monologue)*, premiered at the Guthrie 2 Theatre in Minneapolis in 1977. The revised version, entitled *Annulla, An Autobiography*, was presented at the Repertory Theatre of St. Louis in 1985 and then in New York in 1988 at the New Theatre of Brooklyn. The 1988 version is available for viewing at Lincoln Center's Performing Arts Library.
7. Passing as not Jewish invokes a stereotypical 'Jewish look,' featuring a big nose, thick lips, heavy eyelids, and a generally 'swarthy' – black in a white

world – complexion. This Jewish look is not Ashkenazic, Sephardic, Cochin, or Ethiopian. But the stereotype persists.

8. Behavior around the marble slab can range from prayer to photo opportunities. I have seen some people place plastic shopping bags on the marble and photograph the bags. When asked what they were doing, they explained that they were documenting the blessing of the souvenirs they had purchased. Some Christians also pray at the *Kotel* (also known in English as the Wailing Wall).

9. 'My brother's blood cries out from the ground.'

5 Occupying Public Space

1. On 1 July 2010 the Style & Fashion section of the *New York Times* included a photojournalism feature instructing viewers on how to take their own photos in the self-shot genre. 'This Year's Model: Me' offers advice such as 'Better to look bad in a picture or two to show that you don't care than to look flawless-and vain-in all of them;' turn up a cheap flash to 'blow out wrinkles;' use your camera phone to get an 'on-the-fly' look; be subtle by making sure your viewer knows it is Paris behind you without using the Eiffel Tower; show off your muscles without seeming vain by wearing a Halloween mask; use animals in your self-shot to avoid appearing over controlling of the image; resize and color to change the entire look of the image. All the advice is about how to create the image you want while avoiding appearing that you are trying too hard. See Chandler (2010).

2. The self-proclaimed violent Palestinian resistance to Israeli occupation known as the Second Intifada or the Al-Aqsa intifada after the golden-domed mosque, located in the old city of Jerusalem and the third holiest site in Islam. This Intifada began in September 2000 (in July 2000 Yasser Arafat walked out of the Middle East Peace Summit hosted by president Clinton at Camp David) after a provocative visit by Ariel Sharon to the Temple Mount, the area surrounding the Al-Aqsa mosque known to Muslims as Al-Haram Al-Sharif. During the Second Intifada, suicide bombers continued targeting Israeli civilians and the IDF continued killing many, many Palestinians. For Israelis, the ideological imperative of the Holocaust, where the world did nothing to save the European Jewry, was invoked to rationalize extreme measures. For Palestinians, 1948 or Al Nakba (the disaster) when the Jewish state was declared by the United Nations was confirmation of world prejudice against Palestinians and indifference to their being a unique people different from the surrounding Arab world and also deserving their own homeland, the land in which they were already residing.

3. The International Solidarity Movement (ISM) website reported that on 11 June 2010 activists disputed a shareholder meeting of Caterpillar by shouting accusations that Caterpillar's D9 bulldozer was used by Israel to destroy farmland and olive groves and demolish homes. According to the website, Caterpillar CEO James Owens responded by saying, 'the company was not responsible for the way Israel uses the bulldozers the company manufactures in the United States' (Szremski 2010).

4. Palestinians claimed the tunnels were for smuggling goods delimited by the Israeli blockade. Israelis claim the tunnels were for smuggling weapons for use against Israel.
5. These perspectives are arguably changing.
6. The term 'verbatim' emerged in the United Kingdom and is now widely used in relation to theatre constructed from verbatim quotation of all sort of documents.
7. This website can be viewed at http://rachelcorriefacts.org/.
8. The blockade was established, in part, in response to Hamas's refusal to release the kidnapped Israeli soldier Galid Shalit (who also holds a French passport), captured in 2006, or to let him receive humanitarian visits from any organization.
9. This video can be viewed on YouTube: http://www.youtube.com/watch?v=9r YzB5DJUEI&feature=related. See universalstudios13 (2008).
10. This video can be viewed on YouTube: http://www.youtube.com/watch? v=UK8Z3i3aTq4&feature=related. See theevilofthezionists (2008) (accessed 6 June 2010).
11. An op-ed by Thomas Friedman entitled 'The Real Palestinian Revolution' notes the work of the Palestinian Prime Minister Salam Fayyad, a former World Bank economist, who has helped the West Bank Al-Quds Index outperform most economic indexes in the Arab world. Instead of resistance meaning no development under occupation, Fayyad has helped redefine resistance as building Palestinian institutions and employing people to get ready for the formation of the state (2010:A31).
12. Hamas was elected in June 2007.
13. The Introduction is written by 'Craig Corrie for the Corrie Family.'
14. http://www.huffingtonpost.com/vincent-warren/live-from-corrie-trial-in_b_ 770337.html (accessed 26 November 2011).
15. The 'About Us' section of the online English version of *Ma'an News Agency* states:

> Launched in 2005, *Ma'an News Agency* (MNA) publishes news around the clock in Arabic and English, and is among the most browsed websites in the Palestinian territories, with over 3 million visits per month.
> *Ma'an News Agency* is an integral part of Ma'an Network, a non-profit media organization founded in 2002 to strengthen professional independent media in Palestine, build links between local, regional and international media, and consolidate freedom of expression and media pluralism as keys to promoting democracy and human rights. Ma'an Network is a partnership between independent journalists throughout Palestine, including nine local television stations and nine local radio stations. In addition to MNA, its activities include television, video, and radio production, and training courses for Palestinian journalists and media personnel.
>
> (2010)

16. http://www.huffingtonpost.com/vincent-warren/live-from-corrie-trial-in_b_ 770337.html, accessed 26 November 2011.
17. Ibid.

18. http://www.democracynow.org/2006/3/22/my_name_is_rachel_corrie_a (accessed 10 November 2011).
19. http://theater.nytimes.com/2006/10/16/theater/reviews/16rach.html (accessed 14 May 2012).
20. http://www.thestar.com/printArticle/164309 (accessed 26 November 2011).
21. Ibid.

6 Seems Like I Can See Him Sometimes

1. Ron Suskind, 2004. 'Faith, Certainty and the Presidency of George W. Bush,' *New York Times*, 17 October. http://www.nytimes.com/2004/10/17/magazine/17BUSH.html (accessed 19 November 2010).
2. Rabih Mroué, 2003. *Looking for a Missing Employee*. Quoted from a performance on 8 January 2012.
3. Hartley was periodically stationed in Iraq with a New York National Guard Army unit since 2004.
4. *House / Divided* premiered at the Wexner Center for the Arts in Columbus, Ohio, in October 2011. I did not see the premiere but I sat through two weeks of rehearsals and a work-in-progress showing at the Baryshnikov Arts Center in July 2011.
5. http://www.getty.edu/art/exhibitions/bristol/ (accessed 27 January 2012).
6. Email to author 23 January 2012.
7. http://www.americanrhetoric.com/speeches/abrahamlincolnhousedivided.htm (accessed 28 February 2012).
8. The performance about which I am writing was at Baryshnikov Arts Center, New York, as part of Performance Space 122's Coil festival. All information is from my observation of that performance and the unpublished script by Rabih Mroué.
9. http://www.youtube.com/watch?v=Q0pFYXHy9CY&feature=related (accessed 27 January 2012).
10. Anthony Shadid died of an asthma attack in Syria on 16 February 2012.
11. http://www.youtube.com/watch?v=e8-_wQYA-IA (accessed 27 January 2012).

Works Cited

Akalaitis, JoAnne. 1979. *Southern Exposure*. Unpublished performance text. Fales Library, Downtown Theatre Collection, New York University.

Anderson, Sam. 2011. 'Anger and Violence and Disaster and Weird Sex and Strange New Realities: The Fierce Imagination of Haruki Murakami,' *New York Times*, 23 October.

Angelos, Moe, and James Gibbs, with The Builders Association. 2011. *House / Divided*. Unpublished performance text. Text contains excerpts from *The Grapes of Wrath* © 1939 John Steinbeck; renewed 1967 John Steinbeck.

Associated Press. 2010. 'W. Bank Street Named after Corrie,' *Jerusalem Post*, 16 March. http://www.jpost.com/MiddleEast/Article.aspx?id171156 (accessed 16 March 2010).

Auslander, Philip. 1992. 'Live Performance in a Mediatized Culture,' *Essays in Theatre/Études théâtrales* 1 (November): 44–6.

——. 1999. *Liveness: Performance in a Mediatized Culture*. London: Routledge.

Ball, Jim, and Gelsey Bell. 2012. '"What Was the War Like?" Experiencing *Surrender*; Talking with Josh Fox,' *TDR* 56, 2 (T214): 56–80.

Bar-Yosef, Eitan. 2007. '"I'm Just a Pen": Travel, Performance, and Orientalism in David Hare's *Via Dolorosa* and *Acting Up*,' *Theatre Journal* 59, 2: 259–77.

Bateson, Gregory. (1971) 2000. 'A Theory of Play and Fantasy.' In *Steps to an Ecology of Mind*, pp. 177–93. Chicago, IL: University of Chicago Press.

Benjamin, Walter. (1936) 1968. 'The Work of Art in the Age of Mechanical Reproduction.' In *Illuminations*, ed. Hannah Arendt, pp. 217–51. New York: Schocken.

Bigsby, Christopher. 2006. *Remembering and Imagining the Holocaust: The Chain of Memory*. Cambridge: Cambridge University Press.

Billington, Michael. 2005. 'My Name Is Rachel Corrie,' *Guardian*, 14 April. http://www.guardian.co.uk/stage/2005/apr/14/theatre.politicaltheatre (accessed 7 June 2010).

Bleeker, Maaike. 2011. 'Playing Soldiers at the Edge of Imagination: Hotel Modern and the Representation of the Unrepresentable,' *Arcadia: International Journal for Literary Studies* 45, 2: 276–94.

Bottoms, Stephen. 2006. 'Putting the Document into Documentary: An Unwelcome Corrective?' In 'Documentary Theatre,' ed. Carol Martin, special issue, *TDR* 50, 3 (T191): 56–68.

Brecht, Bertolt. [1957] 1964. *Brecht on Theatre*. New York: Hill & Wang.

Brown, Bill. 2004. 'Thing Theory.' In *Things*, pp. 1–16. Chicago, IL: University of Chicago Press.

Brukenfeld, Dick. (1972) 1975. 'Learn and Live,' *Village Voice*, 22 June 1972. Reprinted in Jonathan Ned Katz, *Coming Out! A Documentary Play about Gay Life and Liberation in the U.S.A.* New York: Arno Press, 1975.

Carlson, Marvin. 2001. *The Haunted Stage*. Ann Arbor, MI: University of Michigan Press.

Carmines, Al. (1973) 1975. 'Politics Is Not Art,' *New York Times*, 29 July 1973: D12. Reprinted in Jonathan Ned Katz, *Coming Out! A Documentary Play about Gay Life and Liberation in the U.S.A.* New York: Arno Press, 1975.

Chaikin, Joe. (1972) 1991. *The Presence of the Actor.* New York: Theatre Communications Group.

Chandler, Rachel. 2010. 'This Year's Model: Me,' *New York Times*, 1 July. http://www.nytimes.com/2010/07/01/fashion/01ONLINE.html (accessed 1 July 2010).

Cherry, James M. 2011. 'Kamp,' *Theatre Journal* 63, 1: 109–11.

Claycomb, Ryan M. 2003. '(Ch)oral History: Documentary Theatre, the Communal Subject and Progressive Politics,' *Journal of Dramatic Theory and Criticism* 17, 2: 95–122.

Cohen, Robert. 1998. 'The Political Aesthetics of Holocaust Literature: Peter Weiss's *The Investigation* and Its Critics,' *History and Memory* 10, 2: 43–67.

Connerton, Paul. 1989. *How Societies Remember.* Cambridge: Cambridge University Press.

Corrie, Cindy, and Craig Corrie. 2005. 'Rachel Was Bulldozed to Death, But Her Words Are a Spur to Action,' *Guardian*, 8 October. http://www.guardian.co.uk/world/2005/oct/08/comment.mainsection (accessed 28 June 2010).

Corrie, Craig. 2008. Introduction. In *Let Me Stand Alone: The Journals of Rachel Corrie*, by Rachel Corrie, pp. ix–xx. London: Granta Books.

Davis, Clive. 2005. 'My Name Is Rachel Corrie,' *The Times*, 18 April. http://entertainment.timesonline.co.uk/tol/arts_and_entertainment/article381578.ece (accessed 7 June 2010).

Dawson, Fisher. 1999. *Documentary Theatre in the United States: An Historical Survey and Analysis of Its Content, Form, and Stagecraft.* Westport CT: Greenwood Press.

Duberman, Martin. (1973) 1975. 'The Gay Life: Cartoon vs. Reality?' *New York Times*, 22 July 1973. Reprinted in Jonathan Ned Katz, *Coming Out! A Documentary Play about Gay Life and Liberation in the U.S.A.* New York: Arno Press, 1975.

Eldar, Akiva. 2010. 'Trial over Death of U.S. Activist Rachel Corrie Begins,' *Haaretz*, 10 March. http://www.haaretz.com/hasen/spages/1155500.html (accessed 18 March 2010).

Favorini, Attilio. 1995. *Voicings: Plays from the Documentary Theater.* Hopewell, NJ: Ecco Press.

——. 2009. 'History, Memory and Trauma in the Documentary Plays of Emily Mann.' In *Get Real,* ed. Alison Forsyth and Chris Megson, pp. 151–66. Basingstoke: Palgrave Macmillan.

Feingold, Michael. (1972) 1975. 'In Straight America,' *Village Voice*, 14 September 1972. Reprinted in Jonathan Ned Katz, *Coming Out! A Documentary Play about Gay Life and Liberation in the U.S.A.* New York: Arno Press, 1975.

Ferguson, Alex. 2010. 'Improvising the Document,' *Canadian Theatre Review* 143: 35–41.

Forsyth, Alison, and Chris Megson, eds. 2009. *Get Real.* Basingstoke: Palgrave Macmillan.

Foster, Hal. 1996. *The Return of the Real: The Avant-Garde at the End of the Century.* Cambridge, MA: MIT Press.

Friedan, Betty. 1963. *The Feminine Mystique.* New York: Dell.

Friedman, Thomas. 2010. 'The Real Palestinian Revolution,' *New York Times*, 29 June: A31. http://www.nytimes.com/2010/06/30/opinion/30friedman.html?_ r1&refthomaslfriedman (accessed 5 July 2010).

Fuchs, Elinor, and Joyce Antler. 1973. *Year One of the Empire: A Play of American Politics, War and Protest Taken from the Historical Record.* Boston, MA: Houghton Mifflin.

Gaines, Jane M. and Michael Renov, eds. 1999. *Collecting Visible Evidence.* Minneapolis, MN: University of Minnesota Press.

Godmilow, Jane, and Ann-Louise Shapiro. 1997. 'How Real Is the Reality in Documentary Film?' *History and Theory* 36, 4: 80–101.

Goldenberg, Susan. 2005. 'Bulldozer Firm Sued over Gaza Death,' *Guardian*, 16 March. http://www.guardian.co.uk/world/2005/mar/16/israelandthepalest inians.warcrimes (accessed 19 July 2010).

Grassano, Lorraine. (1972) 1975. 'Gay Life and Liberation Come Alive,' *Rutgers Daily Targum*, 18 October. Reprinted in Jonathan Ned Katz, *Coming Out! A Documentary Play about Gay Life and Liberation in the U.S.A.* New York: Arno Press, 1975.

Gray, Paul, and Erika Munk. 1966. 'A Living World: An Interview with Peter Weiss,' *Tulane Drama Review* 11, 1 (T33): 106–14.

Gray, Spalding. 1978. 'Playwright's Notes,' *Performing Arts Journal* 3, 2: 87–91.

——. 1979. 'About *Three Places in Rhode Island*,' *TDR* 23, 1 (T81): 31–42.

Gussow, Mel. 1979. 'Stage: Downtown Setting for Antarctic Adventure; A Penguin Beginning,' *New York Times*, 18 December: C19.

Hale, Mike. 2009. 'Reality, Fiction and Points Between,' *New York Times*, 7 June: MT8.

Hanisch, Carol. (1969) 1970. 'The Personal Is Political.' In *Notes from the Second Year –Women's Liberation: Major Writings of the Radical Feminists*, ed. Shulamith Firestone and Anne Koedt, pp. 76–8. New York: Radical Feminisms.

Hare, David. 1998. *Via Dolorosa*. London: Faber & Faber.

——. 1999. *Acting Up*. London: Faber & Faber.

Harris, William. 1979. 'Off and On,' *Soho Weekly News*, 22 February. http:// outhistory.org/wiki/Jonathan_Ned_Katz,_Recalling_My_Play_%22Coming_ Out!%22_June (accessed 10 August 2011).

Hesford, Wendy. 2006. 'Staging Terror.' In 'Documentary Theatre,' ed. Carol Martin, special issue, *TDR* 50, 3 (T191): 8–15.

Hughes, Catherine. 2011. 'Is That Real? An Exploration of What Is Real in a Performance Based on History.' In *Enacting History,* ed. Scott Magelssen and Rhona Justice-Malloy, pp. 134–52. Tuscaloosa, AL: University of Alabama Press.

Hüppauf, Bernd. 1993. 'Experiences of Modern Warfare and the Crisis of Representation,' *New German Critique* 72: 3–44.

International Solidarity Movement (ISM). n.d. 'About ISM,' *International Solidarity Movement.* http://palsolidarity.org/about-ism/ (accessed 5 July 2010).

Jacobs, Steven. 2010. 'Hitchcock, the Holocaust, and the Long Take: Memory of the Camps,' *Arcadia: International Journal for Literary Studies* 45, 2: 264–75.

Jannarone, Kimberly. 2001. 'Puppetry and Pataphysics: Populism and the *Ubu* Cycle,' *New Theatre Quarterly* 17, 3: 239–53.

Johnson, Claudia Durst. 1999. *Understanding The Grapes of Wrath*. Westport, CT: Greenwood Press.

Kaprow, Allan. 1983. 'The Real Experiment,' *Artforum International*, 4 December: 201–28.

Katz, Jonathan Ned. 1972. 'Jonathan Ned Katz, Recalling My Play "Coming Out!"' June 1972.' http://outhistory.org/wiki/Jonathan_Ned_Katz,_Recalling_My_Play_%22Coming_Out!%22_June_1972 (accessed 15 August 2010).

———. 1975. *Coming Out! A Documentary Play about Gay Life and Liberation in the U.S.A.* New York: Arno Press.

———. 2009a. Interview with author. New York City, 26 December.

———. 2009b. Interview with author. New York City, 19 November.

Khoury, Jack. 2010. 'Did IDF General Cut Short Probe into U.S. Activist Corrie's Death?' *Haaretz*, 26 March. http://www.haaretz.com/print-edition/news/did-idf-general-cut-short-probe-into-u-s-activist-corrie-s-death-1.266660 (accessed 19 July 2010).

Kinoshira Junji. 1979. *Between God and Man.* Trans. Eric. J. Gangloff. Tokyo: University of Tokyo Press.

Klein, Naomi. 2003. 'On Rescuing Private Lynch and Forgetting Rachel Corrie: The Israeli Army Got Away with Murder – and Now All Activists Are at Risk,' *The Guardian*, 22 May. http://www.guardian.co.uk/world/2003/may/22/comment (accessed 3 January 2012).

Lahav, Pnina. 2004. 'Theater in the Courtroom: The Chicago Conspiracy Trial,' *Law and Literature* 16, 3: 381–474.

Laub, Dori. 1992. 'An Event without a Witness: Truth, Testimony and Survival.' In Shoshana Felman and Dori Laub, M.D., *Testimony: Crises of Witnessing in Literature, Psychoanalysis, and History*, pp. 75–92. London: Routledge.

LeCompte, Elizabeth. 1978. 'An Introduction,' *Performing Arts Journal* 3, 2: 81–6.

———. 1981. 'Who Owns History?' *Performing Arts Journal* 6, 1: 50–3.

Lehmann, Hans-Thies. 2006. *Postdramatic Theatre.* London: Routledge.

Leverett, James. 1979. 'Other Voices, Other Ruins,' *Soho Weekly News*, 22 November: 47. Fales Library, Downtown Theatre Collection, New York University.

Luckhurst, Mary and Tom Cantrell. 2010. *Playing for Real: Actors on Playing Real People.* Basingstoke: Palgrave Macmillan.

Ma'an News Agency. 2010. 'About Us.' http://www.maannews.net/eng/ViewContent.aspx?PAGEAboutUs (accessed 14 August 2010).

Magelssen, Scott. 2009. 'Rehearsing the "Warrior Ethos": Theatre Immersion and the Simulation of Theatres of War,' *TDR* 53, 1 (T201): 139–55 .

Malsin, Jared. 2010. 'Corrie Parents to Ma'an: We Want Accountability,' *Ma'an News Agency*, 12 March. http://www.maannews.net/eng/ViewDetails.aspx?ID268061 (accessed 18 March 2010).

Mann, Emily. 1979. *Still Life: A Documentary.* New York: Dramatists Play Service.

———. 1997a. *Annulla Allen (An Autobiography).* In *Testimonies: Four Plays*, pp. 1–30. New York: Theatre Communications Group.

———. 1997b. *Testimonies: Four Plays.* New York: Theatre Communications Group.

Marranca, Bonnie. 1979. Review of *Southern Exposure* and *Before the Revolution. Live Performance* 1: 41–2.

Martin, Carol. 1994. *Dance Marathons: Performing American Culture in the 1920s and 1930s.* Jackson, MS: University Press of Mississippi.

——. 2006a. 'After Paradise.' In *Restaging the Sixties: Radical Theaters and Their Legacies*, ed. James Harding and Cindy Rosenthal, pp. 79–105. Ann Arbor, MI: University of Michigan Press.

——. 2006b. 'Bodies of Evidence,' *TDR* 50, 3 (T191): 8–15.

——. 2009a. 'Living Simulations: The Use of Media in Documentary in the UK, Lebanon and Israel.' In *Get Real: Documentary Theatre Past and Present*, ed. Alison Forsyth and Chris Megson, pp. 74–90. Basingstoke: Palgrave Macmillan.

——. 2009b. 'Reality Dance.' In *Ballroom, Boogie, Shimmy Sham, Shake: A Social and Popular Dance Reader*, ed. Julie Malnig, pp. 93–108. Urbana, IL: University of Illinois Press.

——. 2010. *Dramaturgy of the Real on the World Stage*. London: Palgrave Macmillan.

Mason, Gregory. 1977. 'Documentary Drama from the Revue to the Tribunal,' *Modern Drama* 20, 3: 263–77.

McGreal, Chris. 2003. 'Activist's Memorial Service Disrupted,' *Guardian*, 19 March. http://www.guardian.co.uk/world/2003/mar/19/israel (accessed 16 June 2010).

Mroué, Rabih. 2003. *Looking for a Missing Employee*. Unpublished performance text.

——. 2011. *The Pixelated Revolution*. Unpublished performance text.

New York Theatre Workshop (NYTW). 2006. Timeline April 2005 – November 2006. Unpublished pamphlet, distributed by NYTW.

Nickell, Joe. 2005. *Secrets of the Sideshow*. Lexington, KY: University of Kentucky Press.

Orvell, Miles. 1989. *The Real Thing: Imitation and Authenticity in American Culture, 1880–1940*. Chapel Hill, NC: University of North Carolina Press.

Paget, Derek. 2010. 'Acts of Commitment: Activist Arts, the Rehearsed Reading, and Documentary Theatre,' *New Theatre Quarterly* 26, 2: 173–93.

——. 2011. 'Acting with Facts,' special issue of *Studies in Theatre and Performance* 31: 2.

The Performance Group. 1968. *Dionysus in 69*. Unpublished script. Personal collection of Richard Schechner.

Puchner, Martin. 2006. 'The Performance Group between Theater and Theory.' In *Restaging the Sixties*, ed. James Harding and Cindy Rosenthal, pp. 313–31. Ann Arbor, MI: University of Michigan Press.

Raad, Walid. 1996. 'Bayrut Ya Beyrouth: Maroun Baghdadi's "Hors la vie" and Franco-Lebanese History,' *Third Text* 36: 65–82.

Radosh, Daniel. 2009. 'While My Guitar Gently Beeps,' *New York Times*, 11 August: MM26.

Rayner, Alice. 2002. 'Rude Mechanicals and the Specters of Marx,' *Theatre Journal* 54, 4: 535–54.

Reinelt, Janelle. 2006. 'Toward a Poetics of Theatre and Public Events.' In 'Documentary Theatre,' ed. Carol Martin, special issue, *TDR* 50, 3 (T191): 69–87.

——. 2009. 'The Promise of Documentary.' In *Get Real: Documentary Theatre Past and Present*, ed. Alison Forsyth and Chris Megson, pp. 6–23. Basingstoke: Palgrave Macmillan.

Reuters. 2010. 'Family of Slain U.S. Activist Sues Israel,' *Reuters*, 9 March. http://www.reuters.com/article/idUSTRE62840220100309 (accessed 16 March 2010).

Rickman, Alan, and Katharine Viner, eds. 2005. *My Name Is Rachel Corrie*. London: Nick Hern Books.

Roach, Joseph. 1996. *Cities of the Dead: Circum-Atlantic Performance*. New York: Columbia University Press.

Rokem, Freddie. 1998. 'On the Fantastic in Holocaust Performances.' In *Staging the Holocaust*, ed. Claude Schumacher, pp. 40–52. Cambridge: Cambridge University Press.

——. 2000. *Performing History: Theatrical Representations of the Past in Contemporary Theatre*. Iowa City: University of Iowa Press.

Rubin, Shira. 2010. 'Trial Begins over Death of US Activist in Gaza,' *New York Times*, 10 March. http://www.nytimes.com/aponline/2010/03/10/world/AP-ML-Israel-US-Activist.html?_r1&scp2&sqrachel%20corrie&stcse (accessed 18 March 2010).

Saal, Ilka. 2011. '"It's About Us!" Violence and Narrative Memory in Post 9/11 American Theater,' *Arcadia: International Journal for Literary Studies* 45, 2: 352–72.

Sack, Leeny. 1990. *The Survivor and the Translator: A Solo Theatre Work about Not Having Experienced the Holocaust by a Daughter of Concentration Camp Survivors*. In *Out from Under: Texts by Women Performance Artists*, ed. Lenora Champagne, pp. 119–52. New York: Theatre Communications Group.

——. 2004. Interview with author. Ithaca, NY, 30 June.

Sainer, Arthur. 1997. *The New Radical Theatre Notebook*. New York: Applause Books.

Saivetz, Deborah. 2003. *The Architecture of Chaos: Actor, Image, and the Dynamics of Space in the Directing Process of Joanne Akalaitis*. Ann Arbor, MI: University of Michigan Press.

Schechner, Richard. 1973. 'Drama, Script, Theatre, and Performance,' *TDR* 17, 3 (T59): 5–36.

——. 2012. 'Building the Builders Association: Marianne Weems, James Gibbs, and Moe Angelos in Conversation with Richard Schechner,' *TDR* 56, 3 (T215): forthcoming.

Shadid, Anthony. 2012. 'Syrian Leader Vows "Iron Fist" to Crush "Conspiracy,"' *New York Times*, 11 January. http://www.nytimes.com/2012/01/11/world/middleeast/syrian-leader- vows-to-crush-conspiracy.html?refbasharalassad.

Sherwin, Richard K. 2000. *When Law Goes Pop: The Vanishing Line between Law and Popular Culture*. Chicago, IL: University of Chicago Press.

Smith, Anna Deavere. 1993. *Fires in the Mirror: Crown Heights, Brooklyn, and Other Identities*. New York: Anchor Books/Doubleday.

Sontag, Susan. 1966. 'Film and Theatre,' *Tulane Drama Review* 11, 1 (T33): 24–37.

Stasio, Marilyn. 1979. 'Exploring *Southern Exposure*,' *New York Post*, 2 March. Fales Library, Downtown Theatre Collection, New York University.

Swift, Byron. 1979. '*Southern Exposure* by Joanne Akalaitis,' *Washington Review*, August–September. Fales Library, Downtown Theatre Collection, New York University.

Szremski, Kristin. 2010. 'Activists Disrupt Caterpillar Shareholder Meeting,' *International Solidarity Movement*, 11 June. http://palsolidarity.org/2010/06/12723/ (accessed 5 July 2010).

Taylor, Diana. 2003. *The Archive and the Repertoire*. Durham, NC: Duke University Press.

theevilofthezionists. 2008. 'Rachel Corrie 5th Grade Speech I'm Here Because I Care,' YouTube video. http://www.youtube.com/watch?vUK8Z3i3aTq4&featurerelated (accessed 6 June 2010).

Thompson, Howard. (1973) 1975. 'Theater: On Liberation,' *New York Times*, 18 June 1973. Reprinted in Jonathan Ned Katz, *Coming Out! A Documentary Play about Gay Life and Liberation in the U.S.A.* New York: Arno Press, 1975.

Universalstudios13. 2008. 'Armed MC – Rachel Corrie JFK Tupac Malcolm X All Murdered by Illuminati,' YouTube video. http://www.youtube.com/watch?v9r YzB5DJUEI&featurerelated (accessed 16 June 2010).

Van Alphen, Ernst. 1997. *Caught by History: Holocaust Effects in Contemporary Art, Literature, and Theory*. Stanford, CA: Stanford University Press.

Van Itallie, Jean-Claude, and The Open Theatre. 1969. *The Serpent*. New York: Atheneum.

Viner, Katharine. 2005. 'Let Me Fight My Monsters,' *Guardian*, 8 April. http://www.guardian.co.uk/stage/2005/apr/08/theatre.israelandthepalestinians (accessed 24 April 2010).

Weiss, Peter. 1966. *The Investigation*. Woodstock, IL: The Dramatic Publishing Company.

Weiss, Philip. 2006. 'Too Hot for New York,' *The Nation*, 16 March. http://www.thenation.com/print/article/too-hot-new-york (accessed 4 May 2010).

West, Cornel. 1993. Foreword. In Anna Deavere Smith, *Fires in the Mirror: Crown Heights, Brooklyn, and Other Identities*. New York: Anchor Books/Doubleday.

Wiesel, Eli. 2006. *Night*. New York: Hill & Wang.

Wright, Doug. 2004. *I Am My Own Wife*. New York: Faber & Faber.

Wright, Lawrence. 2009. 'Captives: What Really Happened during the Israeli Attacks?' *New Yorker*, 9 November. http://www.newyorker.com/reporting/2009/11/09/091109fa_fact_wright (accessed 12 November 2009).

——. 2010. *The Human Scale*. Unpublished performance text. Dated 14 September, numbered 23. Personal collection of Lawrence Wright.

Wyatt. Edward. 2009. 'On Reality TV, Tired, Tipsy and Pushed to the Brink,' *New York Times*, 2 August: A1.

Index